WINGS OVER NEBRASKA

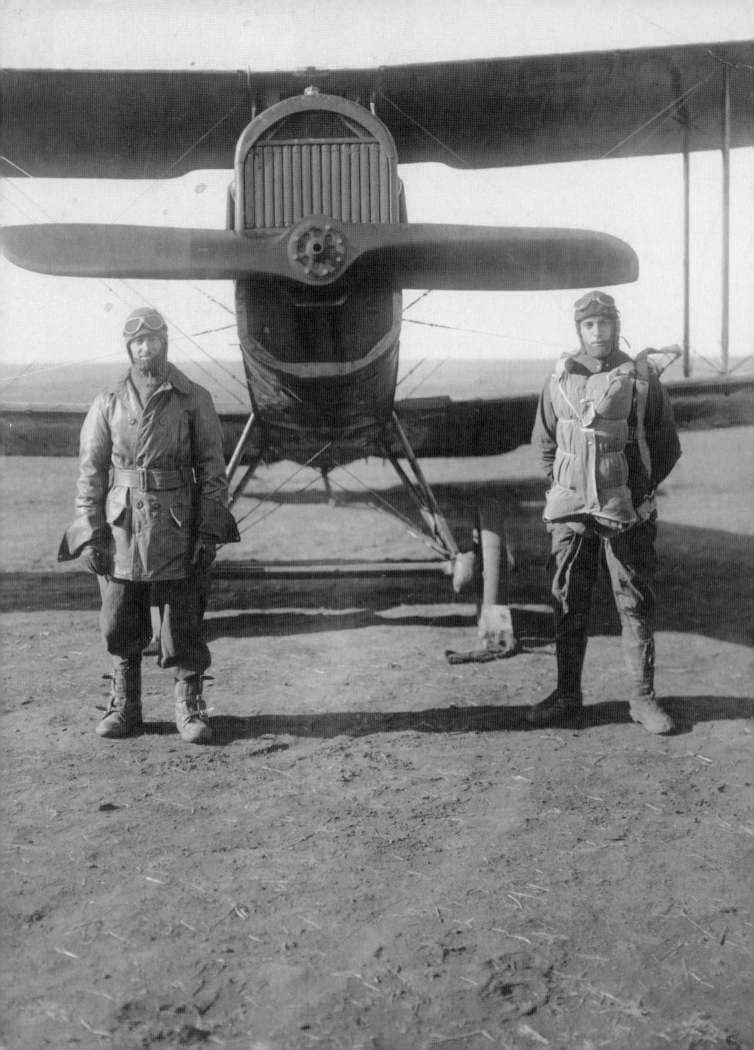

Wings Over Nebraska
Historic Aviation Photographs

BY VINCE GOERES

with Kylie Kinley and introduction by Roger Welsch

Nebraska State Historical Society Books

An imprint of the Nebraska State Historical Society
Lincoln

Nebraska
STATE HISTORICAL SOCIETY

Cover: Gary Petersen of Walton, Nebraska, flies past Chimney Rock in his 1942 Waco UPF-7 in September 2009. Photograph by Tom Downey, Downey Studio.

Opposite: Lt. Paul Wagner and Sgt. Encil Chambers prepare for Chambers's 1921 record jump of 22,200 feet (see p. 59). Later, at the 1921 American Legion convention in Kansas City, Chambers set a new record with a jump of 26,800 feet.

Unless otherwise credited, all photographs in this book are from the collections of the Nebraska State Historical Society. Archival photos are identified by their Record Group (RG) number. To obtain copies of photos, or to request publication permission, contact NSHS reference staff at (402) 471-8922, or email nshs.libarch@nebraska.gov, or visit www.nebraskahistory.org

Many of the photos in this book have been digitally enhanced and restored.

Chapter 13 of this book is adapted from *Aviation Development in Nebraska*, a publication that was funded, in part, by a federal grant from the U.S. Department of the Interior, National Park Service. However, the contents and opinions expressed in this publication do not necessarily reflect the views or policies of the U.S. Department of the Interior.

Book design by Reigert Graphics, Lincoln, Nebraska

ISBN 978-0-933307-31-5
Library of Congress Control Number: 2010935439
Printed in the U.S.A.

To the staff, past and present, of the Nebraska State Historical Society, who have been so helpful in so many ways during the twenty years I have had the privilege of doing volunteer research at the Society.

—V.G.

CONTENTS

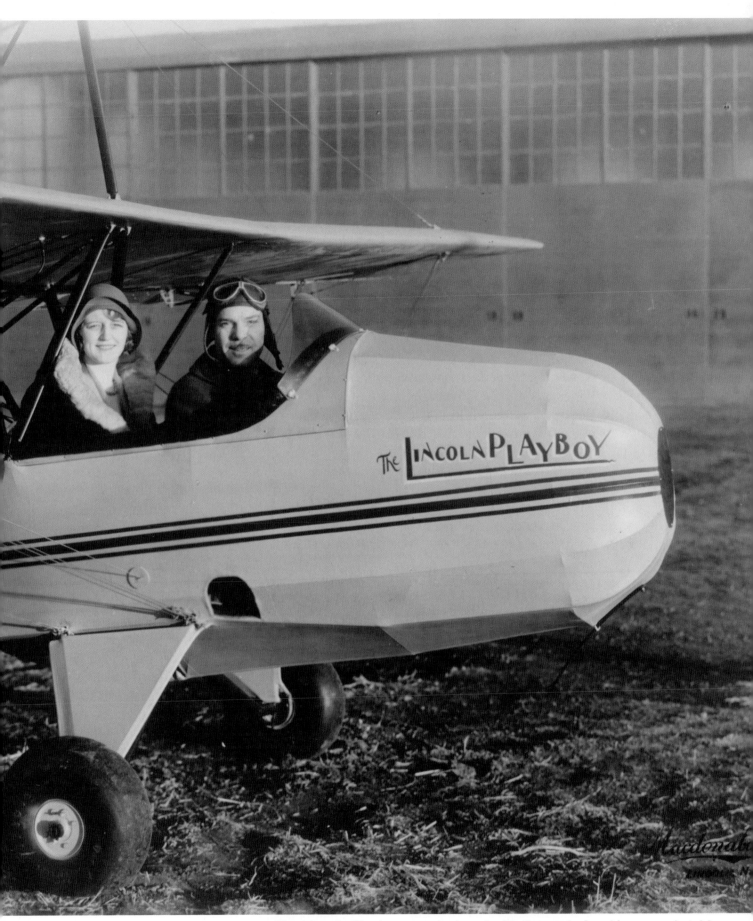

The Lincoln Playboy was designed with the goal of making a marketable small plane. This Playboy is manned by Victor Roos and his wife in 1931.
RG2929-303

INTRODUCTION

By Roger Welsch

Ithink I would be safe in asserting that I was the worst trumpet player ever to grace the Lincoln High School band. For three years I occupied that trumpet section's last chair, blooping, bleating, tooting, and blatting. I clearly had no future in trumpeting.

So, you might be wondering, what does that have to do with Nebraska, flying, and airplanes? Well, for me, quite a bit actually. Because I was so far from the band's best players in the front row, I was exiled to the tail end of the brass section, which put me directly in front of the tuba players. And Fred Bockelman, a tall, lanky kid who played the tuba.

One day during the endless rests last chair trumpet players enjoy in any musical composition that has a prayer for success, our director Lyle Welch was busy working with the reed section and Fred and I at the opposite end of the huge band room found a chance for idle chatter. Fred was excited that he had found an organization called the Civil Air Patrol. Fred had dreams of being an air force pilot and maybe some day a commercial pilot (dreams he did indeed realize eventually) and he was telling me that even kids like us had a chance to fly in the Civil Air Patrol, maybe even in all kinds of military aircraft, and to different places around the country. Not that any of that mattered. The only words I heard Fred say were "airplanes" and "fly." I had none of Fred's career aspirations but man, did I want to fly. I don't know why. I suppose just as every kid at that time wanted to be a cowboy or Indian, every kid wanted to look down on the earth from the clouds. Maybe they still do.

At any rate, I went to the next CAP meeting with Fred, and eventually we did fly in all sorts of military aircraft. I never lost the romance of flight. Eventually I flew, always as a passenger please note, in other military aircraft as part of my service in the Nebraska Air National Guard and then on commercial and private flights as my work involved more and more air travel. Between 1973 and 1981 I think I spent more time in the air than on the ground. I wish I had kept track of how many landings and takeoffs I enjoyed—thousands. I wish I had kept track of the kinds of planes I have flown in and the circumstances—a British troop carrier in Bosnia, a Twin Otter on skis off the sea ice at Thule, a seaplane out of Victoria, alone in a luxury private Learjet out of Cody, Wyoming, an F-16 in full afterburner mode over Memorial Stadium in Lincoln and then over Dannebrog and our tree farm.

And the most common element of every one of those thousands of flights has been my request for a window seat. While I have gloried at the stunning beauty from those window seats of northern Italy, the Yucatan jungle, and down the Potomac on the approach to Washington's lights, my greatest pleasure and most attention has always been when I was at altitude—whether five hundred feet or five miles—over my beloved Nebraska. You see, Nebraska is beautiful to me when my feet are flat on her ground, but there is something special about regarding her grander features with a widened perspective.

I have studied, driven, canoed, rafted, and flown over Nebraska enough, you see, that now I am rarely at a total loss about where I am. I recognize the features of our principal river courses—how could anyone possibly mistake the island-studded Platte for any other river in the world? It is a geographic singularity! The Nebraska Sandhills are the largest sand dune area in the Western Hemisphere so there's no mistaking that geography for any other!

I'm sure you are familiar with the stunning image from space of the Earth at night, showing where population is concentrated (or even worse, compacted) by the brilliant blotches of night lighting. The next time you see that image, try to spot Chicago—the

darkness of the Great Lakes will help you. Then move your focus to the south and west a bit— that's Des Moines with the I-dot of Ames not far to its north. Straight west to the torch of Omaha, a short jog to the southwest is Lincoln and then a fading line of lights along the Platte and Interstate 80 as towns and cities grow smaller and fewer and then—then Nebraska's real glory in my eyes: the enormous, dark, empty blackness of the Sandhills, unblighted by all that goes along with light. Nothing but the darkness that night deserves.

It's a long story but I'll make it short, which is not my usual talent, but I was once on our state plane doing some work across the state for then-Governor Bob Kerrey. My boon companions were State Senators Loren Schmitt and Don Wesely, which means the trip was more like a high school skip day than serious work. Yes, we did have some fun that day and night. But the most memorable feature of that trip for me was the late night leg of the flight from Scottsbluff to Norfolk, over those Sandhills I love. And again my nose was glued to the window. I was utterly amazed and charmed by the view of the Sandhills that dark night. What I saw was—nothing. Not a light. Not a street light, automobile light, yard light—nothing. No wonder people take field trips to the Sandhills to get clearer views of stars. And that night I found as much wonder looking down into the dark emptiness as I had often found wonder looking up into the spangled brilliance of the Nebraska sky.

Thousands of flights over this state have let me learn, for example, that the Middle Loup River, which is one of the boundaries of our land here near Dannebrog, cuts a huge W between the Centura Bridge of Highway 11 five miles upstream from us and the Highway 58 bridge that lies at the southeast corner of our property. And my home for the last thirty years lies at the top of the last upright tine of that W. I can spot the Platte River, get a general idea of when it is exiting the short grass Sandhills cattle country of the west, and then I watch for the larger cities (in Nebraska terms!) of Kearney and Grand Island and look north for that huge W. If I can spot that whiteness of the Dannebrog Highway 58 bridge crossing the river, I get a tingly feeling knowing that's my tiny spot on the great Earth beneath me. I can't see any details at all, but I know each of the trees on that sixty acres. I know my beloved Linda is down there, and my beloved dogs. My books are there, and my tractors. Yes, the world is huge beyond my grasp, but even up here, in the fast emptiness of the sky over the endless plane of the Earth, I have a place that I know and that is mine.

Circling Lincoln when coming in for a landing I can spot Lincoln High, where I destroyed music with my trumpet. I can spot various places I have lived in that city. For once our splendid Capitol is small enough to be taken in with one glance. There's Salt Creek, where my German ancestors fought floods. And O Street, the longest straight main street in the world.

I think you see where I'm going with this. After this long life and thousands of takeoffs and landings in flights all over the world, the romance of flying has never been lost to me. And in my mind, the ultimate fascination of the Earth seen from altitude is still my Nebraska. Some people bristle when detractors sneer that this is "fly-over country," but not me! Damn right this is fly-over country! The very best fly-over country there is!

And no, you can't have the window seat.

A Lincoln Sport LS-2, one of many airplanes designed and manufactured in Nebraska during the early decades of aviation. (Photo reversed from original.)
RG2801-1-128

PREFACE

When I was planning my retirement, I made a list of organizations with volunteer activities I wanted to consider. The Nebraska State Historical Society was near the top of the list because of my love of history. At the time, the Society was cataloguing the Macdonald Collection of photographs and John Carter, then curator of photography, put me to work.

Frederick Macdonald was a commercial photographer in Lincoln during the 1920s, 1930s and 1940s. His pictures document much of the city's history during this period. Working with his collection, I saw many pictures of aviation activities in Lincoln, which rekindled my long-held interest in aviation. (As a teenager I learned to fly at Arrow Airport, but did not continue after starting college.) Moving beyond the Macdonald photographs, I searched for Nebraska aviation pictures and history throughout the Society's archives. My original intent was simply to enjoy these beautiful old pictures and learn about their history; a secondary objective was to list all the different collections that included aviation materials so that we could help people who came to the archives to research aviation.

More than fifty Society collections hold significant material describing early aviation in Nebraska, and from time to time I find a new collection to add to the list. The Society is particularly fortunate to have the collection of Nathaniel Dewell, a commercial photographer in Omaha during the 1920s and 1930s. Dewell appears to have had a special interest in aviation, since little happened in Omaha flying that he did not record. We have in this collection almost seven hundred of his high-quality aviation photos. Many of Dewell's photos can also be found at the Smithsonian Institution in Washington, D.C.

Prof. George E. Condra, longtime dean of the University of Nebraska Conservation and Survey Division, also apparently photographed almost everything he saw during his long and productive life,

leaving us some fine pictures of early Nebraska Aircraft Corporation airplanes and of the landing field on Lincoln's South Twentieth Street. Mrs. Ray Page (later Mrs. Ethel Abbott) kept a marvelous scrapbook of the activities of the Lincoln Standard Aircraft Corporation during the 1920s, and Encil Chambers, parachute jumper and later plant manager for the company, also kept a fine scrapbook. As a result, we have three sources of information about this pioneer aviation company.

This book concentrates heavily on the period between World War I and World War II. It was called the "Golden Age of Aviation," a time when an individual or a small group of people could have a great impact on aircraft design and on the exploration of new frontiers of flight. In many ways, photography and aviation advanced together in that time. The amateur photographer joined the professional in recording the rapid changes in aviation, first with the Kodak Brownie and its successors, then with 35 mm film, and now with the digital camera that creates an image that can be manipulated on a personal computer. Often the amateur snapshots do not match the high quality of the professionals' work, but they do record much that otherwise would have been missed.

A few pictures were solicited for the book in order to fill in gaps, but a number of Nebraska aviation activities are still not included because we lack historic photographs or knowledge of the events in question. Therefore this book is not intended to be an all-inclusive history of aviation in Nebraska, but simply a photographic presentation of many of the early aviation activities in our great state.

My research on these old pictures has involved many hours of reading old newspapers, magazine articles, and books, as well as talking to a great number of people interested in aviation. I would especially like to mention Robert E. Adwers and his book *Rudder, Stick and Throttle,* a great resource for anyone interested in early flying activities in Nebraska.

– *Vince Goeres*

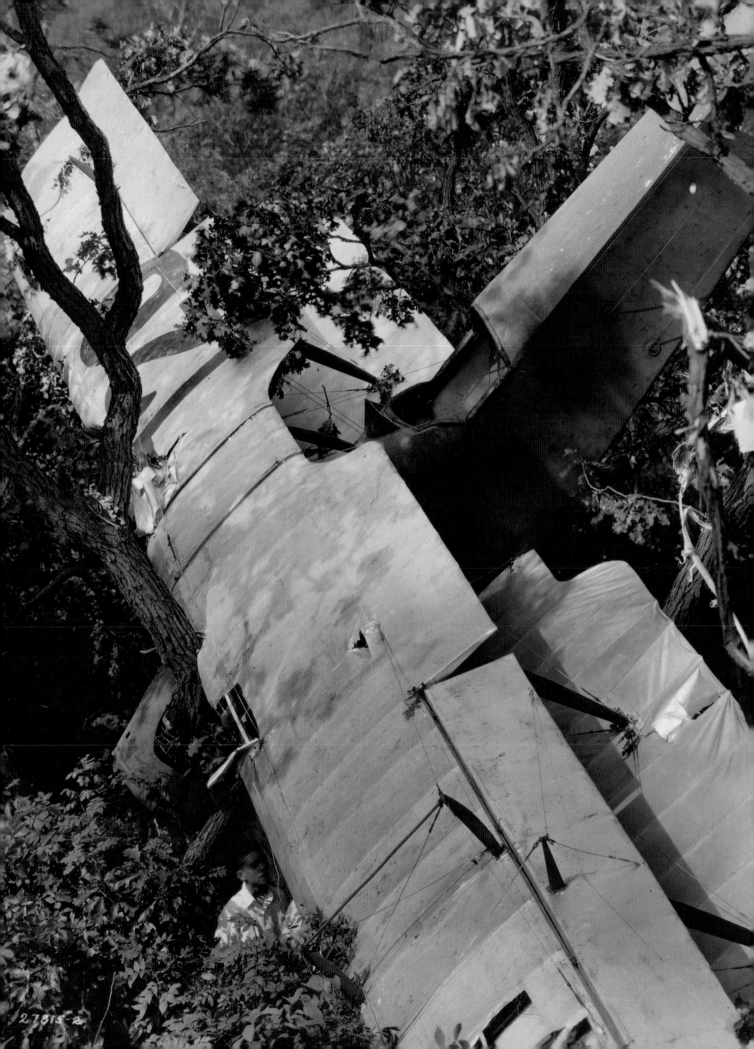

CHAPTER 1

THE EARLY YEARS

For centuries, man's quest to leave the ground had been unsuccessful. But in 1783, two French papermakers, brothers Joseph Michel and Jacques Etienne Montgolfier, succeeded in breaking free of the Earth's grasp. They noticed while burning wastepaper that charred pieces drifted skyward. In later experiments they held paper bags over a fire and watched them rise into the sky, thus inspiring their first hot-air balloon. After a successful flight with animals as passengers, Pilatre de Rozier and Marquis d'Arlandes flew free over Paris in a Montgolfier balloon on November 21, 1783. J. A. C. Charles, a French physicist who followed a different approach, ascended to 2,800 feet in a hydrogen balloon from the Tuileries Gardens in Paris in December 1783.

It would be well into the nineteenth century before propeller-driven, controlled, lighter-than-air flights were successful. Early devices to provide power to propellers included clock-works, steam engines, and electric motors. In 1901, the son of a Brazilian coffee grower, Alberto Santos-Dumont, flew a gasoline-powered airship around the Eiffel Tower to the cheers of thousands. He and his assistants built a number of airships that flew over Paris in the early 1900s.

The balloon had made its way west to Nebraska by the 1870s. Airships, which had power and directional control, followed in the early twentieth century. The state's first airship demonstrations were held at the1906 Ak-Sar-Ben Festival when Charles J. Hamilton flew an airship built by Roy A. Knabenshue, an award-winning dirigible builder and later a member of the Wright brothers' exhibition team.

Gliders ushered in the age of heavier-than-air flight in the nineteenth century when an Englishman, Sir George Cayley, created gliders capable of supporting one person. In 1849, a Cayley glider carried a boy down a hillside, and in 1853 one of his gliders carried his coachman across a small valley in Yorkshire. (Rumor has it that the coachman, not eager to be an aviation pioneer, subsequently quit.) In Germany in the late 1880s, Otto Lilienthal flew his gliders more than two thousand times before a fatal crash in 1896.

The fathers of powered flight, Orville and Wilbur Wright, began their career as bicycle mechanics before becoming interested in aviation. They gathered information about gliding and corresponded with Octave Chanute, an early glider pioneer. They read Otto Lilienthal's book, *The Problem of Flying and Practical Experiments in Soaring,* and then began experimenting with gliders. They even built a small wind tunnel to learn more about wing cord shape and its effect on lift. In 1902 at Kitty Hawk, North Carolina, they made many successful glider flights, having discovered a way to control their glider in all three axes of flight—namely yaw (movement around the vertical axis), pitch (movement up and down), and roll (movement clockwise or counterclockwise on the axis running the length of the plane).

During the winter of 1902, the brothers built an engine for a new glider. In the fall of 1903, they returned to Kitty Hawk and on December 17, 1903, they made man's first successful powered and controlled heavier-than-air flight.

They did so with the help of a former Lincoln, Nebraska, resident named Charles Taylor. Taylor's family had moved to Lincoln when he was a boy. He attended school there until he quit at age twelve to work for the *Nebraska State Journal.* He moved to Kearney when he was in his early twenties and went

Inflated over a fire pit, this smoke balloon was part of the Polk, Nebraska's, fourth anniversary celebration on September 2, 1910. Such balloons quickly cooled and descended. Pilots often parachuted to the ground as part of the show.
RG2407-2-7

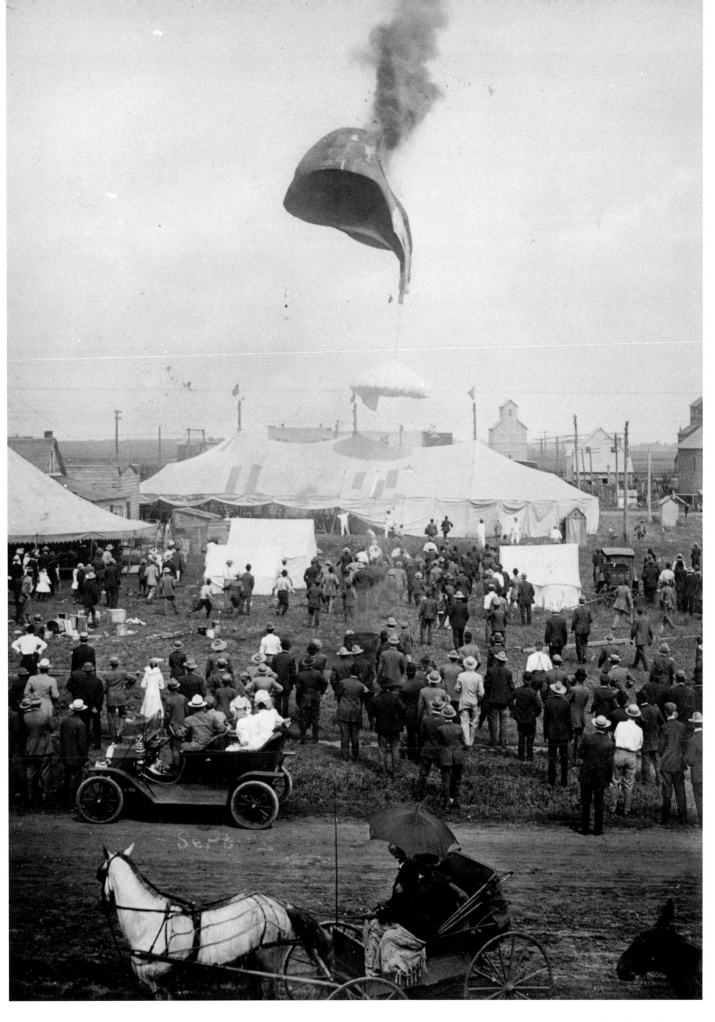

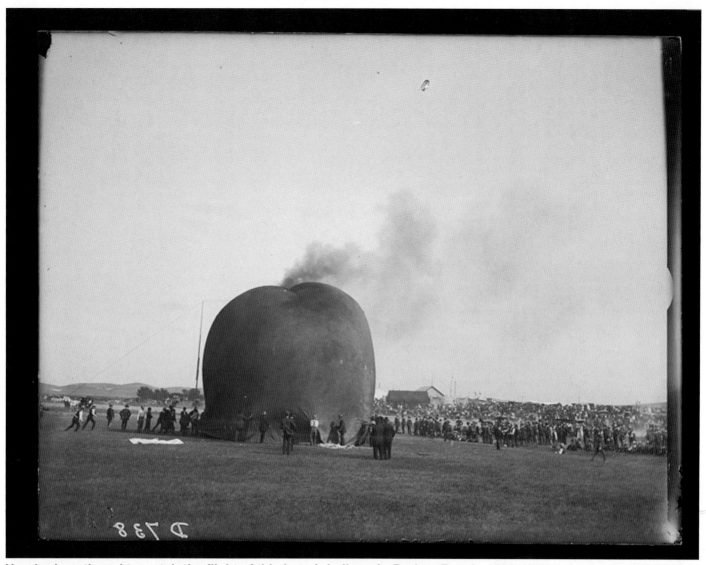

Hundreds gathered to watch the flight of this hot-air balloon in Broken Bow in 1903. Hot-air balloons of that era were inflated over a fire pit. Because they carried no source of heat on board, flights were necessarily short. This balloon was likely the first aircraft that most of the spectators had ever seen.
RG2608-738

into business manufacturing house numbers. Not long after his marriage in 1894, he moved to Dayton, Ohio, and after meeting the Wright brothers, went to work for them. They hired him to help in their bicycle shop, and later he helped design and build the 12-horsepower engine that powered the first flight.

Taylor figured in another chapter in aviation history as well. In the fall of 1911, when Calbraith Perry Rogers flew a Wright EX biplane across the United States from Sheepshead Bay, New York, to Pasadena, California, the Wrights volunteered Taylor to act as mechanic. This first transcontinental flight took fifty days to cover 4,231 miles because the plane crashed a number of times and Taylor had to rebuild it.

Nebraska had its own set of brothers who were passionate about aviation. In 1907, Omaha's Baysdorfer brothers, Otto, Gus, and Charles, constructed the *Comet,* the first Nebraska-built airship. Charles successfully flew the machine, adding the feat to the brothers' impressive list of achievements. Otto and Gus Baysdorfer had built the first automobile in the city in 1898 and the first motorcycle in 1899, but the brothers' most successful invention may have been an automobile spark plug that they sold by the thousands.

The Baysdorfers went on to perform flying demonstrations in St. Louis and other Midwestern cities, including Crescent and Waterloo, Iowa; Kansas City; Louisville; and Indianapolis. In Minneapolis in 1909, Charles crashed when the engine in his airship failed. He escaped death, but the airship was destroyed.

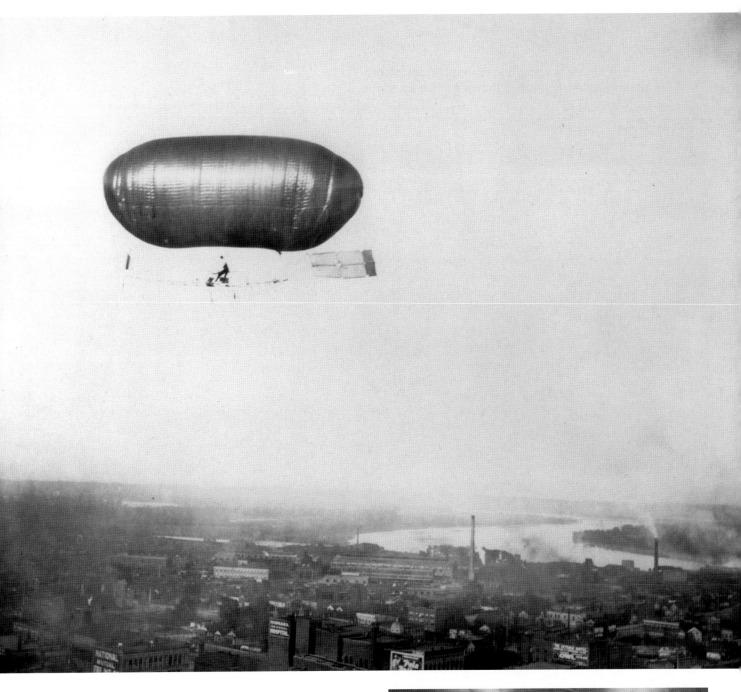

Above: The Baysdorfer dirigible flies over Omaha in 1903. Baysdorfer Collection, Photo Archive, The Durham Museum.

Right: Inside the Baysdorfer dirigible during the varnishing process, The balloon was varnished to make it hydrogen-tight. Baysdorfer Collection, Photo Archive, The Durham Museum.

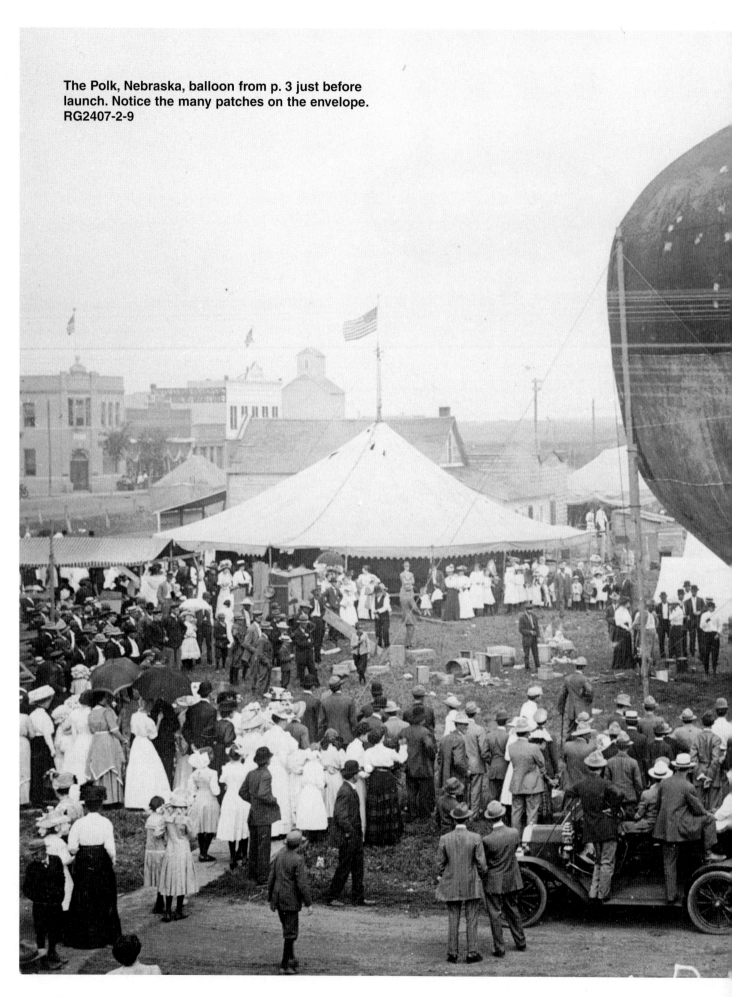

The Polk, Nebraska, balloon from p. 3 just before launch. Notice the many patches on the envelope. RG2407-2-9

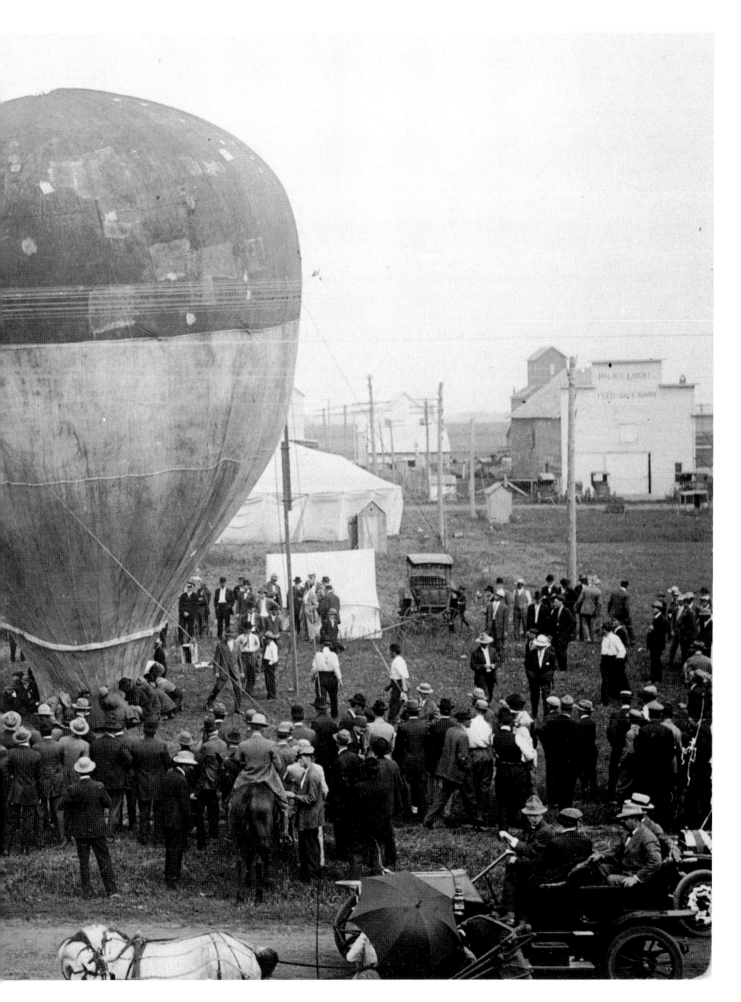

Despite this setback, the Baysdorfers continued to play an invaluable role in Nebraska aviation. In the fall of 1910, they constructed the first Nebraska-built airplane capable of flight. They built the plane in Omaha, then disassembled it and transported it by train and wagon to Waterloo, where a large flat field provided a suitable testing space. Their first flights covered at least 150 feet. Charles—seemingly unshaken by his earlier close call—made eight flights that day. One flight even included a 180-degree turn.

Nebraska's first air show was held July 23-27, 1910, when Glenn Curtiss demonstrated powered flight in Omaha. Curtiss was one of the first Americans to build and fly an aircraft after the Wright brothers. That same year Arch Hoxey, a former Nebraska resident and one of the pilots trained by the Wright brothers, performed flying shows at the Nebraska State Fair. Not long after his Nebraska appearance, Hoxey set a new altitude record when he flew to 11,474 feet in southern California. After he died in a crash in December 1910, his ashes were returned to Atkinson, Nebraska—where he had lived for a few years as a young boy—to be mixed with the soil on his father's grave.

Aviation pioneers again visited Nebraska in 1911, when the "International Aviators" came to Omaha. This company, formed by Alfred J. and John B. Moisant, flew exhibitions around the country using French Bleriot monoplanes. The Aviators had heard of the Baysdorfer biplane and offered to pay $1,000 per month to use it in their air shows. In the early teens, most people had never seen a plane fly, and crowds of six to nine thousand spectators gladly paid entrance fees of fifty cents or a dollar per person—about eighteen dollars in today's money.

Charles Baysdorfer earned fifty dollars a month as a mechanic on the Aviators' tour. The Baysdorfer biplane was fitted with a French Gnome rotary engine and piloted by Capt. John Frisbie, but it wasn't long before Charles was doing most of the flying. After Captain Frisbie was killed flying another airplane, Charles flew the Baysdorfer plane throughout the country. In 1916, while flying for a movie being filmed in Vermont, Charles crashed after his engine

The arrival of these dirigibles in Lincoln might have been the spark that ignited the passion of many of the city's future aviation lovers. This picture was probably taken at the 1907 Nebraska State Fair.
RG2158-2868

The Wright Brothers' plane at the Nebraska State Fair in September 1910.
RG3356-208a

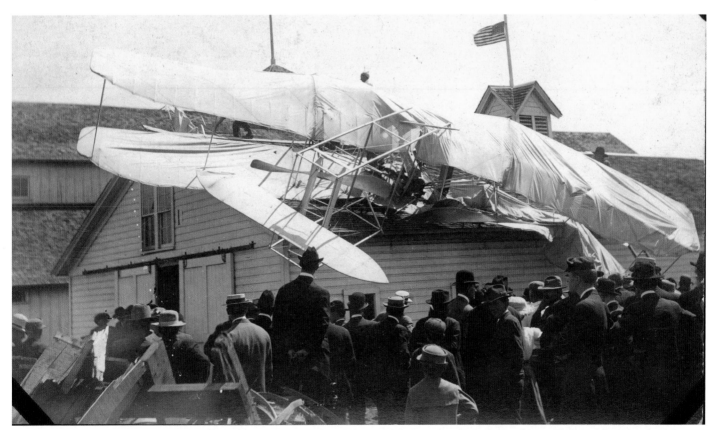

Arch Hoxey crashed the Wright Brothers' airplane into the stables at the Nebraska State Fair on September 6, 1910. Hoxey walked away from the crash with just a few scratches. The airplane was a complete wreck.
RG849-1-13

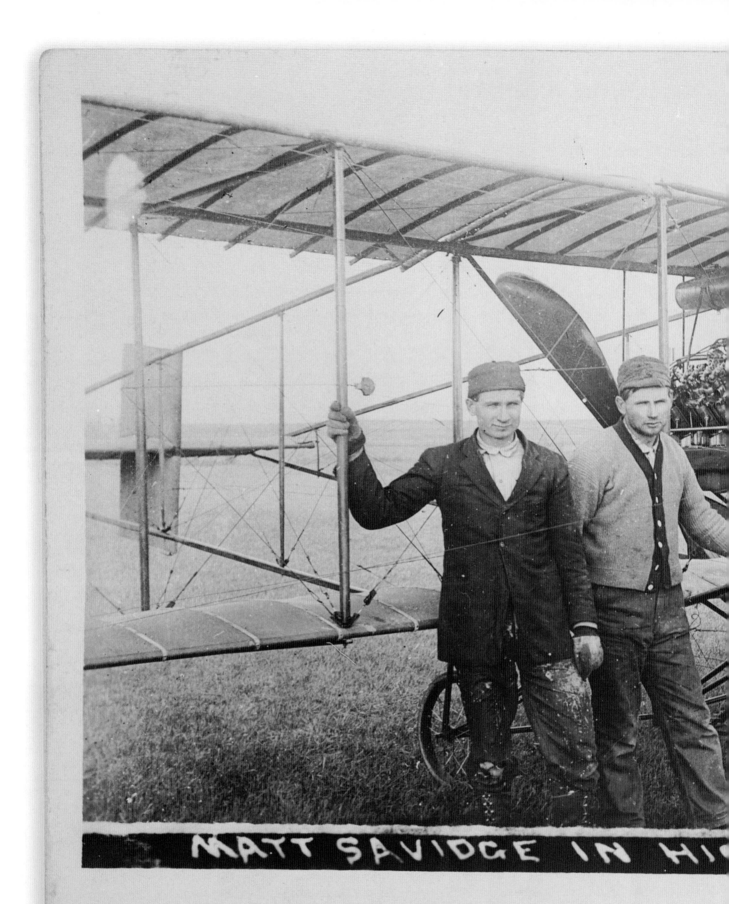

MATT SAVIDGE IN HIC

John, Joe, George, and Matt Savidge, shown with their plane in 1912, built their first glider on their ranch west of Ewing in 1907. Their sister, Mary, was probably the first female in Nebraska to be a passenger in a plane. RG2508-3

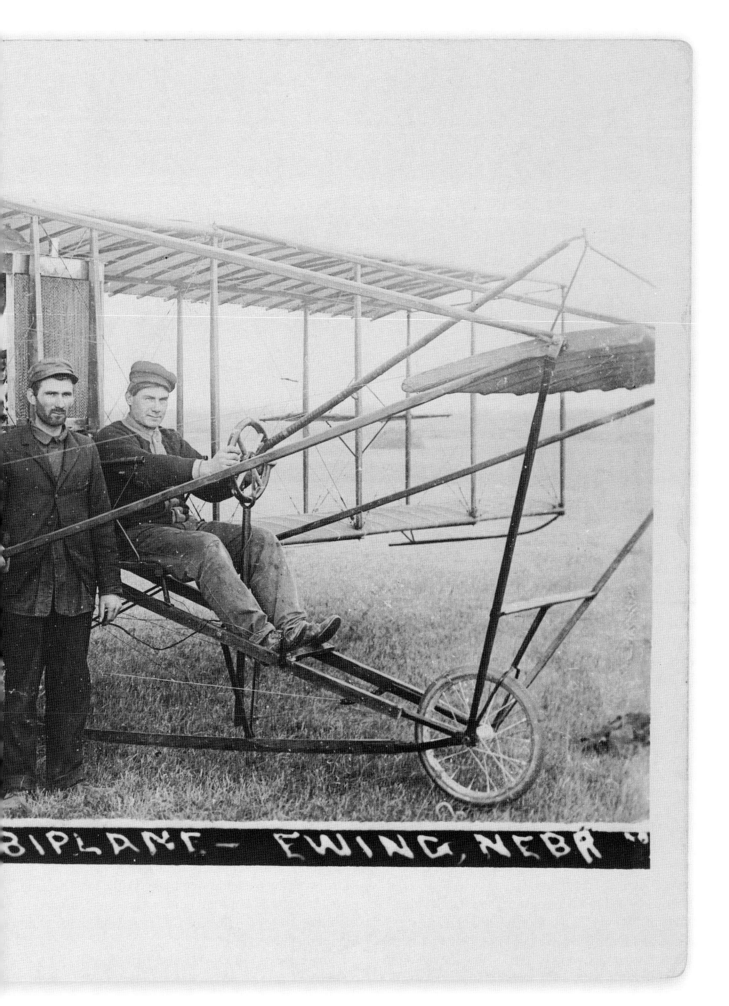

BIPLANE - EWING, NEBR

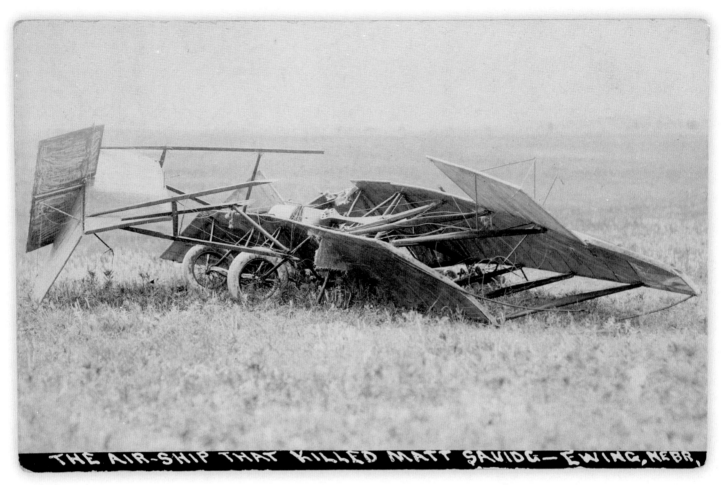

THE AIR-SHIP THAT KILLED MATT SAVIDGE—EWING,NEBR.

The remains of the plane after the crash that killed Matt Savidge on June 17, 1916.
RG2508-2

failed. This time, his injuries prevented his return to flying. He settled in Tampa Bay, Florida, and became a fisherman and guide.

Records indicate that Charles was Nebraska's first pilot. Frank Kaiser Miller of Hebron was the second. Born at Humphrey, Nebraska, Kaiser later went by the name Frank Miller because, after getting into trouble in his early years, he had grown up living with the William Miller family on a farm just east of Hebron. As a young man, he moved to Cleveland, Ohio, and later went to work for C. J. Strobel, an early aviation promoter in Toledo. Frank soon became a pilot and flew exhibitions for the Strobel Company. It is unclear if he ever flew in Nebraska, but he flew at the Pratt County Fair in Kansas on August 17, 1911, and made eight flights at the Republic County Fair in Belleville, Kansas, September 12-15. He was killed in a crash one week later in Troy, Ohio.

Other early Nebraska aeronauts were the Savidge brothers of Ewing and the Morrow brothers of Carleton and Ord. The Savidges built their first glider on a ranch west of Ewing in 1907. They moved on to powered flight in May 1911 when Matt successfully

flew. Brother John followed shortly after and took his sister Mary along for the ride; she was probably Nebraska's first woman passenger. The brothers barnstormed the Midwest, constantly improving their planes and flying skills. In 1916, Matt died in a crash on his home place while testing a new plane. The six remaining brothers gave up flying.

Edward and Everett Morrow, the sons of Carleton's blacksmith, built their first airplane in 1911, but their early attempts to fly it were unsuccessful. Its wingspan appears to be too short, and the engine was presumably underpowered. It was not until 1912 that they got into the air at Ord. They flew exhibitions in Nebraska, and spent the winter of 1913 in the South, barnstorming in Alabama, Georgia, and Florida and reportedly receiving $600 to $1,200 per appearance. Little more is known about their flying, but Ed Morrow, who also had bricklaying skills, later became a contractor who built tall smokestacks and chimneys, according to John Stable of Carleton, who spoke with him in the mid-1950s.

Frank Coleman of Omaha also built one of Nebraska's first planes in the summer of 1911. With

Coleman's mechanical abilities, the financial backing of Pete Loch (a one-time professional wrestler who owned an Omaha restaurant and bar), and the flying skills of pilot Glenn Turner, the machine got into the air on June 27, 1912, on a farm near Papillion.

Aviation also captured the imagination of Nebraska's youth. Two Lexington seventeen-year-olds, Ira Emmett McCabe and Aage Bris, built and flew an unusual glider of their own design in 1911. The biplane glider wings came together at the tips. This triangular design resulted in lighter and more stable construction and permitted airflow to provide additional lift. McCabe later built a more advanced design with an engine and successfully flew it in Lexington in 1915.

While nothing ever came of this design, McCabe went on to a successful career as an engineer and was granted 133 patents during his life. His wife donated his 1918 plane to the Dawson County Historical Museum (see photo on p. 166).

Frank Kaiser Miller was one of Nebraska's first native-born aviators and professional pilots, though his career was remarkably short. Miller learned to fly in April 1911 and died in a plane crash on September 22 of that same year. He was twenty-six years old.
RG2929-45p

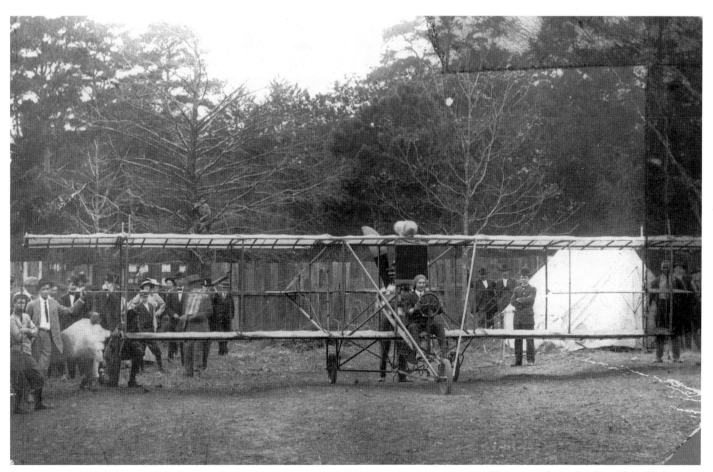

Morrow plane in Opelika, Alabama.
RG2929-9

FORT OMAHA BALLOON SCHOOL

As soon as the Montgolfier brothers launched their first balloon in 1783, the military saw the balloon's potential as a weapon of war. The Austrians used hydrogen balloons in the 1849 War of Italian Independence to drop bombs into Italian territory. In the American Civil War, they were used as military observation posts and communicated with ground commanders by telegraph. By World War I, modern armies had balloon observation units as a standard part of all battlefield operations.

The U.S. Army opened a balloon school at Fort Omaha in 1905 and equipped it with a large balloon hangar and facilities to make and store hydrogen. By 1913, the army had closed this unit and moved most of the equipment to Fort Leavenworth, Kansas. When the United States entered World War I, the army reopened the Fort Omaha balloon school and the government leased Florence Field (later called Steele Field) at Twenty-fourth and Reed to meet the school's expanded needs. Both free flight and captive balloons were used to train observers and ground crews. The hydrogen used to fill the balloons was highly flammable and on various occasions during the teens several men were killed and others injured when static electricity ignited balloons. About sixteen thousand men were trained at the balloon school during the war and many served in France.

After the war, in 1921, the school was moved to Belleville, Illinois, and then phased out of existence. First Lt. Ashley C. McKinley, balloon pilot from Fort Omaha, later became a famous aerial photographer and surveyor; he flew over the South Pole with Richard E. Byrd, a leading arctic explorer at the time. Promoted to lieutenant colonel by 1940, McKinley was in charge of the Cold Weather Department at Ladd Field, Alaska. This facility was moved to Florida in 1943. Current U.S. cold weather testing for both civilian and military use is conducted in a huge facility named in honor of McKinley.

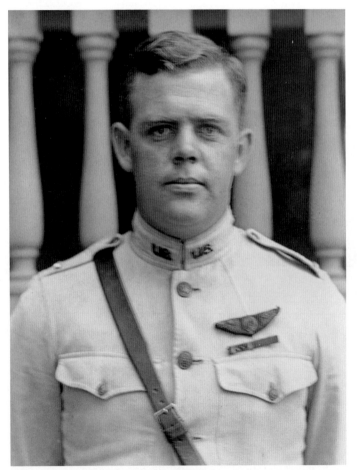

First Lieutenant Ashley C. McKinley, balloon pilot from Fort Omaha, later became a famous aerial photographer and surveyor.
RG3882-90

Opposite: Most of the men at the Fort Omaha Balloon School lived in tents.
RG2340-13

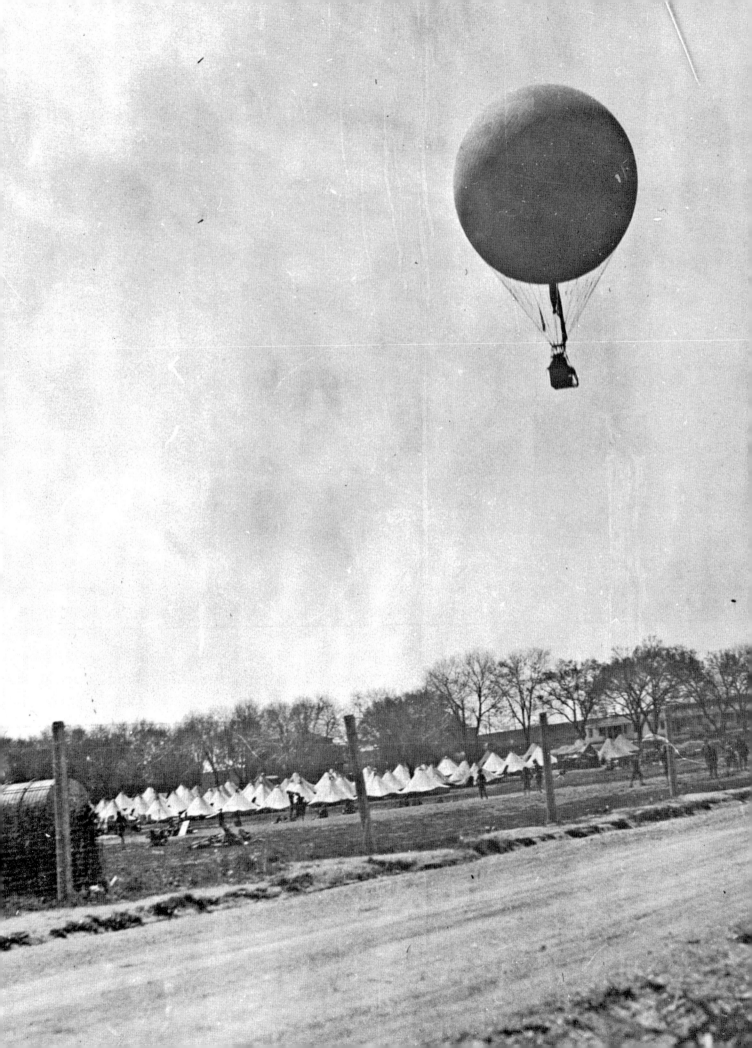

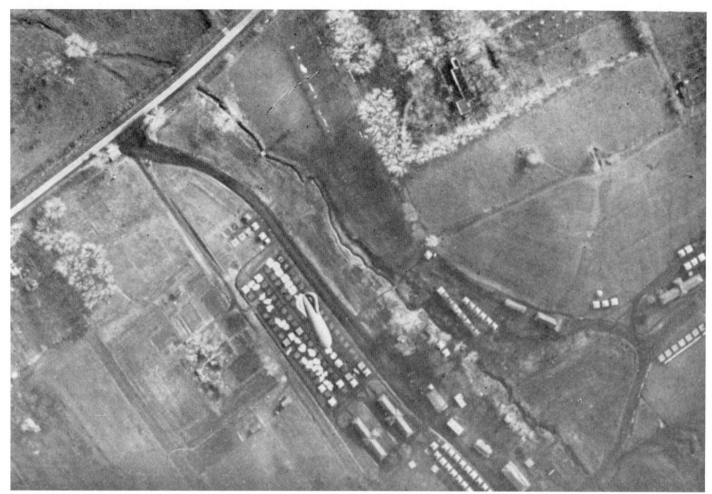

An aerial view of Florence Field. Notice balloon in flight. From the book *Pictorial History of Fort Omaha.*

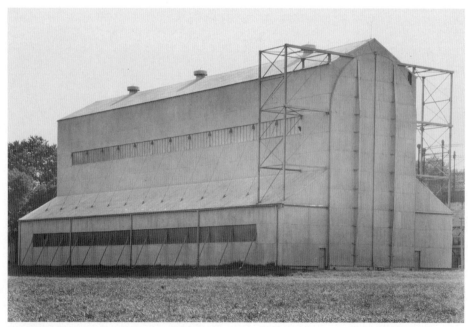

Fort Omaha Balloon School hangar.
RG3882-89

Opposite: Officers of Florence Field grouped at the tail of a Cacquot balloon. Notice the "Haul Down Boys" in background. From the book *Pictorial History of Fort Omaha.*

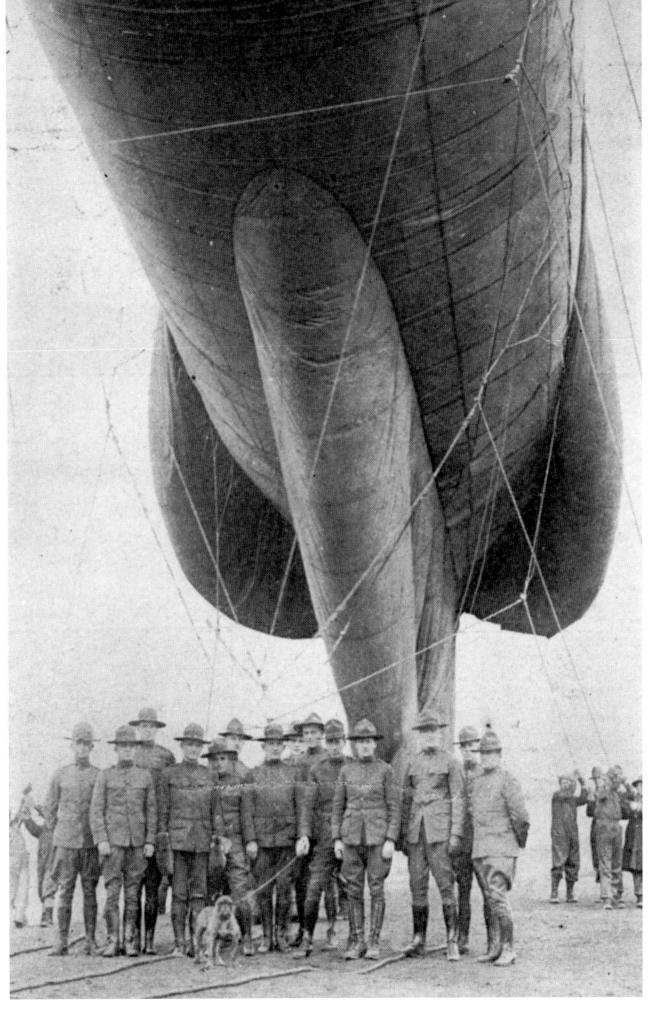

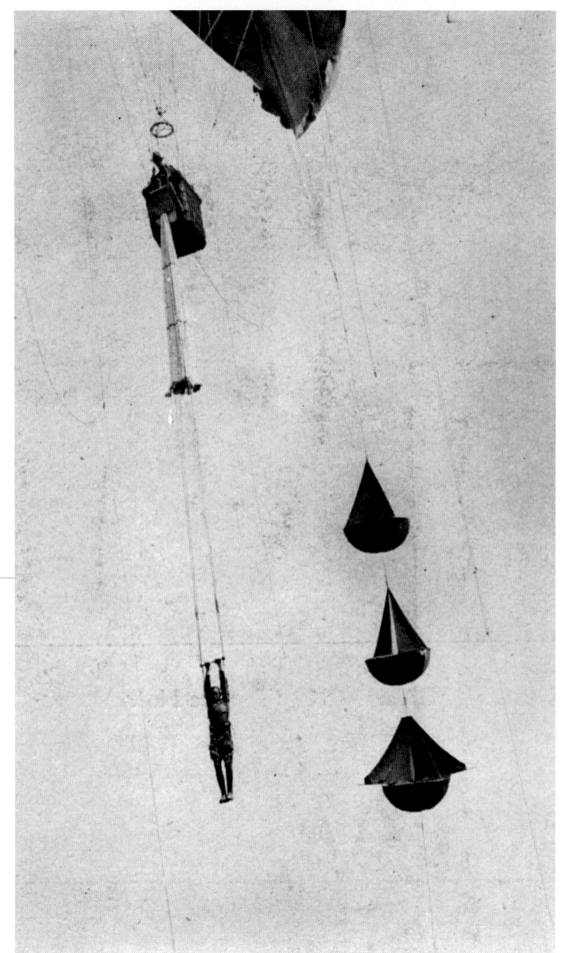

This photo is captioned "Descende: within one second his statoscope will be breaking 40 a minute."
From the book *Pictorial History of Fort Omaha.*

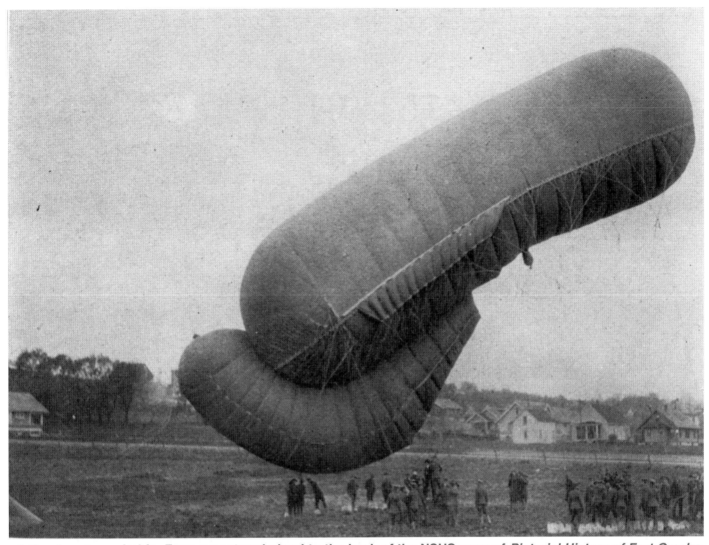

A Drachen type airship. From a postcard glued to the back of the NSHS copy of *Pictorial History of Fort Omaha.*

Observation balloons tethered at the balloon school.
RG2340-17

ORVILLE RALSTON, NEBRASKA'S WWI FLYING ACE

During World War I, Nebraska produced only one flying "ace," a pilot with five or more confirmed victories in aerial combat. His name was Orville A. Ralston. Born near Weeping Water in 1894, he graduated from Peru State Teachers College in 1915, and was attending the University of Nebraska Dental College when the United States entered the war.

Upon enlistment, Ralston received flight training in Canada, Texas, and England before joining the Royal Air Force's famed Eighty-fifth Squadron in France on July 10, 1918. The squadron was flying the famous S.E.5 under the direction of squadron leader Major Ed Mannock, legendary for his seventy-three victories. On September 5 of that year, Ralston was transferred to the 148th Squadron in the United States Army. The 148th squadron was then flying Sopwith Camels, slower than the S.E.5s but more maneuverable. Ralston did not care for the Camel, but he learned to fly it well. He was an aggressive pilot eager for dogfights. During his time in the army he kept a journal that is an excellent account of his training and combat experience.

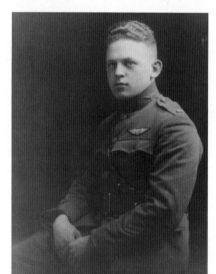

Entry of July 24, 1918

Weather fine but a few low clouds. McGregor, a great flyer and wonderul [sic] pilot from New England, has been put on for "A" flight commander and he is a fine leader. We leave about 5:15 for offensive patrol. We drop our bombs near Armentiers in Hunland. Soon after, our lower formation with Capt. Roudall leading, is attacked by six Huns (Fokker biplanes). We are in the top formation with McGregor leading three of us. We take the Hun by complete surprise because they are diving on our lower formation and everybody commences firing at close range on the machines. I fire at close range at a Fokker that spins out of my line of aim, so I let him go and attack another from behind and to the side. After firing nearly a whole drum of Lewis [rounds of ammunition] into him, as my Vickers has jammed, he turns slightly and goes into a vertical dive. I follow at a terrible rate of speed and fire my remaining shots from the Lewis drum. He still dives on. The speed is so terrific that I flatten out at 5,000 ft. and see the Hun go down vertically into the ground. In the meantime I pick up my formation and see Huns spinning and dropping in all directions. These Hun machines are sure beautifully colored in green and black and some with white tails. Such beautiful streamlining of body is certainly marvelous. When we got home, after I had been struck by archie [German anti-aircraft fire], a terrific jolt but I was not hurt, we find McGregor got one crashed and one out of

Above: Orville A. Ralston was Nebraska's only World War I ace. He had five victories and several probables. RG2929-351

Opposite: Lt. Orville Ralston while serving with the 85th Squadron of the Royal Air Force. Later, he served with 148th Squadron U.S.A. RG2929-348

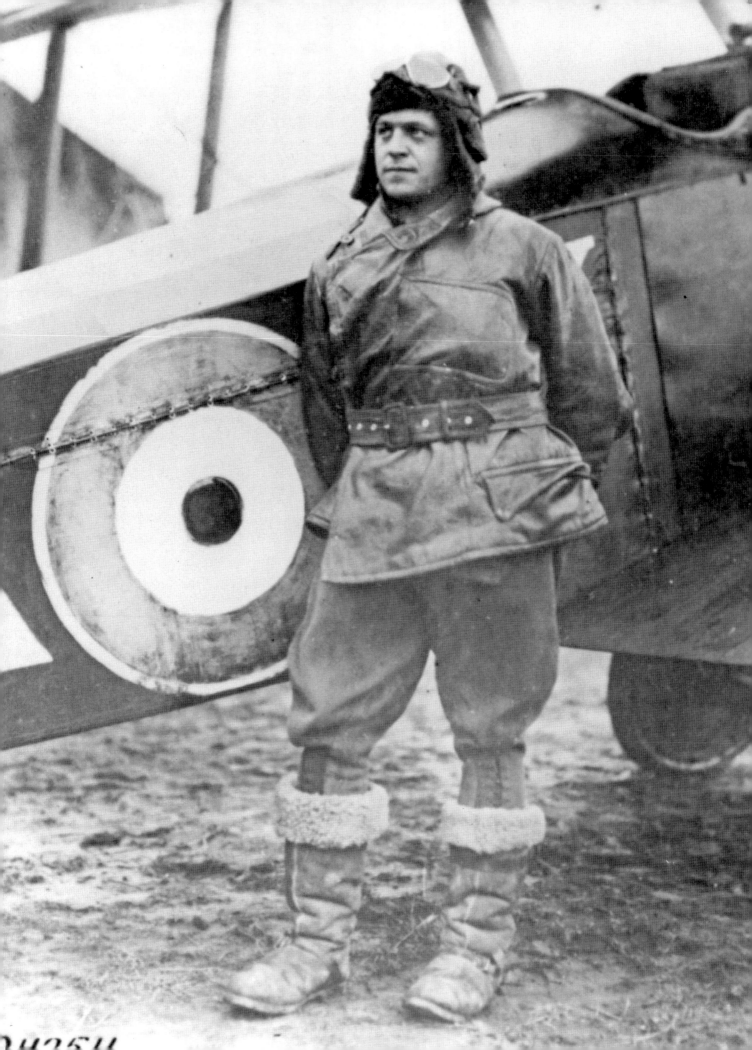

control, Lomgtom [*sic*] got one, and Randall claims one. So—we got four Huns crashed and two out of control, not a bad mornings work by any means. Believe me, it was great sport and I was thoroughly crazed over the fight. It was lucky for me since I am so new at the game that a dog fight did not ensue for I would probably have gotten the worst of it them [*sic*]. My machine was struck partly by Hun shrapnel from the ground and had three large holes in the wings, but luckily no serious damage done. In the evening McGregor led us out again, we drop our bombs and fly all over up and down between Nieppe Forest and Ypres but see only three Huns going for home at a high altitude, probably 21,000 ft.

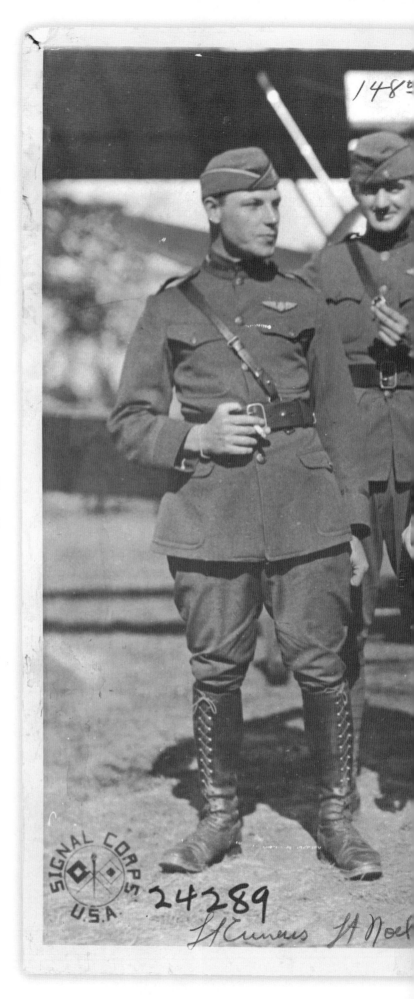

Lieutenant Ralston was credited with five confirmed victories, though he listed seven and likely had at least ten. He was awarded the Distinguished Service Cross in October 1918 for his "combat success and daring" in leading a flight over the Western Front.

After the war, Ralston returned to the University of Nebraska Dental College, where he took his degree. From 1920 to 1936 he practiced dentistry in Ainsworth, Nebraska, before moving to Valentine in 1937. Ralston reenlisted in 1942, at age forty-eight, and was commissioned a major in the Army Air Forces. On December 30, 1942, Ralston was on his way home for a family reunion when the plane in which he was hitching a ride crashed near Great Falls, Montana. He and ten other men died in the crash.

A World War I Distinguished Service Cross similar to that awarded to Orville Ralston. Courtesy of the National World War I Museum.

"B" Flight of the 148th Pursuit Squadron, United States Army, taken near the River Somme in France, 1918. Pictured left to right: Lt. P. Cunius, Lt. Sid Noel, Lt. Elliott White Springs, Lt. Callahan, Lt. O. A. Ralston, Lt. Harry Jenkinson. Elliot White Springs went on to write the popular book *Diary of an Unknown Aviator* as well as other books. He was a successful author and businessman. He succeeded his father in the family business, Springs Cotton Mills, and quadrupled the business's worth in his lifetime. RG2432-5

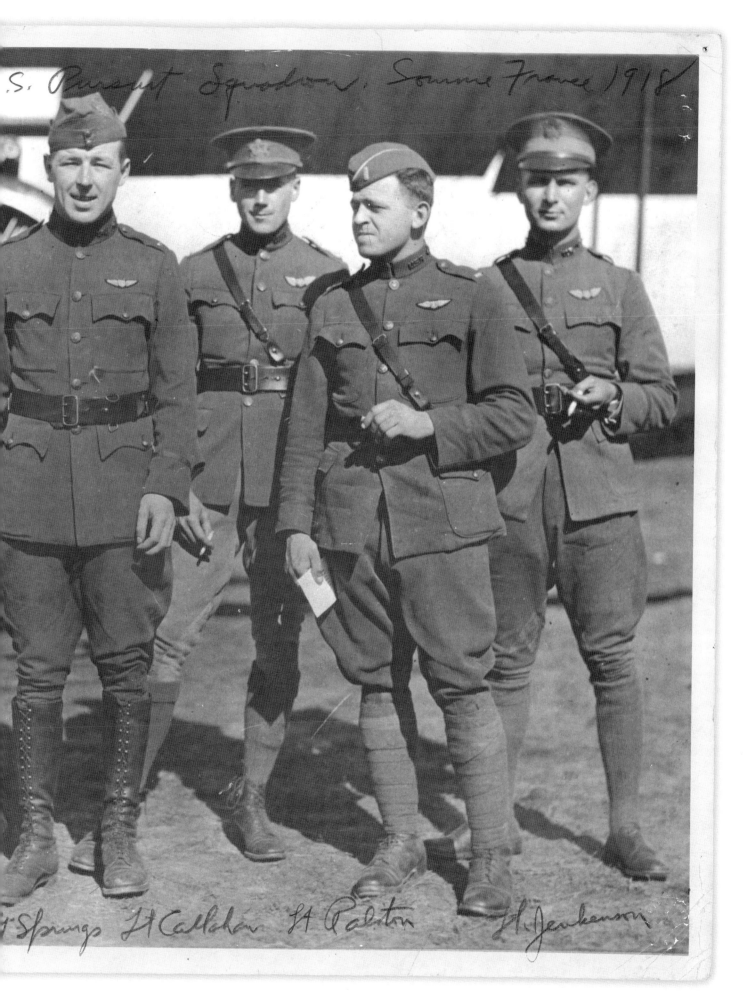

S. Pursuit Squadron, Somme France 1918

t Springs Lt Callahan Lt Ralston H Jenkenson

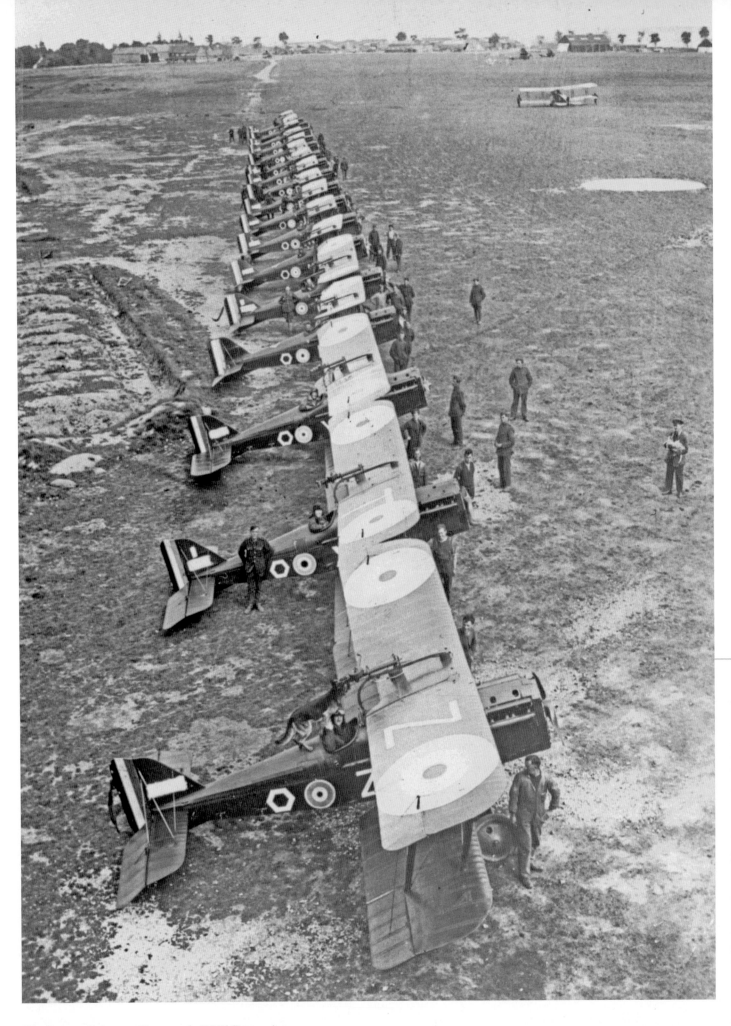

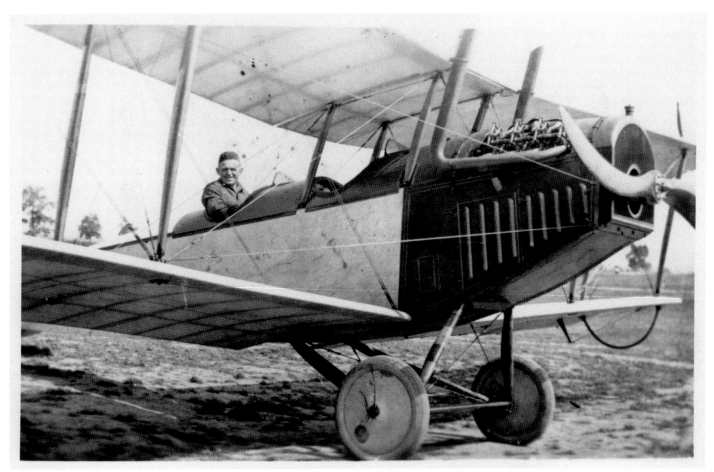

Orville A. Ralston in a JN-4 training plane
at Camp Rathbun, Canada, in 1917.
RG2432-11

In this much-reproduced image, a line of S.E.5s of the 85th Squadron line up for inspection. This famous squadron was at one time commanded by Maj. W. A. (Billy) Bishop and Maj. Ed Mannock, renowned British pilots who shot down 72 and 73 enemy planes, respectively. Note the dog on top of the plane nearest to the camera. RG2432-1-214

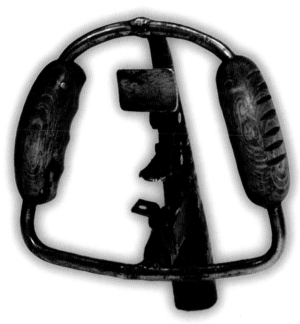

The control stick from Ralston's Sopwith Camel.
He carved a notch for each enemy plane he shot down.
NSHS 10091-15

CHAPTER 4

CHARLES LINDBERGH IN NEBRASKA

On April 1, 1922, a young man named Charles Lindbergh arrived in Lincoln on his motorcycle. He stayed at the Savoy Hotel at Eleventh and P streets for the first few nights, and enrolled at the Lincoln Standard Aircraft Company to learn to fly. He was the only student that spring. Otto Timm, an exhibition pilot and aircraft designer who worked at Lincoln Standard for a short period, gave twenty-year-old Lindbergh and a sixteen-year-old named Harlan "Bud" Gurney their first airplane ride after they had helped him assemble a Lincoln Standard Tourabout at the South Twentieth Street field.

I. O. Biffle, a Missouri native who had come to Lincoln to work for Ray Page, became Lindbergh's instructor. Biffle was discouraged by the death of his friend Turk Gardener in a recent crash; Lindbergh complained that Biffle often did not come in until noon or declared that it was too windy to fly. A month passed before Biffle felt that Lindbergh was ready to solo.

Flying solo was not (and is not today) a standardized testing process. The instructor's role was comparable to that of a parent teaching a teenager to drive a car, except that the instructor rather than an independent evaluator determined when the student was competent to fly alone.

In the end, Lindbergh did not solo in Lincoln because he didn't have the money. Ray Page, owner of Lincoln Standard Aircraft, required five hundred dollars as a bond to cover potential damage to an airplane that Page had already sold. Temporarily deprived

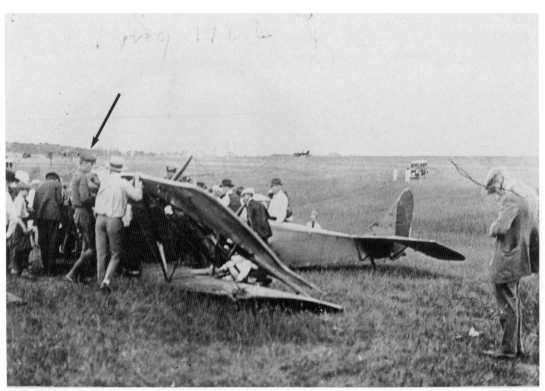

The tall man in the cap (second from the right near the crashed airplane underneath arrow) may be Charles Lindbergh while he was in Lincoln during 1922. RG2929–434

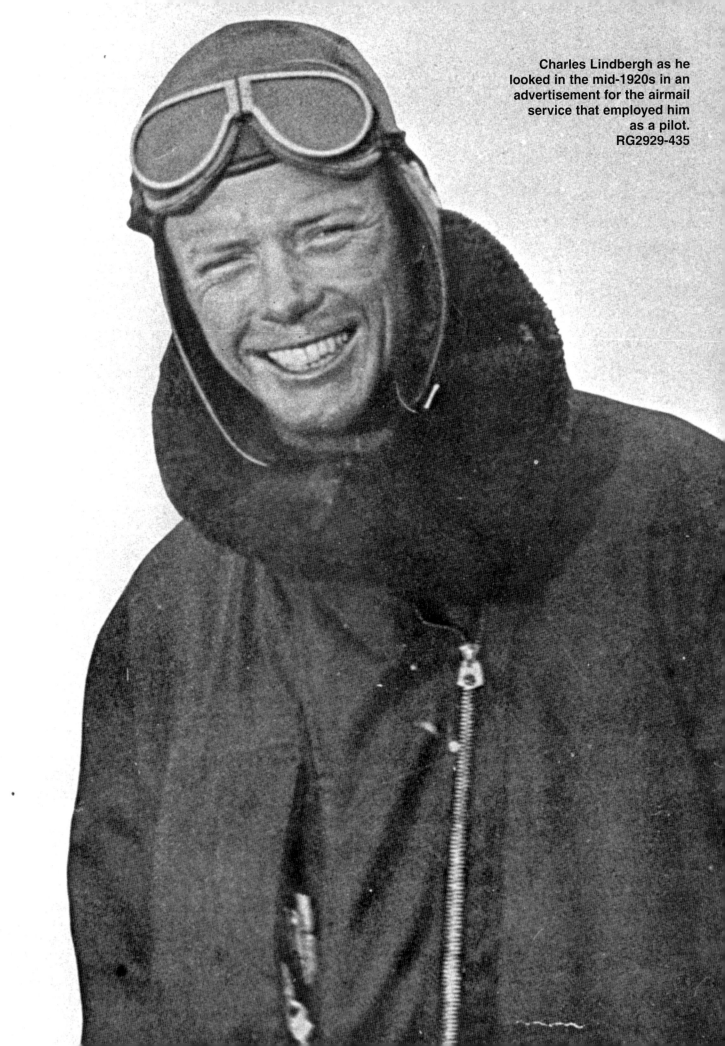

Charles Lindbergh as he looked in the mid-1920s in an advertisement for the airmail service that employed him as a pilot.
RG2929-435

I. O. Biffle was Charles Lindbergh's flight instructor in Lincoln. The picture was taken when Biffle was flying mail out of Omaha. The plane behind him is a Boeing Model 40.
RG3882–442

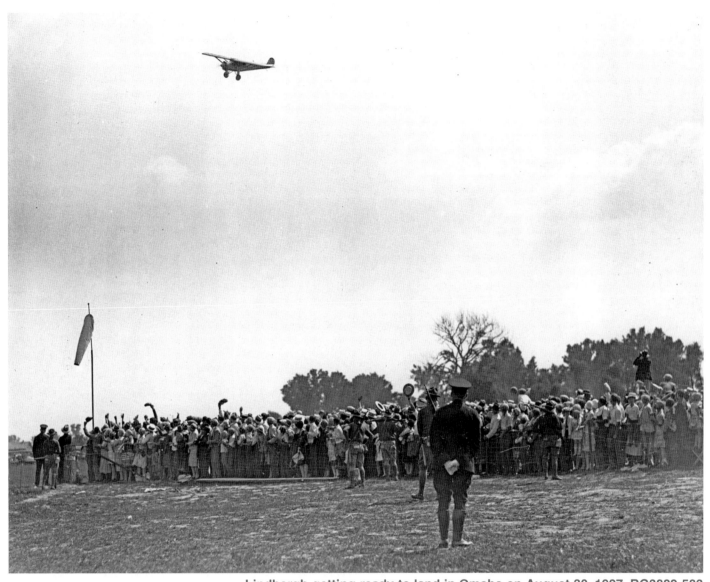

Lindbergh getting ready to land in Omaha on August 30, 1927. RG3882-583
Below: The Savoy Hotel, where Lindbergh stayed his first three nights in Lincoln. RG2158-1916

of the thrill and sense of accomplishment that comes with a pilot's first solo flight, Lindbergh traded his last two pre-paid hours of flight training to Ray Page for a Hardin-made parachute. Lindbergh and Gurney made their first jumps on the same day.

During the spring of 1922, Lindbergh acted as ticket seller, ground crew, parachute jumper, and wing walker for Errold Bahl as he barnstormed through southeastern Nebraska. In July, after returning briefly to Lincoln,

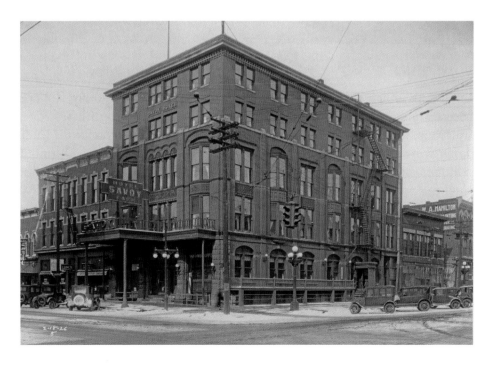

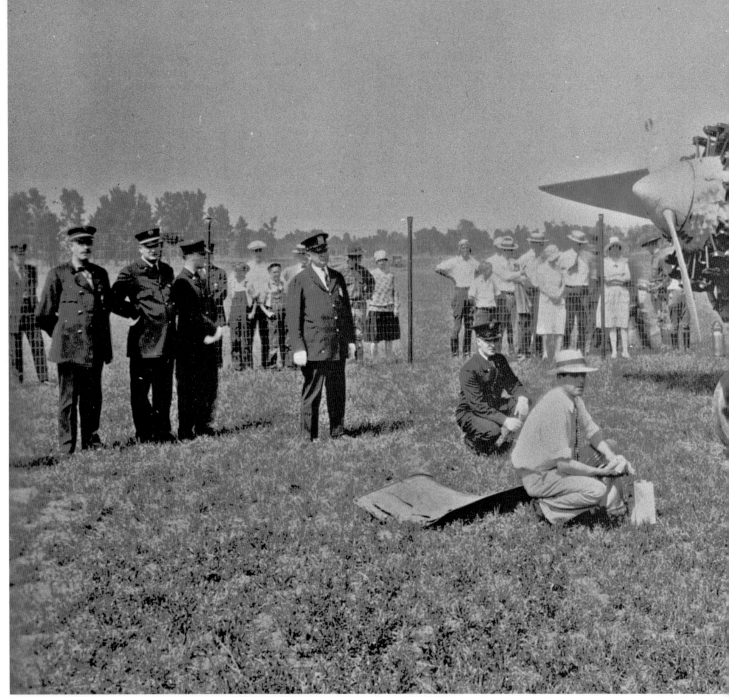

A crowd gathers around the *Spirit of St. Louis* during its stop in Omaha.
RG3882-1-5

Lindbergh joined J. H. (Cupid) Lynch on a barnstorming tour of the small towns of Kansas, Colorado, Nebraska, Wyoming, and Montana—again doing wing walking and parachuting.

In the spring of 1923, Lindberg left Lincoln and went to Americus, Georgia, where he bought a World War I-surplus Curtiss JN-4 ("Jenny") and finally soloed. He then barnstormed his way north to Minnesota, where he helped his father campaign for public office. Desiring to fly bigger and better airplanes, Lindbergh entered the Army Air Corps in March 1924 as a cadet and graduated first in his class as a second lieutenant on March 14, 1925.

Lindbergh soon became chief pilot for Frank and

William Robertson, who had won the airmail contract for the St. Louis-to-Chicago run. He was soon flying again with Bud Gurney, who remained a lifelong friend. During his airmail flying, Lindbergh started planning his trans-Atlantic flight to Paris, which he completed in May 1927. In August of that year, Lindbergh made a triumphant tour of the United States in the *Spirit of St. Louis,* stopping in Omaha but not in Lincoln.

Lindbergh's friend Bud Gurney went on to a long and successful career in aviation, though—as we'll see in the next chapter—he had fond memories of the early days.

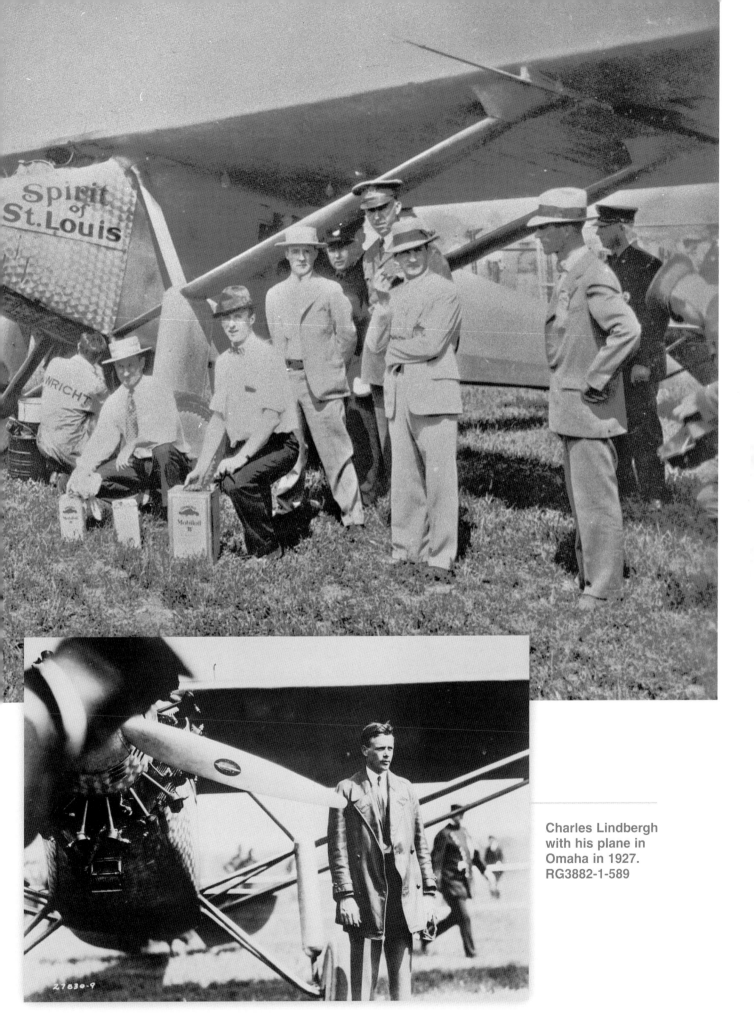

Charles Lindbergh
with his plane in
Omaha in 1927.
RG3882-1-589

BUD GURNEY, NEBRASKA AVIATOR

Nebraska pioneers often remarked upon the region's vast open skies. A generation later, aviation pioneer Harlan "Bud" Gurney made full use of them.

His love of the skies began when he was just eleven. His family lived next to the Nebraska State Fairgrounds, and he often sneaked onto the grounds to watch Capt. Ralph McMillen (one of Nebraska's early pilots) work on his airplane.

When Gurney was sixteen, he began part-time work at Lincoln Standard Aircraft's flying school. There he met a young man who would become a lifelong friend and one of the most famous pilots in the world: Charles Lindbergh.

Gurney played a substantial role in aviation himself. After his first airplane ride (which he describes in the letter below), he went on to become a parachutist, wing walker, and exhibition pilot for Page Aerial Pageants, a barnstorming company run by Lincoln Aircraft owner Ray Page.

Gurney left Lincoln in the mid-1920s and became one of the first airmail pilots for Robertson Aircraft Corporation, which held the airmail contract for the

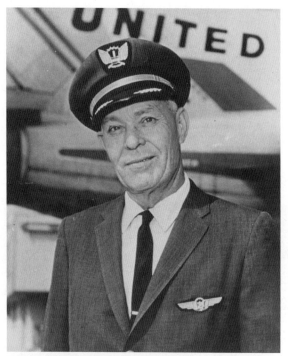

Above: Charles Lindbergh's friend Harlan (Bud) Gurney. Gurney flew United Airlines' inaugural DC-8 jet flight from New York to Los Angeles in 1959.
RG2929-436

Opposite: Charles Lindbergh and Harlan (Bud) Gurney barnstorming in 1925 in Carterville, Illinois.
RG2929-433

Chicago-to-St. Louis route. Gurney survived the company's various mergers and went on to be a senior captain for United Airlines. He began his career walking the wings of rickety biplanes, and completed it flying the initial coast-to-coast jet service for United.

Gurney retired to Woodland Hills, California, in 1965, and died in 1982. His legacy lives on in the letters he wrote to Ethel Abbott (Ray Page's widow) and to the Nebraska State Historical Society. In them, he vividly describes his experiences during the "golden age" of aviation.

In 1977, NSHS historian L. G. DeLay wrote to Gurney, asking about the early years of Nebraska aviation. Here is Gurney's reply:

November 5, 1977

Dear Sir:

With reference to the information regarding the early years of aviation activities in Lincoln, perhaps it would be best to clarify a few details and leave the choice of interpretation or selection to you.

My entry into aviation came in the autumn of 1921 when, shortly after Ray Page became the court appointed receiver for the bankrupt firm, The

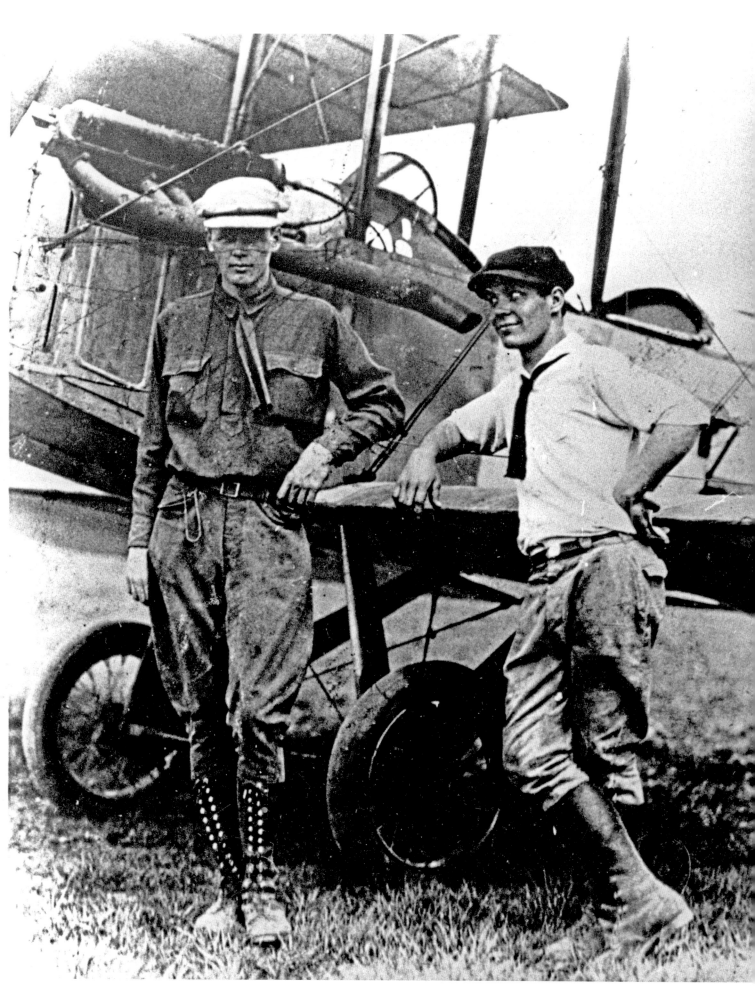

Nebraska Aircraft Corporation. You might research the newspaper morgues to find the name of the former head of the Corporation who bagged the firm's assets and had Eyer Sloniger fly him to Mexico. Eyer, of course, had no idea of the real purpose of the long flight.

As I recall it, Ray Page had spent the previous months in California, where he had met his wife to be, Ethel. However it was a year or more after I began working for Ray before Ray and Ethel married and she became active in the firm's affairs. In the meanwhile the assets of Nebraska Aircraft Corporation were sold to the highest bidder. Ray Page bought the company and changed its name to The Lincoln Standard Aircraft Corporation.

Page engaged Otto Timm to be the company engineer in late 1921. Under his direction the major part of my work was in repairing damaged J-1 Standard wings. However the first aircraft I worked on was the Fokker D7 which is today in the Tallmantz Air Museum at Santa Ana, Calif. Lindbergh arrived sometime in late autumn, 1921 [actually it was April 1, 1922], the only prospective student to respond to Lincoln Standard advertising. We became friends. That friendship endured for fifty- three years.

Up until the spring of 1921 the company was located in the concrete structured building vacated earlier by Ford Automobile Agency, the Hebb Motor Company. If memory serves me right, the address was the south east corner of 12th and R. Page then moved the factory to the 24th and O street building which still stands. As I recall, a Nebraska National Guard Unit occupied the second floor of that structure.

After the first Lincoln Standard Tourabout was assembled at the South Twenty-seventh street [the location is actually closer to Twentieth Street] meadow in early April, 1922 and Lindbergh and I had helped Otto Timm to "safety wire" every turnbuckle and cotter-key, every castled nut on the airplane, "Salty" Saltzman, the chief mechanic, cranked the propeller for Otto Timm. The engine caught and set the "Liberty" propeller to spinning. Salty pulled the chocks and Otto began taxiing toward the north end of the meadow. Perhaps he saw the expressions on our faces for he let the ship coast to a stop in the spring grass. "Boys," he called out, "Do you want to go with me?"

I made the front cockpit first. Lindbergh was second!

I'll let him tell about that first flight— he does it so well in his book, *The Spirit of St. Louis.*

Lindbergh and I both called the Lincoln YMCA our temporary home. Room rent was $5 a week which took most of my $9 a week pay check, I survived by racing like mad for a restaurant on 14th street where I waited on tables for a quick lunch before running back to the factory for the 1:00 deadline. Lincoln, a college town, seemed to be a hard place for a youth to earn his living. I didn't dare lose my job.

After Ira Biffle had pronounced Lindbergh was ready to solo, Ray Page, who had sold the airplane, couldn't see fit to let him do so. Instead, he offered Lindbergh a parachute manufactured by Charles Hardin and his wife, Kathryn, Lindbergh accepted the offer and to make it convincing, talked Page into letting him do a double-drop, that is, use two parachutes, one after another, on the same descent.

The parachutes were sewn of cotton muslin strung with twisted cotton fish-cord that terminated in an old automobile steering wheel. Being too bulky to wear, the parachutes were packed in a canvas bag which was tied to a wing strut fitting half way out to the tip of a lower wing. To attach the parachute one had to walk the front lower wing spar while clinging to the wing brace wires and then sit on the leading edge while attaching the parachute to a brief body harness. Then one had to let one's body down from the wing and hang from the parachute bag until over the drop point. The parachute, ring, shroud lines and canopy were slid out of the canvas bag by untying the bag lacing. Usually, a thirty pound break cord was used to tie the canopy vent to the airplane or to the ring of another upper parachute where more than one was used. The purpose of the break-cord was to stretch out the canopy for immediate opening by the wind generated during the initial fall.

I was at the field the day Lindbergh made his first parachute jump. Hardin packed the parachutes but when they were being placed in the canvas bag he couldn't find a piece of strong fish cord. The best he could find was an old piece of grocery string. It would have to do. The spectators were waiting to see the parachute jump. That short piece of twine became a "break-cord"!

When Lindbergh unlaced the canvas bag and left the Tourabout flown by Earl Barnes, the break cord had already failed and both jumper and tightly packed parachute descended almost together. Finally the falling speed blew the canopy to streaming. Suddenly it blossomed, Lindbergh, with not too much altitude remaining immediately cut it loose, the second canopy streamed and opened.

After he landed safely I carried the collapsed first canopy back to him while commenting about that first delayed opening. For a moment there was no reply, then he laughed and said, "Buddy, It's your turn!"

So I made my first parachute jump and became a part of Ray Page's Flying Circus. Most of my airplane rides became one-way things. I took off aboard an airplane but came down in a parachute. Lindbergh was doing the same that year. He walked the wings and made parachute jumps that year of 1922. Strangely enough it was with the same Tourabout he flew while Ira Biffle was teaching him how to fly.

Perhaps a short portrait of Kathryn Hardin is in order. Charles, her husband, had been a parachute instructor at the Omaha balloon school during W.W. I. After the war, Charles continued making and selling parachutes. He also demonstrated his products in air shows. Sometimes Kathryn, who was billed as the "intrepid lady parachutist," participated, but I never saw her make a parachute jump. Never the less, she was kinder to me than she thought. At one of the first air shows Page arranged and promoted at Columbus, Nebraska, I was busy with my chores of pouring oil into the airplane engines and filtering gasoline into Tourabout tanks through chamois-skinned funnels when I heard a "barker" yell through his megaphone, "Ladies and gentlemen, while your own program shows that this is the hour when our lovely lady parachutist, Kathryn, will thrill you with a parachute jump, she is indisposed. You ladies will understand, won't you? However, for this special occasion we are presenting the world's youngest parachute jumper who will thrill you with his daring."

Down goes the five gallon gasoline pail. Kathryn and Charles have the bagged parachute tied to a wing strut; Page sells the seat beside me to someone who pays extra to see me leave the airplane and soon I'm floating down toward the murmurs of the crowd below. That was one way to start a career in aviation! I owe Kathryn an unpaid debt. Kathryn may not have liked parachute jumping but she was a kindly person and truly a lady.

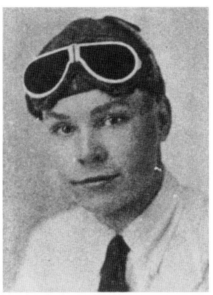

A newspaper clipping of Harlan Gurney, "the world's youngest parachute jumper. This boy seems to know no fear. Harlan is only fourteen but he has developed a wonderful act. You will like him." Gurney was actually sixteen at the time.

Earl Barnes usually flew me to altitude at Page's "Aerial Pageants." On weekends when I happened to be free, I flew to some small town with Errold Bahl to attempt an imitation of Dick Hazelrig's really exciting acrobatic routine on a trapeze slung below the undercarriage of an airplane. He performed without safety equipment of any kind while hanging by his toes from the precarious ash bar of his trapeze while the airplane made low passes in front of the spectators. Dick was so good that nothing ever happened. These were the years when aviation was used for entertainment, not transportation.

Eyer Sloniger was another star of the shows promoted by Ray Page. He was then the only one to fly the Fokker D7, one of the best pursuit aircraft in the Kaiser's forces. "Sarge" Chambers made frighteningly long delayed parachute drops from high altitude while tumbling over and over at terminal velocities. Our balloon-type parachutes were not in the same league.

I note the identification as the F-l when referring to the Lincoln Standard "Tourabout" biplane. The correct identity is J-l (Jay One). During World War One the Standard Aircraft Corporation and James Day, their designer, brought out a so called "advanced training aircraft". It had superior performance to the earlier famed Curtiss JN4-B (the "Jenny"). However the available engine was the Hall-Scott "Bear" engine—a four-cylinder water cooled engine. That engine had many design faults; one of the worst was a cam misdesign that permitted flames to flash back through the intake manifold and set the airplane afire. After numerous accidents, these airplanes were grounded. The hundreds of such aircraft together with spare parts were purchased by the Nebraska Aircraft Corporation and shipped to Lincoln. When Hispano Suiza engines were installed the added power made the Hisso Standard the best barnstorming airplane ever made. I have flown them from fenced baseball fields and from small residential lots at the edge of a town. They were great for wing-to-wing plane changes where a wingwalker traded airplanes in mid air. Lindbergh and I used to perform them in 1925 over county fairs with

Herb Budd, our wingwalker. Sometimes when no one else was on hand I made the change myself. For skilled pilots, it isn't dangerous.

The memory of Ethel Page is dimmed a bit because she came to Lincoln in the spring of 1923, if my memory is correct. In September of that year I left Lincoln to meet Lindbergh at the St. Louis Air Races where I hoped to compete with the best parachutists in the country. I was successful until the last day when an aircraft coming in to land spotted my parachute and zoomed over it. The downwash and propeller blast blew me into the earth and into a hospital.

Ray Page was kind to me and arranged my working hours to fit my high school schedules. However, so far as I know he never learned how to fly. Nor did Siel [Milo A. Siel, a member of Page's Aerial Pageant] ever fly so long as I was a part of the organization. Augie Pedlar came to Lincoln about the time I left and while he was a fine pilot, he had no knowledge of how to fly through clouds and weather. We who were flying air mail schedules had to learn, or else! It might be interesting to know that Augie Pedlar and Eyer Sloniger flipped a coin to choose which would pilot Mildred Doran to Hawaii. Slonnie lost. Shortly after acting as chief pilot for air mail Route #2 (I took Lindbergh's place), I wired Slonnie to come to St. Louis for an interview. When he came I found he had not the dimmest idea of how to accomplish instrument flying through clouds. An initial ten hours of personal instruction followed. Slonnie told me that Augie Pedlar had never learned how either. [See pp. 50-51.]

On the other hand, Charles Lindbergh was a very skilled instrument pilot.

So here you have my brief history of aviation as it grew from entertainment to the safest means of transportation ever devised by man. In these days of huge jet airliners we can demonstrate repeatedly our ability to approach, land and roll the ship to a stop on a narrow runway—all while under polarized glasses that absolutely prevent any vision outside the fully instrumented cockpit. Some of our aircraft are programmed to land themselves. But for the most part the cruising altitudes are above all of the most severe weather. When a destination is covered with storm, we can, if wise, tarry at low fuel consumption until the storm passes by or the fog lifts.

But Lincoln had a part in the transportation revolution. I only regret that Page, with his limited resources, had not been able to attract gifted engineers who could have made Lincoln's name the aviation

envy of the world.

I'll always remember Lincoln with affection. It was MY HOME TOWN!

Bud Gurney

The correspondence between Gurney and DeLay continued for several more letters in which Gurney replied to specific questions. Excerpts from these letters are below:

November 6, 1977

For myself, I have witnessed the growing pains of air transportation from the fragile relics of the first world war to my last six years flying the modern huge jet transports. During these years air transportation has grown from a risky venture to the safest transportation man has ever known and the railroads which once sneered at our competition are now out of passenger travel—or almost so.

But I do share Charles Lindbergh's fear that mankind is endangering the quality of life and the very existence of other forms of life who have shared this lovely blue planet as it spirals through our galaxy of stars.

November 18, 1977

One of these days I shall forward you a short anecdote of a barnstorming trip I had with Errold Bahl on the 3rd, 4th and 5th of July in 1923. We left Lincoln at dawn on the 3rd, flew all day with landings here and there for refueling trying to get to Callaway, Nebraska, against forty to fifty mile-an-hour winds. The old Hisso-Standards cruised no faster than 60 at best so we ended up at a cattle feeding station named "Buzzards Roost" in darkness, miles short of Callaway. The next day we ferried on to Callaway and I learned what not to do while wing walking above the town streets and buildings. To be brief, a dustdevil took the wingskid I was hanging from out of my grasp, then another rampant downdraft put the wingskid right back in my open palm. It scared me so much I almost sprinkled the crowds in the street below.

I guess I'll call the true story, "Fourth of July in Callaway, 1923. . . ."

One day in 1926 after I had a risky forced landing at night in total darkness, I expressed my feelings to Charles Lindbergh. I was very discouraged.

"Bud," he answered, "Some day engines will be so perfected they will never fail. Some day we will be able to fly above the highest mountains and even

across the oceans as if they weren't there. And some day people will travel by airplanes just like we take the street car to town."

How right he was!

On Feb. 4th Hilda and I plan to be on the island of Maui to kneel at the resting place of one of the great men of history who marked his simple place with the words, "If I take the wings of the Wind and dwell in the innermost depths of the sea . . ." Perhaps I could add a last line, "We will remember thee."

December 17, 1977

In the fall of 1922 there was a Page Aerial Pageant air show at St. Joseph, Missouri. Walter Beech who then sold and barnstormed Kansas in Laird Swallows flew to Lincoln to join up with Sloniger in the Fokker D7, Pete Hill on a Tourabout and Earl Barnes in another Hisso Standard of Page's. I was assigned to fly in the front cockpit with Walter Beech (who later created Beech Aircraft Corp.) I wasn't very happy about it, having to ride with a strange pilot with my parachutes in my lap. But although we took off last and the Swallow only had a 90 horse OX5 engine, it wasn't long before we had passed the two Standards and arrived at St. Joseph right behind the Fokker. But first we circled over the town while the tardy Tourabouts began the stunting low above the city. After the others straightened out and flew to the meadow (which later became Robidoux Field) Walter, who had remained high above town, pulled the Swallow into a tail spin—and did that ship spin! Down and down, straight toward a cemetery with the central monument the center of the twirl. I had a struggle to keep the parachutes out of the front cockpit while the grave stones grew and grew in size. Finally, I twisted about to see if Beech was still alive in the rear cockpit. He was grinning! Then he pulled the ship out of [the spin] about a hundred feet above the unawakened dead—about the time I thought I was going to join them. So I became acquainted with Walter Beech. I had no idea that later I would be buying air mail planes from him in the years to come.

Undated

I really enjoyed a laugh over the collection of newspaper items you have somehow resurrected from the past. I noticed the State Fair program which listed the multiple parachute jumps in Hardin's name and the single canopy drop in the name of his wife, Kathryn.

It just wasn't that way! Of course, only Earl Barnes,

Dick Hazelrig and Ray Page knew the facts at the time, I guess. As I wrote you before, I never saw Kathryn Hardin make a parachute jump although her name was most prominent in the pre-show publicity. So Dick and I were the ones who actually performed this stunt. It wasn't a last minute switch for I knew the night before that Dick and I were scheduled to make simultaneous drops from the two opposite lower wings of Barney's Lincoln Standard biplane. The strong winds that dragged me so severely on landing had nothing to do with the schedule Ray Page had set up. Charles Hardin and Kathryn liked, I think, to get paid for their performances somewhat more than Page paid Dick and me. The people on the ground couldn't tell whether the smaller performer hanging below that six foot stack of dyed parachutes was a youth or a young lady. So that's show business. Barnes flew us over the Fair Grounds at about 2500 feet so who could tell?

WOMEN IN EARLY NEBRASKA AVIATION

The freedom of the skies also captured the interest of a number of Nebraska women. Mrs. Jack Atkinson, wife of an early Omaha pilot who went on to become chief of the air wing of the Denver police force, was probably Nebraska's first woman pilot; she died in 1921. However, Nebraska native Harriet Long Stotts is also in contention for that honor because she worked for Harding, Zook, and Bahl in 1920 and took lessons from Errold Bahl. Ethel Ives Tillotson of Tilden and Battle Creek and Louise Tinsley-Miller of Omaha were the first two Nebraska women to become licensed pilots in 1928. Tillotson was killed in a crash at Norfolk later that year.

Evelyn Sharp of Ord, one of the best known early women pilots, soloed in an Aeronca C-3 at age sixteen. Two years later she attended the Lincoln Airplane and Flying School. She obtained her Transport License in 1938, the youngest woman in the United States to receive this license and the only woman in Nebraska to have one at the time. By 1940, she was in Spearfish, South Dakota, instructing young men in the Civilian Pilot Training program. In 1942, Sharp became the seventeenth woman to be accepted into the new Women's Auxiliary Ferrying Squadron. Sadly, this adventurous young woman died in the crash of a twin-engine P-38 fighter she was ferrying in 1944.

Grace Elizabeth (Betty) Clements of Elmwood, Nebraska, was another

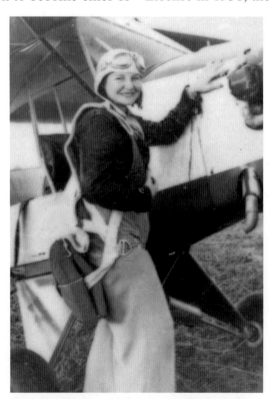

Dorothy Barden in front of a Piper Cub. RG3046-24

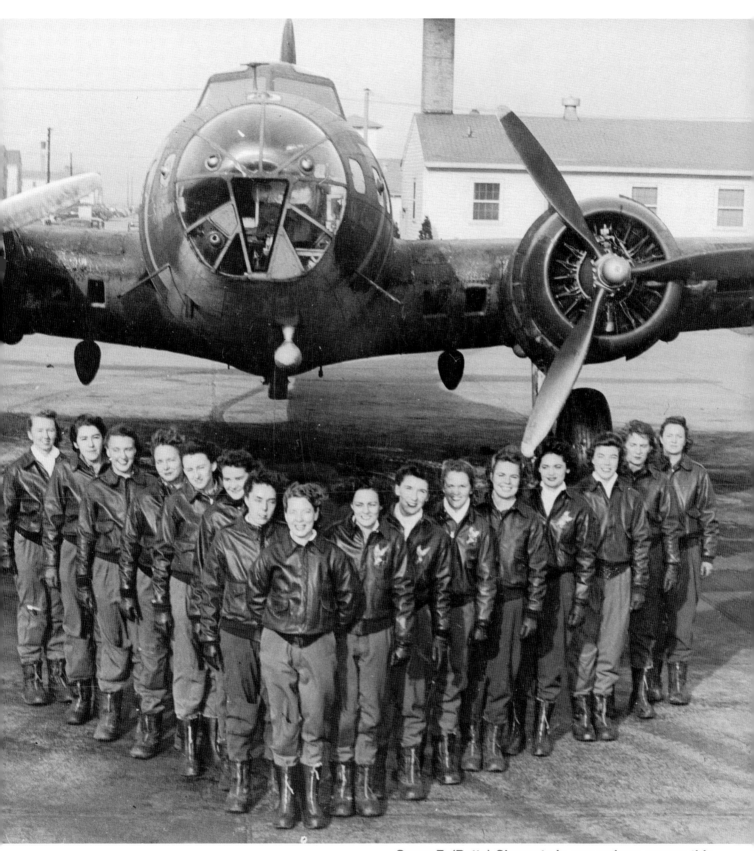

Grace E. (Betty) Clements is somewhere among this
group of WASP pilots in front of a Boeing B-17.
RG3441-2

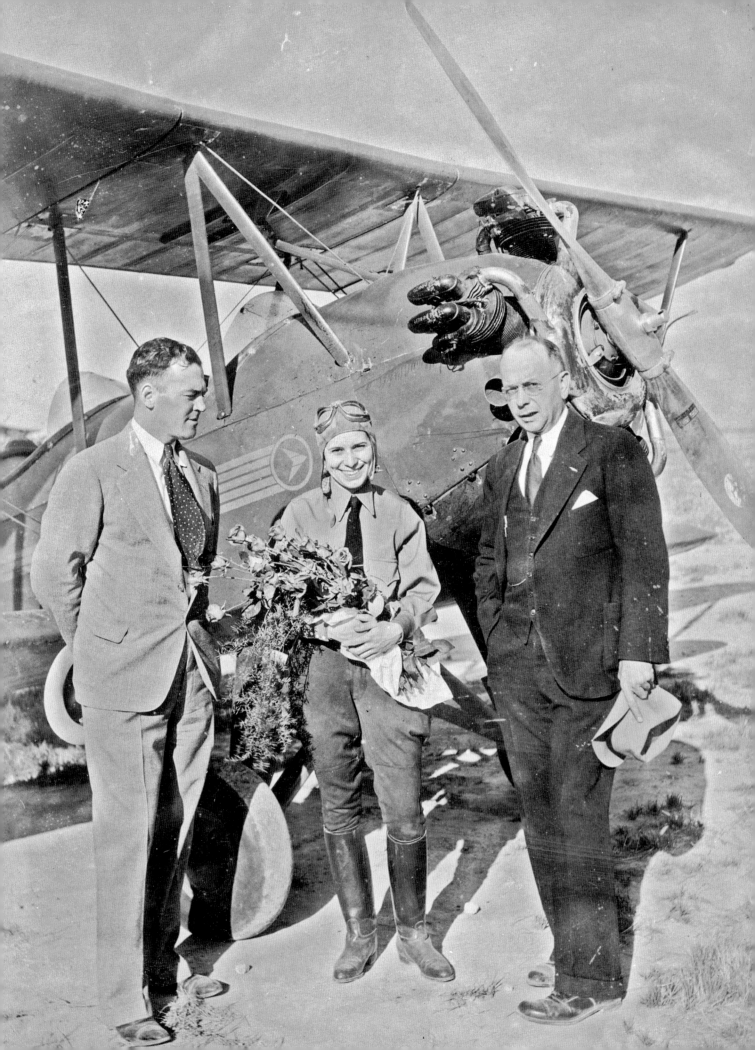

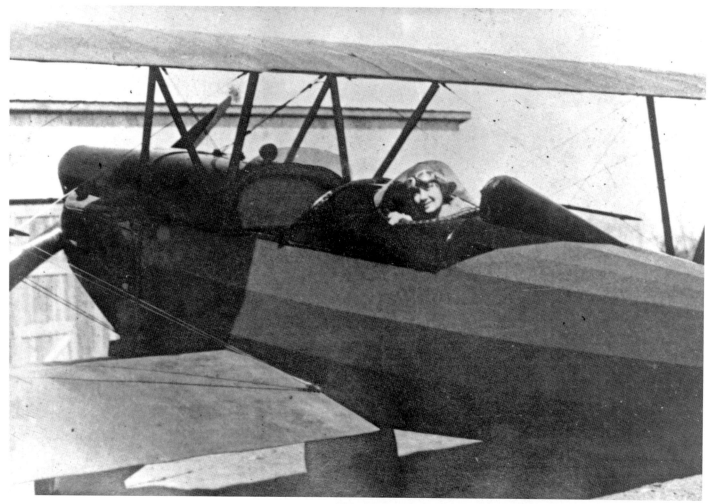

Ethel Ives Tillotson in the cockpit of a Lincoln Page in 1928.
RG2929-386

Louise Tinsley-Miller receiving the World's Barrel Roll record of 312 on May 24, 1936. On the left is C. S. (Charley) Doyle, first secretary of the Nebraska Aeronautics Commission. On the right is Dr. W. W. Arrasmith of Grand Island, commissioner of the Nebraska Aeronautics Commission.
RG2929-398

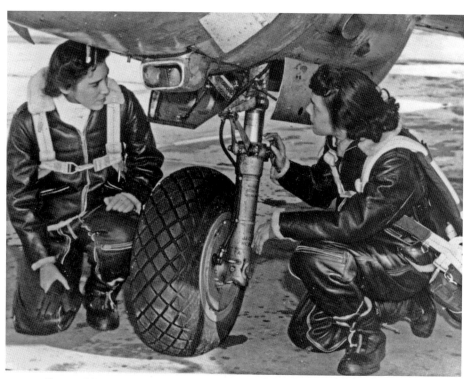

Betty Clements and another pilot inspecting landing gear. (From the photo label it isn't clear which one is Clements.) RG3441-1

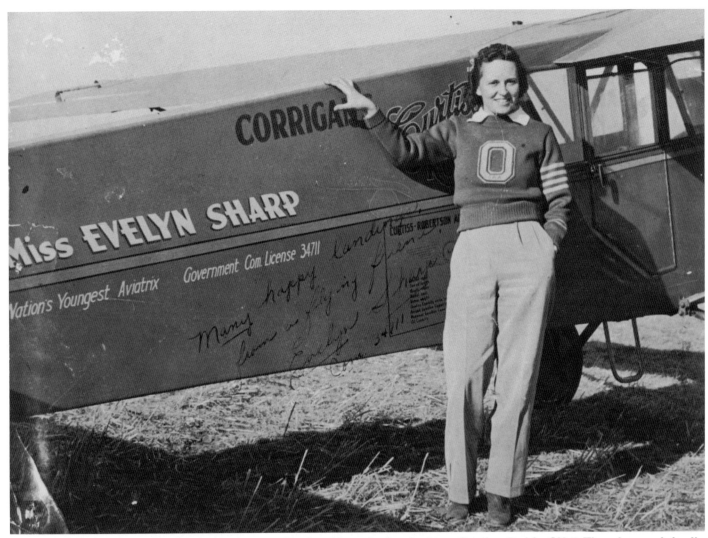

Evelyn Sharp in front of her Curtiss Robin OX-5. The plane originally belonged to Douglas "Wrong-Way" Corrigan, who claimed to have "accidentally" flown from New York to Ireland instead of New York to California.
RG3046-17

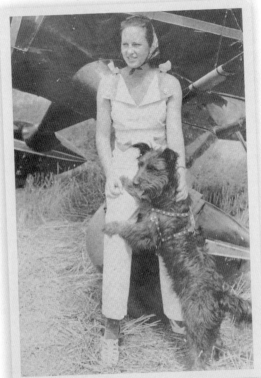

Evelyn Sharp and her dog, Scotty, who was often her co-pilot.
RG2929-4p

young woman who served her country during World War II by ferrying army airplanes. She was a member of the first group of women taught to pilot the four-engine Boeing B-17 Flying Fortress, and she ferried these big planes from Niagara Falls, New York, to Great Falls, Montana. After the war, Betty studied medicine; she was a physician at St. Joseph's Hospital in Phoenix, Arizona, at the time of her death at age forty-seven.

A contemporary of these young women, Dorothy Barden of Bridgeport, Nebraska, started her aviation career as a pilot and parachute jumper for air shows in the 1930s. She became the first woman licensed as a parachute rigger in the United States. During World War II, she ran a parachute shop and became parachute foreman for North American Aircraft in Kansas City. After the war, Dorothy had a long career as jumper, rigger, and instructor before retiring to Bridgeport in the mid-1970s.

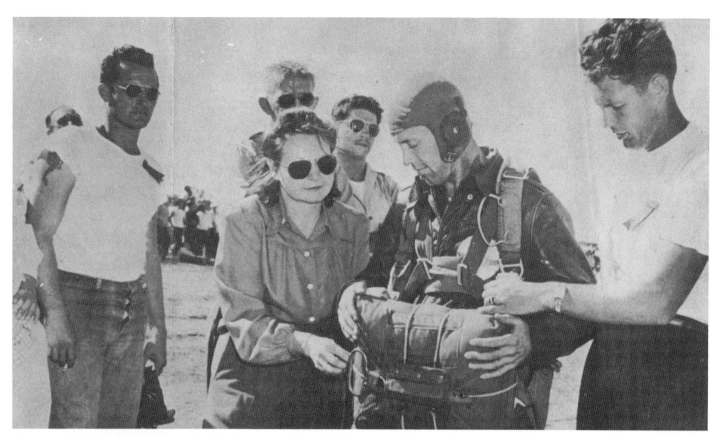

An accomplished pilot, Dorothy Barden was also adept at parachute packing. Here she checks the chute worn by Earl Jackson. Everett Gobels, aerobatic pilot, assists her in the chute fitting.
RG3046-34

Dorothy Barden demonstrates parachute rigging to a student.
RG3046-36

CHAPTER 7

LINCOLN'S COMMERCIAL AIRCRAFT BUILDERS

As early aviation technology advanced, aviators began building aircraft on a commercial level. Three of these businesses existed in Lincoln from the late teens through the early thirties.

During the summer of 1919, three young Lincoln aviators returned home from military service and bought their first plane. Brooks Harding, Abe Zook, and Errold Bahl barnstormed across Nebraska and surrounding states, performed in air shows, and thrilled passengers with

rides in their airplanes. According to a newspaper account, they gathered a fleet of eight ships. In July 1919, they took space at 107 North Ninth Street in Lincoln and established a shop in which they repaired their airplanes. Soon, other aviators were bringing their aircraft to the three men for service.

Errold Bahl had been tinkering with airplane design, and in July he completed the design of his production plane, the Lark. While it isn't clear how much help Bahl had designing this new aircraft, there is

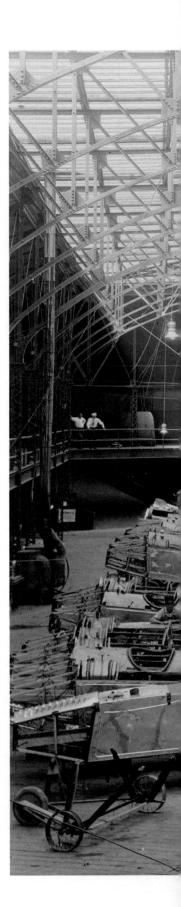

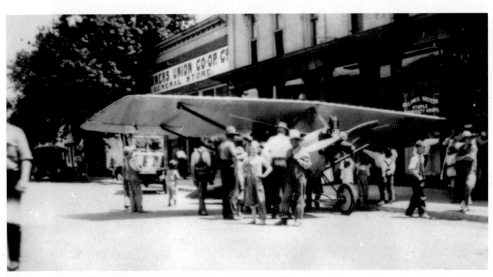

The Lark lands on Humboldt, Nebraska's, main street.
RG5300-4

44 LINCOLN'S COMMERCIAL AIRCRAFT BUILDERS

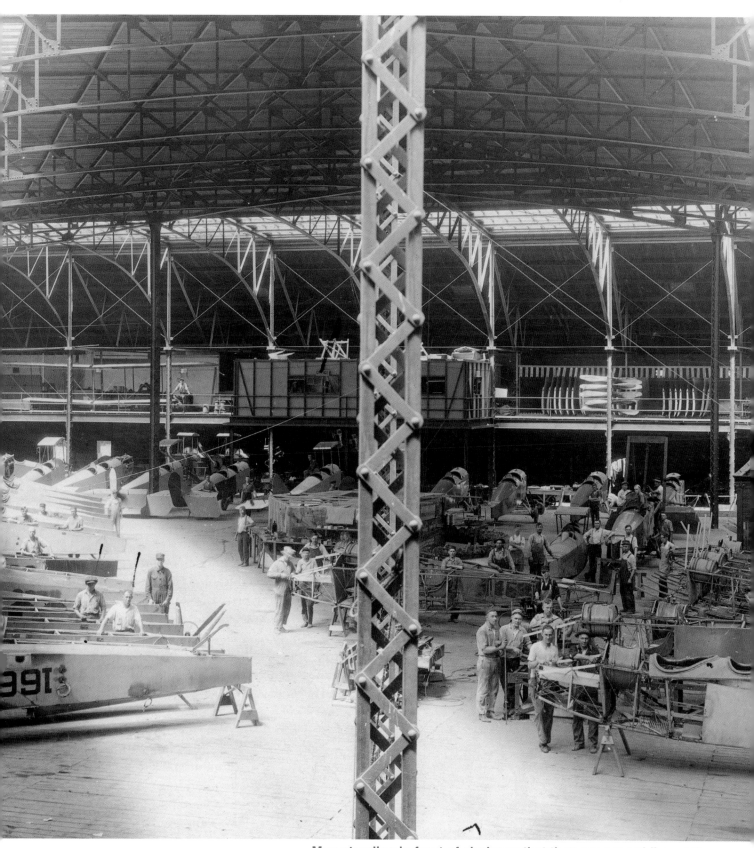

Men standing in front of airplanes that they are assembling at the Industrial Arts Building at the State Fairgrounds.
RG1163-4

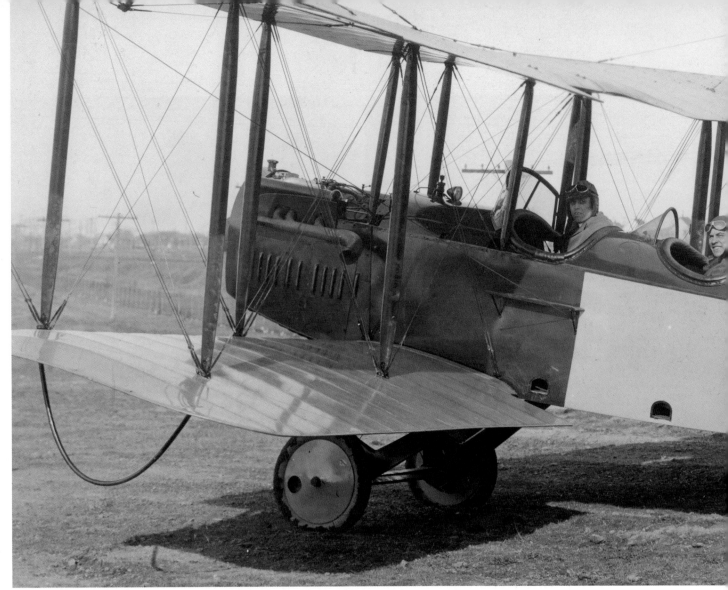

An early Lincoln Standard Tourabout in 1920 or 1921. I. O. Biffle was Lindberg's instructor in 1922. RG1163-2

no question about the uniqueness of its design. The Lark sported a single wing and a monocoque fuselage (essentially a shell similar to an eggshell, with the skin carrying most, if not all, of the load) built of laminated plywood. At only five hundred pounds, the Lark was known as "the lightest plane in the world." It carried a pilot and a passenger and was hailed by the *Nebraska State Journal* as the "flivver" airplane.

The three entrepreneurs incorporated themselves as Harding, Zook, and Bahl in September 1919. The airplane's selling price of $2,000 (about $24,000 in today's dollars) made the craft affordable. The March 14, 1920, *Lincoln Sunday Star* reported that in one year the company had experienced "astonishing growth from a very small beginning," and predicted "that Harding, Zook, and Bahl are the forerunners and pioneers of the great common means of travel of tomorrow."

But competition from several thousand surplus military aircraft narrowed the market. One report indicated that Nebraska Aircraft, Harding, Zook, and Bahl's competitor, bought 480 Standards and parts for 120 more, but there were many more surplus Curtiss JN-4 "Jenny" planes than

A detail from an ad for the Lark that ran in the *Lincoln Star* on March 14, 1920.

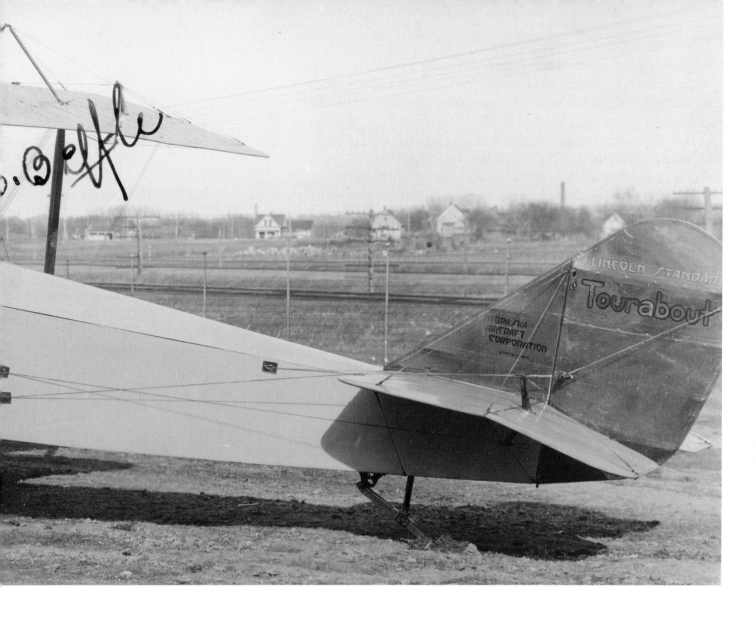

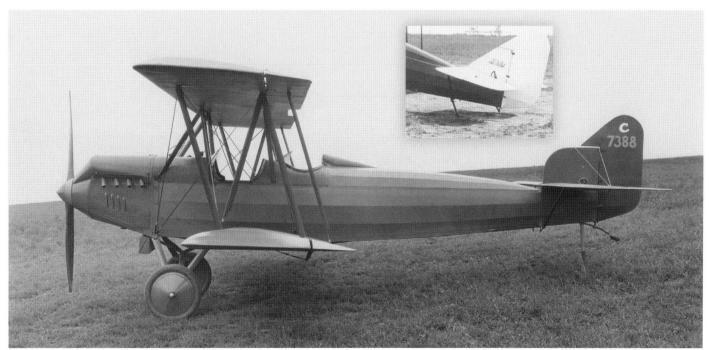

These planes illustrate two of the three different fin and rudder combinations that appeared on the Lincoln Page or Lincoln PT around 1929. RG2929-345 and RG2929-302

Standards. Consequently the new Lark did not sell well.

After a rough beginning, the Lincoln Standard Aircraft Company (originally the Nebraska Aircraft Corporation) was more successful than Harding, Zook, and Bahl. In 1919, A. G. Hebb, L. A. Winship, and E. C. Hammond organized the Nebraska Aircraft Corporation and bought the entire stock of World War I-surplus Standard airplanes as well as a few surplus 150 horsepower Hispano-Suiza engines. The plan was to replace the Standards' Hall-Scott engine, which was underpowered and prone to catch fire when the engine backfired, with the Hispano-Suiza in order to make a more powerful and reliable airplane. The first of these planes was assembled at the Industrial Arts Building on the state fairgrounds.

Ray Page

In 1921, Nebraska Aircraft apparently fell behind in repaying its loans. A frequently quoted rumor suggests that one of the founders took the company's assets in cash and disappeared in Mexico.

Creditors placed a new man in charge: Ray Page, an experienced car salesman and manager of Nebraska Buick in Lincoln since 1915. Page bought the company in 1922 and renamed it the Lincoln Standard Aircraft Company, Inc.

Lincoln Aircraft's chief engineer was Otto Timm, who built his first airplane in Pennsylvania in 1910. The following year he flew a pusher-type biplane out of St. Paul, Minnesota, and by 1915 was flying demonstrations in South Dakota and Montana with a tractor-type biplane of his own design. He spent his World War I years in San Diego, California, as an army flight instructor and designer and

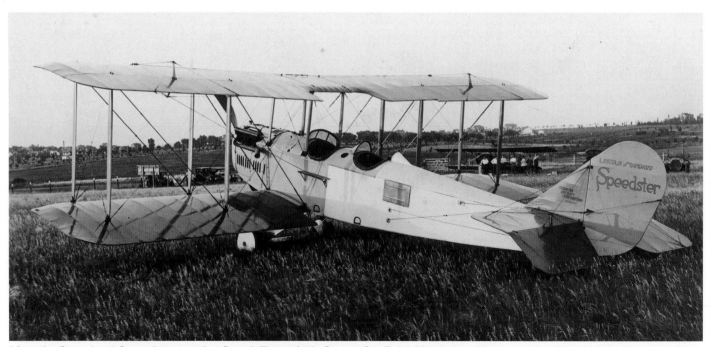

Lincoln Standard Speedster at the South Twentieth Street St. field. Note that the top wing has been shortened to the length of the bottom wing. This was done to cut down drag and make the Speedster a little faster. RG1163-8

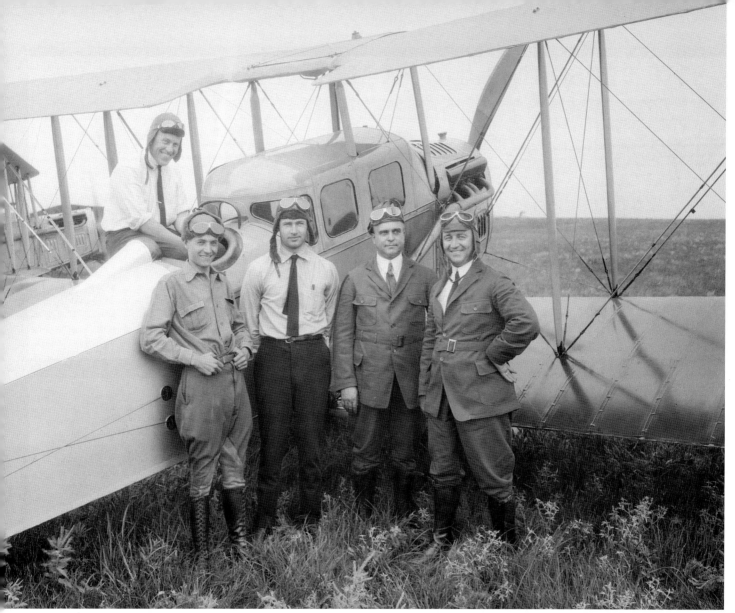

Eyer Sloniger, later seniority number one with American Airlines, is the first on the left of standing pilots sometime between 1920 and 1922. The plane is an LS Cruiser. RG3474-4026

builder of his own airplanes.

Timm came to Lincoln in 1921, where he did design work for Lincoln Aircraft on the three-seat LS-3 and the five-place LS-5. Timm also piloted the plane in which Charles Lindbergh and Bud Gurney took their first airplane ride in April 1922. Later, he returned to California, where he had a long career as an aircraft designer, builder, and consultant.

The home of the Lincoln Standard Aircraft Company for most of its years was at Twenty-fourth and O streets in Lincoln. This building still stands today. It has had many uses over the years, including the Lincoln Airplane and Flying School, which operated there from the late 1920s to the 1940s.

In the early 1920s, Lincoln Standard did most of its flying from a field on the west side of what became South Twentieth between Van Dorn and Calvert (a memorial plaque at Twentieth and High streets marks

the location). The Lincoln Country Club was in the process of building its new links and clubhouse between Twentieth and Twenty-seventh Streets at that time. By the mid-1920s, the field was moved to South Fourteenth Street, just north of where Lincoln Memorial Park Cemetery now stands.

The LS-2 Sport Plane, also called the Baby Lincoln, was introduced during these early years. It had been designed by Swen Swanson, who may also have been involved in the design of Errold Bahl's Lark. Some called it the smallest airplane in the world. It was sold as a kit, and amateurs built quite a few. On June 27, 1925, Augie Pedlar flew this plane off St. Mary's Avenue in downtown Omaha in front of several thousand people. Later, he made a similar flight in Sioux City, Iowa. These publicity stunts were used to promote the Page Aerial Pageants being presented in both cities at the time.

THE PERSONNEL OF PAGE'S AERIAL PAGEANT

SEARGENT CHAMBERS.

Holder of the world's altitude records for parachute jumps. He is probably the most spectacular performer available today. He leaves the plane at high altitude with a pack chute on his back. He makes a sensational roll of about a thousand feet before releasing his parachute. An astounding performance.

EYER SLONIGER.

In Sloniger we present a stunt pilot whose antics with an airplane are simply astounding. He has never performed but to excite his audience to the highest pitch of excited enthusiasm. He does everything a creative mind can think of.

EARL D. BARNES,

Barnes has developed some remarkable stunts in the handling of fast ships and can be depended upon to give the most hardened spectator a real thrill. He is almost too well known to make it necessary for our further comments on his work. He has been flying almost daily for over five years.

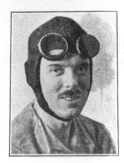

LIEUT. CHARLES HARDIN.

It is almost unnecessary to introduce Charlie Hardin to the aviation world. He is well known as a fearless parachute man and in Page's Aerial Pageant he surpasses all his previous performances by completing a parachute drop using six chutes in a single descent.

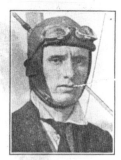

B. H. GRIFFIN.

He is from Oklahoma and down there they are mighty proud of him. He had a remarkable experience with the Italian service and has flown some of the world's biggest ships including the big Caproni. His experience makes him a valuable and attractive member of Page's Aerial Pageant.

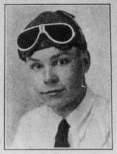

HARLAN GURNEY.

The world's youngest parachute jumper. This boy seems to know no fear. Harlan is only fourteen but he has developed a wonderful act. You will like him.

MILO A. SIEL.

One of the most dependable performers. The chap we call upon for the utmost in hazards and who is always ready to undertake what is seemingly the impossible. We are mighty proud of Siel's work and you will recognize in him a "real" pilot.

KATHRYN HARDIN.

No doubt the best known and most spectacular woman parachute jumper in all the world. Her daring feats make her a wonderful favorite wherever she performs. To watch her is to wonder at her.

DICK HAZELRIG.

The man in whom there is no fear. Far and away the most astounding wing walker in the profession. He rides the wings, the tail, the center section and even does acrobatic stunts from the under carriage of a stunting plane.

"PETE" HILL.

We use "Pete" every day. If it is possible to combine carefulness with the extremes of daring and adventure, he has accomplished the combination. His stunts with a big ship are way beyond the ordinary.

❧ A COMPLETE, SATISFYING ENTERTAINMENT ❧

A newspaper ad promoting Page Aerial Pageant with detailed biographies of the pageant's performers.
RG2929-422

Another well-known Lincoln Aircraft Company pilot was Eyer ("Slonnie") Sloniger. Trained at Kelly Field in Texas and in France during World War I, he returned to Lincoln after the war, re-entered the University of Nebraska and began barnstorming in his spare time. In 1919, his father bought him an OX5-powered Curtiss Canuck that he used to fly passengers. After delivering a Lincoln Standard to Mexico, he stayed on to deliver gold coin payrolls by air to mining companies in Tampico, Mexico. Once back in Lincoln, he started flying for Ray Page as a test pilot, salesman, and stunt pilot. Slonnie flew the German Fokker D.VII with great success, winning many aerobatic championships.

Sloniger later joined Bud Gurney as Lindbergh's replacement at Robertson Aircraft Corporation, an airmail company and flying school established by two brothers who had won the airmail contract for the St. Louis-to-Chicago route. Slonnie's career lasted through many mergers, and he flew most of the airmail and early passenger planes.

One of Sloniger's closest calls happened while he was still on the ground. After Charles Lindbergh's historic flight in 1927, the pineapple tycoon James D. Dole offered a $35,000 prize for a flight from California to Hawaii, hoping that Lindbergh would

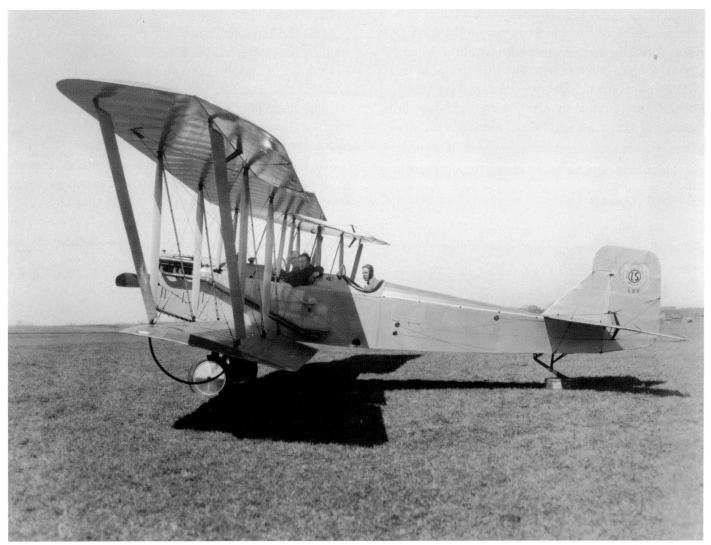

A Lincoln Standard LS-3 with Lincoln Standard owner Ray Page in its front cockpit.
RG2929-313

enter along with other pilots. Lindbergh declined, but fifteen other adventurous fliers signed up for this ill-starred event. Eight pilots and their planes qualified, but most of the qualifiers did not seem to realize the difficulty of preparing a plane and themselves for the challenge of finding islands in the vast Pacific Ocean.

Eyer Sloniger and Augie Pedlar flipped a coin to see which one would pilot a plane in the Dole race. Augie won. Although some questioned the airplane's reliability and Augie's ability to use the instruments, on August 16, 1927, he took off from Oakland, California, with a navigator and a pretty young teacher, Mildred Doran, who was along for publicity purposes.

They were never seen again. Of the eight planes that started the race, only four got out of sight of land, two vanished over the ocean, and two made it to Hawaii. Art Goebel won the race, landing at Wheeler Field outside of Honolulu on August 17, after twenty-six hours in the air.

Eyer Sloniger's wife kept the coin from the coin toss. For many years she wore it on a bracelet. She felt it may have saved her husband's life.

Two years later, Sloniger went to China to help start airmail service there. Eventually, he became chief pilot and number one in seniority at American Airlines. He promoted passenger service, working on publicity with celebrities including Jack Armstrong, Gene Autry, Jimmy Doolittle, and Howard Hughes. During World War II, Sloniger flew the new four-engine planes such as the DC-4 (C-54) for the Air Transport Command, crossing the Atlantic eighty-eight times. He had a total of 24,375 flying hours at the end of his career. When old-timers get together, they speak of Sloniger as a pilot's pilot.

While Sloniger gained more skills as a pilot, Lincoln Standard gained prestige as an aircraft

company. In 1927, Ray Page expanded the administration of Lincoln Standard to include Victor Roos, formerly an executive with Swallow Aircraft Corporation in Wichita, Kansas. Roos brought with him the plans for the Swallow designed by Matty Laird, an early pilot and aviation engineer who built a number of very fast, specialized airplanes for air races in the 1930s. The Swallow, with minor modifications, became the Lincoln Page 3 (LP-3). Further modifications created the Page Trainer (PT). The Lincoln Page and the Lincoln PT, both powered by Curtiss OX-5s or 150 horsepower Hisso engines, became quite popular. When powered with radial engines these models were called PTW (Page Trainer Warner) or PTK (Page Trainer Kinner).

Ray Page retired from the business in 1929 because of ill health and sold the company to a group of investors headed by Victor Roos of Omaha. The

The Lincoln Sport was billed as the "world's smallest practical airplane."
RG2801-1-53a&b

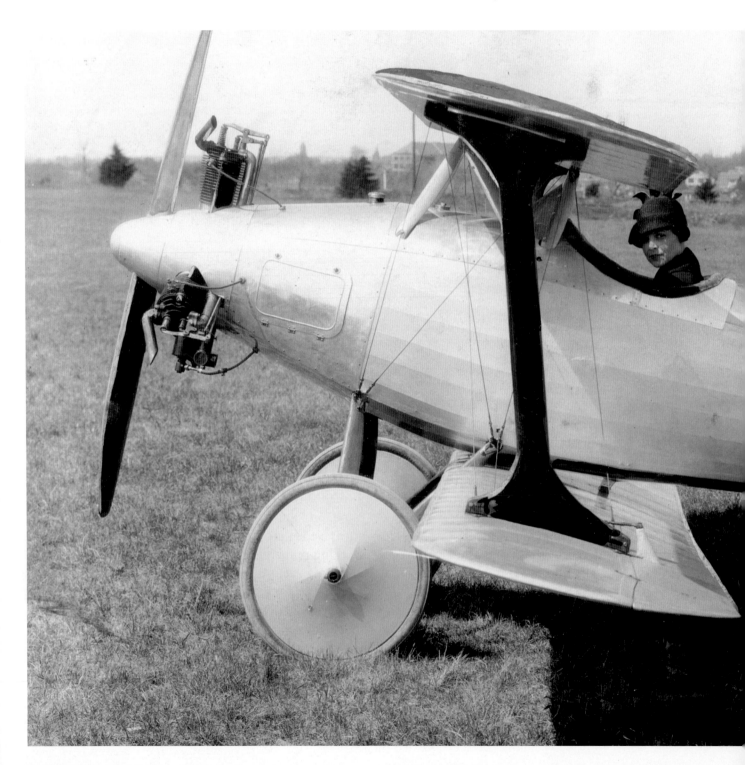

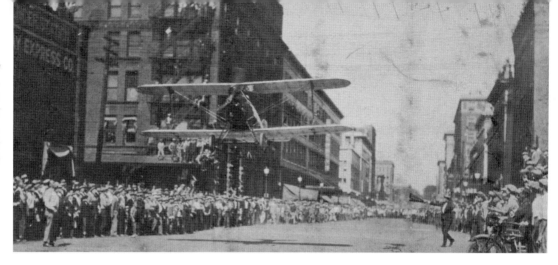

Augie Pedlar flew the Lincoln Sport from St. Mary's Avenue in Omaha as a publicity stunt in 1925. RG2801-1-35 and RG2801-1-153

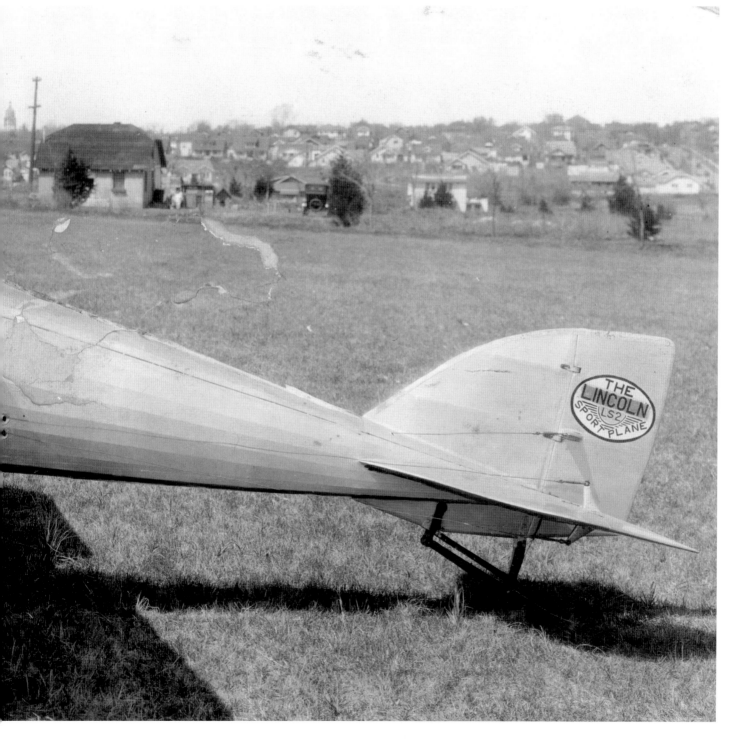

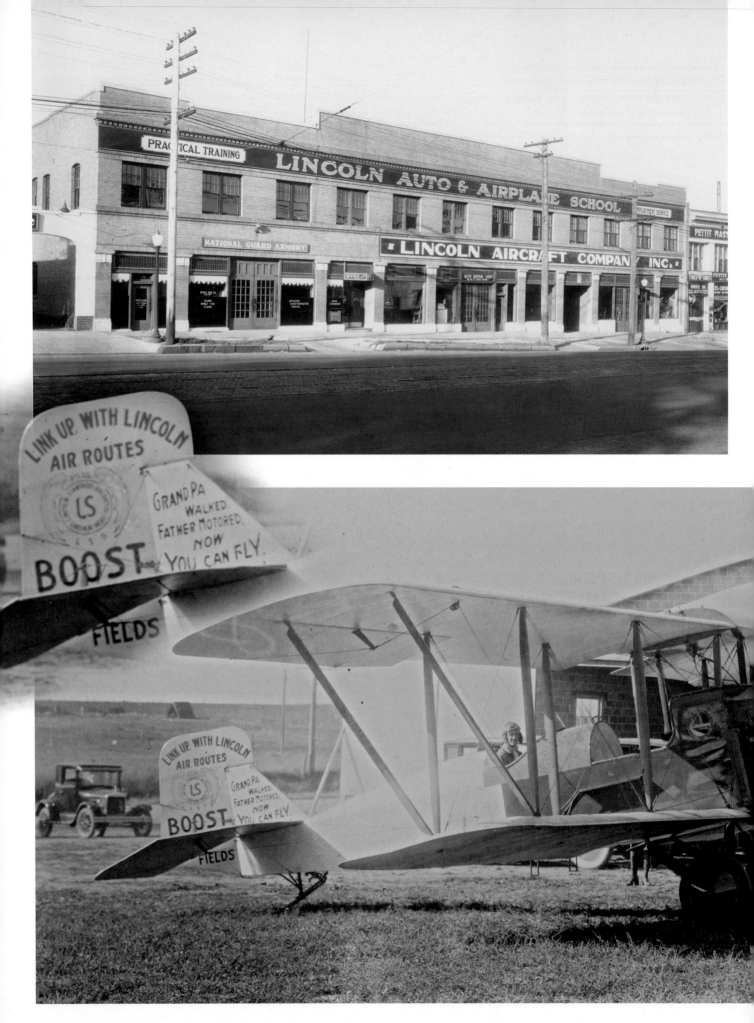

company built several experimental designs in the early 1930s, but the Great Depression saw a severe decline in sales of most small airplanes. The company merged with American Eagle of Kansas City in May 1931. The Lincoln plant closed and production moved to Kansas City.

Lincoln Standard was not only an airplane manufacturer. Through a separate corporation, Ray Page produced aerial pageants in cities and towns in the Midwest. These paid-admission shows featured stunt flying, wing walking, and parachute jumping. Spectators could also pay to ride in the planes. Many of the performers, including Bud Gurney, Eyer Sloniger, and Encil Chambers, became flying legends.

Chambers reached legendary status with a record-altitude parachute jump from 26,800 feet over Kansas City in November 1921. Soon after, he left the Army Air Service and became associated with Ray Page's Aerial Pageant and the Lincoln Standard Aircraft Company. By the early 1930s, Chambers was the plant manager and a director of Lincoln Standard

Aircraft Company.

Many of the companies in the air show business faded away in the 1930s. This was the time of the Depression, of course, but there was another factor. The U.S. Government began to strictly regulate flying

Below: In 1924, Lincoln Standard moved its flying field to South Fourteenth Street, just north of where Lincoln Memorial Park Cemetery now stands. This picture shows the hangar and two LS-5s that were used in an attempt to establish passenger service to Wichita, Kansas, and other cities in the southwest. RG2158-1886

Opposite: E. J. Sias helped found Lincoln Auto and Tractor School in 1918. By 1929, it was Lincoln Auto and Airplane School. Later, the Lincoln Airplane and Flying School incorporated as the Lincoln Aeronautical Institute. The Lincoln Aircraft Company, Inc., was always a separate business with separate ownership. Though the businesses shared the same building at Twenty-fourth and O streets, the two different signs illustrate their separate natures. RG2183-1929-0616-3

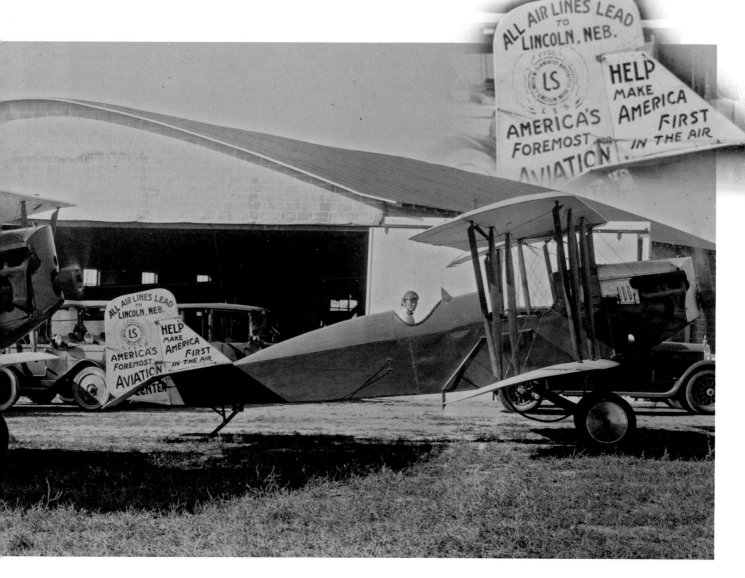

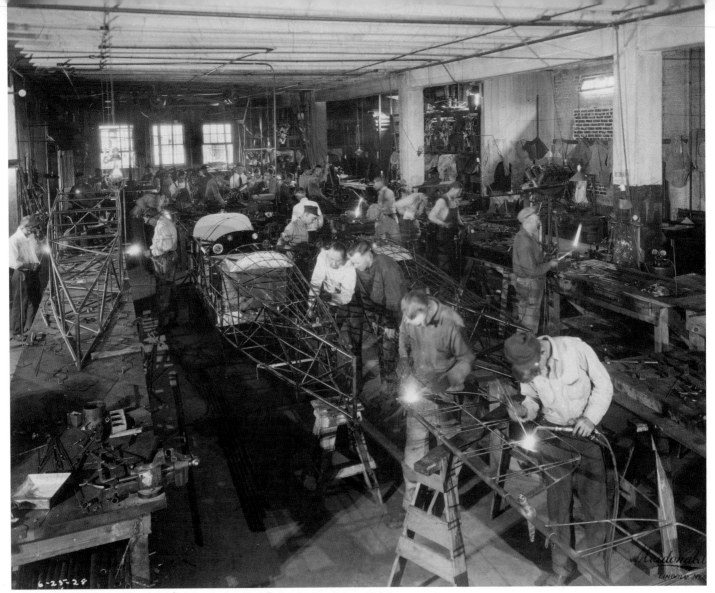

The welding section of Lincoln Aircraft Company in June 1928.
RG2929-307

to save lives and promote commercial aviation as a safe method of transportation.

The final major aircraft builder in the Lincoln area was the Arrow Aircraft Corporation. Its first airplane saw the light of day in 1926 when its builders removed the plate glass window from a storefront at 1424 O Street, at Havelock, Nebraska, and brought the plane outside. The first Arrow 5 was designed jointly by J. B. (Johnny) Moore, Arrow's principal stockholder, and Swen S. Swanson. Moore and Swanson built five of these planes, which were framed in fabric-covered wood and powered by 180 horsepower Hisso V-8 engines.

By 1927, Moore and Swanson had designed and built the first Arrow Sport, a two-place, side-by-side craft, powered by a 30 horsepower Anzani engine. When the aircraft proved to be underpowered, the men replaced the engine with a 60 horsepower Anzani, and the Department of Commerce required that wing struts be added. The plane, now powered

with a sixty horsepower LeBlond engine, was certified as model 2A-60L in February 1929.

By this time, the Woods Brothers Corporation had acquired financial control of the company from Moore. Mark Woods was an entrepreneur from a Lincoln family known for real estate development and construction. He became president, and his son Pace was sales manager.

The company wanted to mass-produce this plane at its plant in Havelock. In 1929, Arrow began production with 271 orders in hand from individuals all over the country and abroad. Then a fire at the Le Blond engine factory created an engine shortage. The Le Blond air-cooled radial engine was difficult to replace on short notice, leading to cancelled orders. Then the Great Depression arrived and more orders were cancelled. According to company records, sixty-eight planes were produced in 1929, but only thirty during 1930-32. The company apparently shut down production of the Arrow Sport in late 1932.

The company was producing a new plane by the mid 1930s, a monoplane powered by a Ford V-8 engine. This mass-produced 82 horsepower automobile engine could be purchased and slightly modified at a fraction of the cost of a standard aircraft engine. The Arrow FV-8 powered model was a low-wing monoplane with

Chrome Molybdenum Fuselage Of Lincoln P. T.
LINCOLN AIRCRAFT COMPANY, INC. LINCOLN, NEBR.

Left: The chrome molybdenum fuselage of a Lincoln Page Trainer (PT) as built in 1928. RG2929-308

Below: A Lincoln Standard is towed along a downtown street in Lincoln. This experimental plane was probably one of a kind. RG3540-1-2

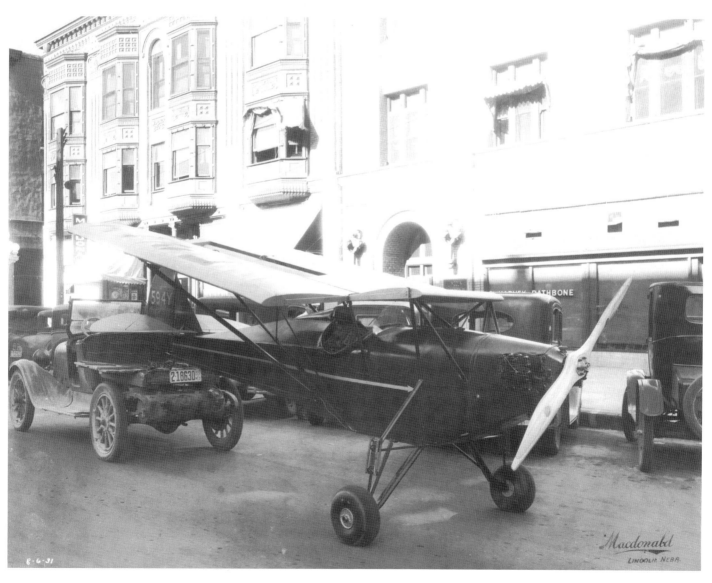

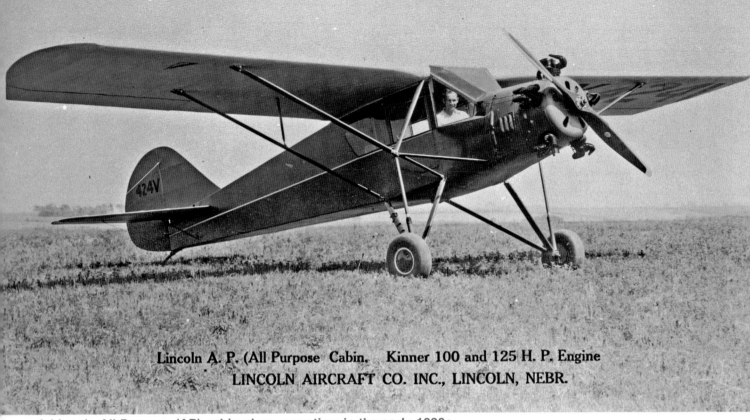

Lincoln A. P. (All Purpose Cabin. Kinner 100 and 125 H. P. Engine
LINCOLN AIRCRAFT CO. INC., LINCOLN, NEBR.

A Lincoln All Purpose (AP) cabin plane sometime in the early 1930s.

two-place, side-by-side seating.

This aircraft cruised at approximately 70 miles per hour, but was "somewhat heavy on the controls" (it took considerable effort to move its stick and rudder pedals) and wasn't popular. The Arrow Aircraft Corporation went out of business by the early 1940s.

Around 1928, Arrow Aircraft built an airfield and hangar at the end of North Forty-eighth Street. The street still ends where the airfield stood; the area was for a time part of the Lincoln city dump. Arrow's

Havelock production plant was purchased by Goodyear and is still in use.

An Arrow Sport biplane now hangs in the passenger terminal of the Lincoln Municipal Airport. Dr. Roy S. Cram of Burwell, Nebraska, restored the plane and later sold it to the Nebraska State Historical Society Foundation in 1977. Several other museums have Arrow Sports, including the Smithsonian Udvar-Hazy Center, and a few are still flying.

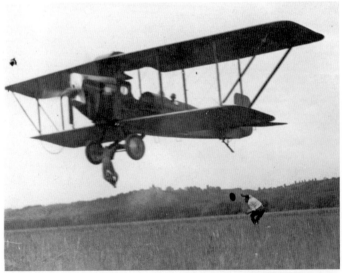

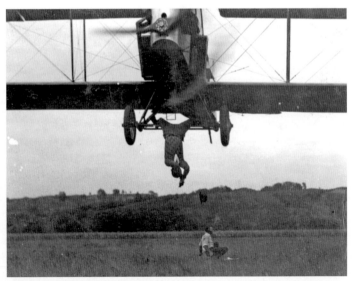

Several photos taken while a plane is in flight demonstrates the daring performance of the members of Page's Aerial Pageant. A man hanging from the landing gear knocked the hat off of the head of the man sitting on the ground. RG2801-1-128

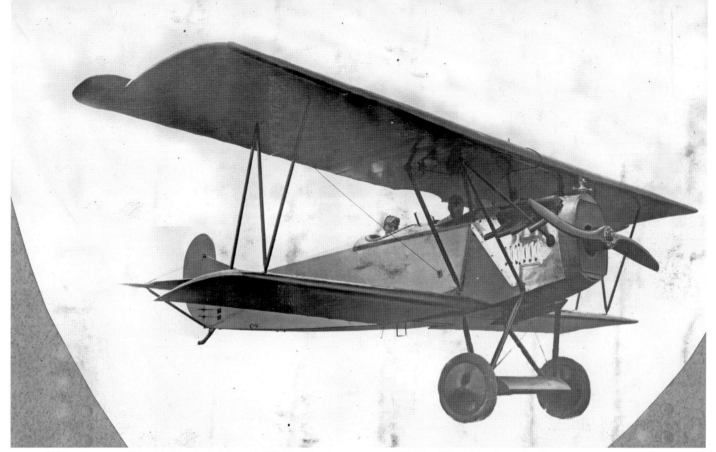

This German World War I Fokker D.VII that had been modified with a front cockpit was a constant feature of Page's Aerial Pageant. Eyer Sloniger flew it for a variety of daring stunts. The front cockpit was added so the plane could also give rides.
RG2801-1-10

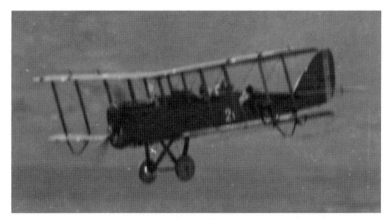

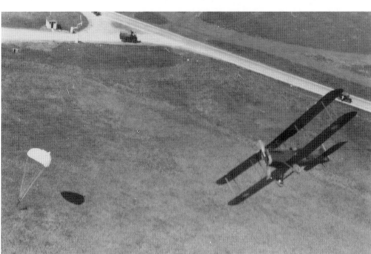

Above left: Sgt. Encil Chambers climbs out on the wing to prepare for his record parachute jump of 22,200 feet, which occurred sometime between February and November of 1921.
RG2929-276

Above: Chambers free falling.
RG2929-282

Left: Chambers ready to land.
RG2929-285

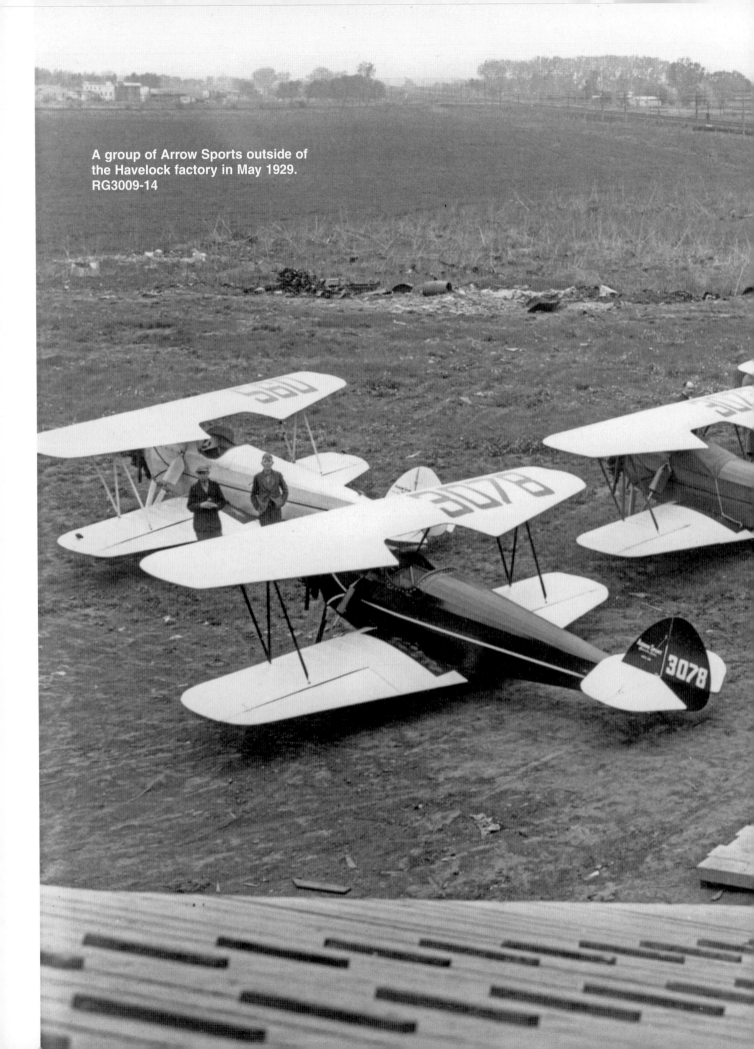

A group of Arrow Sports outside of the Havelock factory in May 1929.
RG3009-14

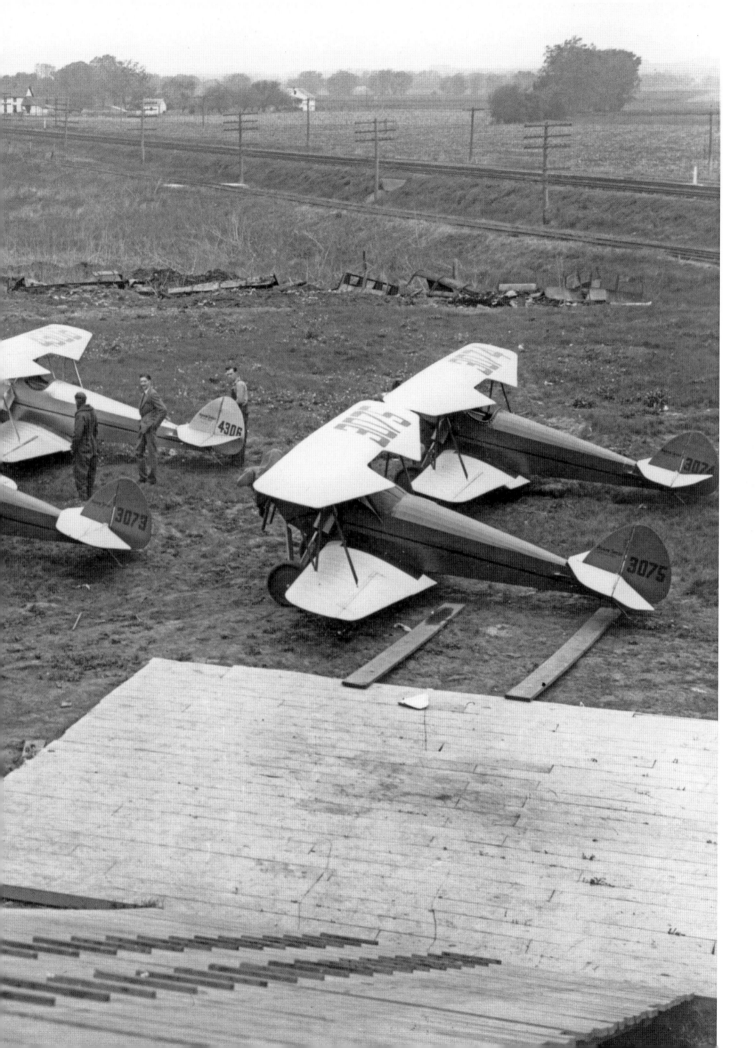

The Arrow Airport around 1928 or 1929. The airport was located on Forty-eighth Street just beyond Superior Street. RG3009-21

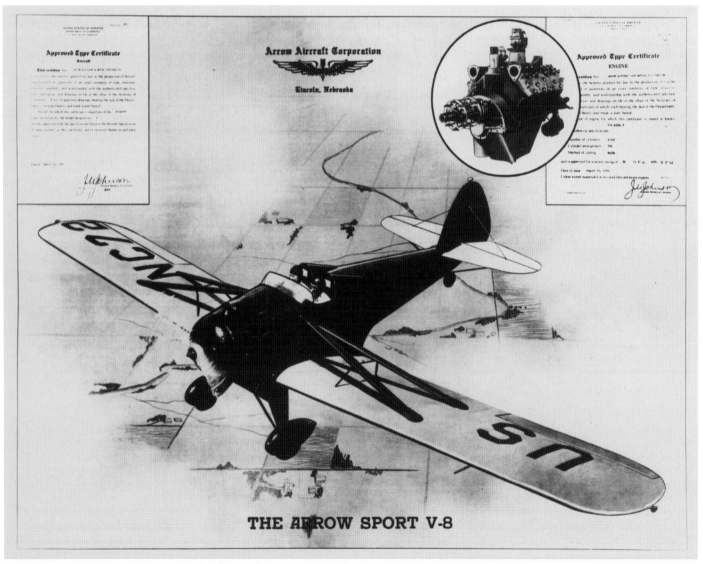

An advertisement for an Arrow Sport V-8 in 1936.
RG3009-37

Stress testing on an Arrow Sport's stabilizer and elevator in August 1929. RG2183-1929-0803-3

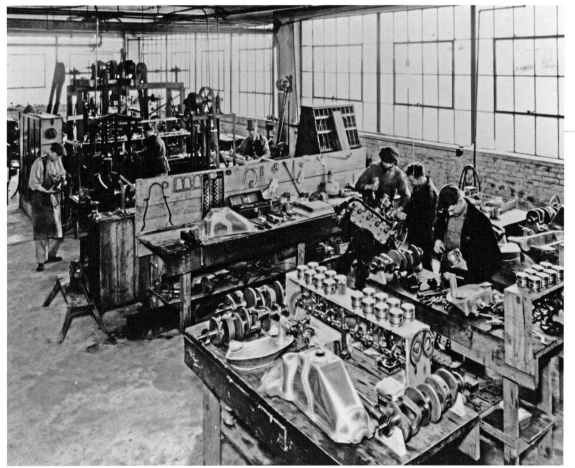

Final engine assembly of the Arrow V-8s in April 1937. RG2183-1937-410

OMAHA'S COMMERCIAL AIRCRAFT BUILDERS

Beginning in the era of the Baysdorfer brothers, Omaha aviators also built a number of early airplanes. Henry A. Ashmusen came to Omaha in 1918 and started his company at Sixty-fourth and Center streets (at the time called Airmail Field or Ak-Sar-Ben Field) to build an aircraft engine of his design as well as an airplane called the Blue Bird. When Ashmusen died at a young age from pneumonia in February 1920, several pilots did a flyby and dropped flowers over his gravesite in Forest Lawn Cemetery. His wife Clara continued the business until 1924, when the airmail service moved to Fort Crook.

Another Omaha builder, Giuseppi M. Bellanca, designed and built one of the first cabin planes in the United States in 1921-22. In spite of its good design, Bellanca and his

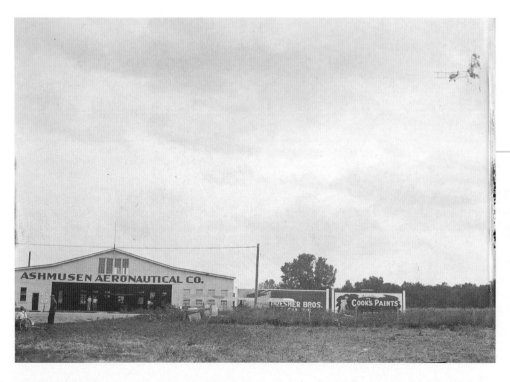

Ashmusen Aeronautical Company, where the Blue Bird airplane was built. The factory was at Sixty-fourth and Center in Omaha on Airmail Field, which was also the Ak-Sar-Ben grounds. RG3882-26

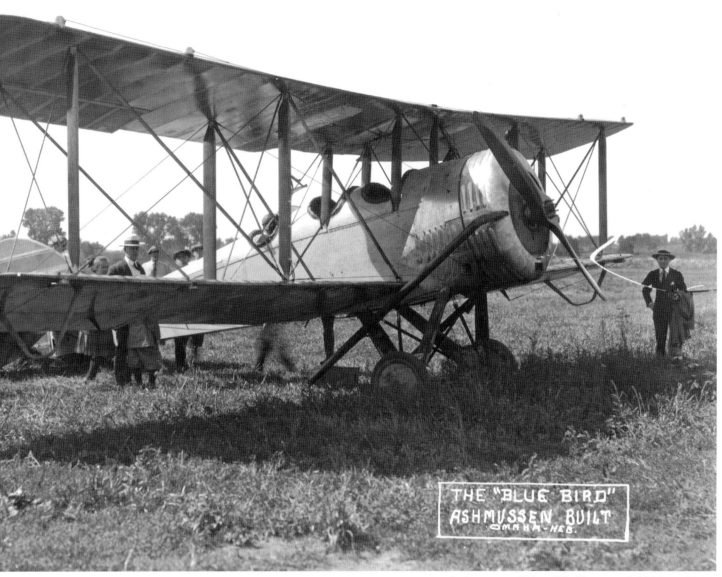

An Ashmusen "Blue Bird" around 1919 or 1920.
RG3882-26

partner Victor Roos were unable to get enough financing for the plane in Omaha. Roos continued to be active in aviation and eventually bought the Lincoln Standard Aircraft Company from Ray Page. Bellanca moved to the East Coast, where he designed and manufactured a number of other fine airplanes. In fact, Charles Lindbergh tried to buy a Bellanca for his New York-to-Paris flight. However, when Charles Levine, owner of the Bellanca plane, insisted on retaining control over the flight, Lindbergh refused and turned to Ryan Airlines in California to build the *Spirit of St. Louis.*

Overland Airways, headed by Roy Furstenberg,

established a flying and mechanics' school in Omaha in 1928, and soon Roy and Harold Phillips decided to build their own "ship" of Phillips's design. The result was the Overland Sport, a two-place biplane.

The design was faulty. L. O. "Dutch" Miller, piloting the plane on an early test flight near Omaha Municipal Airfield, went into a flat spin. (In most airplanes even today it is impossible to recover from a flat spin.) Miller

Roy Furstenberg

parachuted to safety and the plane crashed. After design changes, the second plane passed the tests and was certified. But as in so many cases, the Great Depression ended the production of this pretty little plane.

The Omaha area's most important aircraft manufacturing facility did not appear until World War II, when the Martin Bomber Plant opened at Fort Crook in Bellevue—a subject that will be covered in Chapter 15.

Giuseppi M. Bellanca at the time he was in Omaha in the early 1920s. RG3882-34a

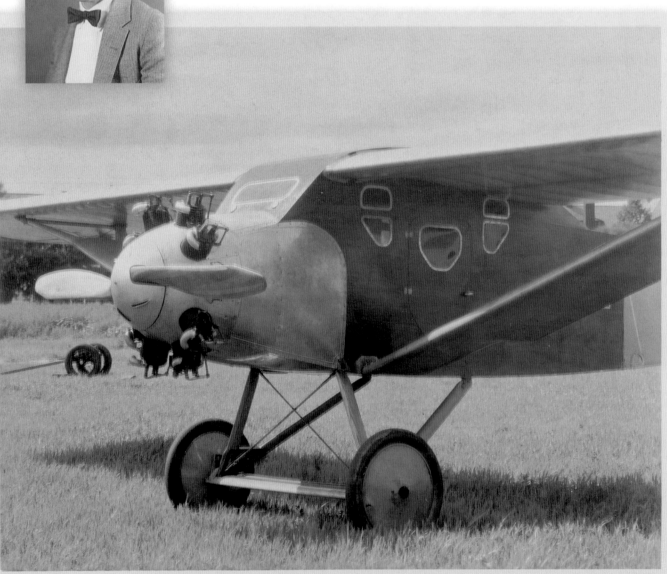

Nos. of Bellanca plane June 10, 1922.

The Bellanca plane that Giuseppi Bellanca built in Omaha. RG3882-35

A side view of the "sweetheart of the air," the Overland Sport, in Omaha in 1929.
RG3882-570

The fuselage of an Overland in front of the shop at Sixteenth and Sprague or Commercial Avenue in Omaha where it was built.
RG3882-574

LINCOLN AIRPLANE AND FLYING SCHOOL

Threats he Lincoln Airplane and Flying School's origins date to 1918 when E. J. Sias was involved in starting an auto and tractor school. By 1929, after Sias bought the flying school share of Ray Page's Lincoln Standard Aircraft, the school was called the Lincoln Auto and Airplane School. It later became the Lincoln Airplane and Flying School with the corporate name Lincoln Aeronautical Institute.

The school was made up of two divisions. The aviation mechanics'

Front cover of a pamphlet advertising the Lincoln Aeronautical Institute Airplane and Flying School that was published in the 1930s. NSHS 11541-1

school was located at Twenty-fourth and O streets. Flight training was held at the Municipal Airport but moved to Union Airport (north of

Havelock) by 1939.

On July 1, 1939, the school was one of nine civilian contract schools selected by the Army Air Corps to give primary flight instruction to army cadets, who trained in Stearman PT-13s. However, during the winter of 1939-40, the weather was so bad that the army moved its training to Lakeland, Florida, in the fall of 1940. Consequently, Sias sold his interest in the army flying contract.

The civilian school trained many pilots and aircraft and engine mechanics as demand increased prior to and during World War II. In a 1952 interview, Sias stated that approximately ten thousand students had been trained at the school. The

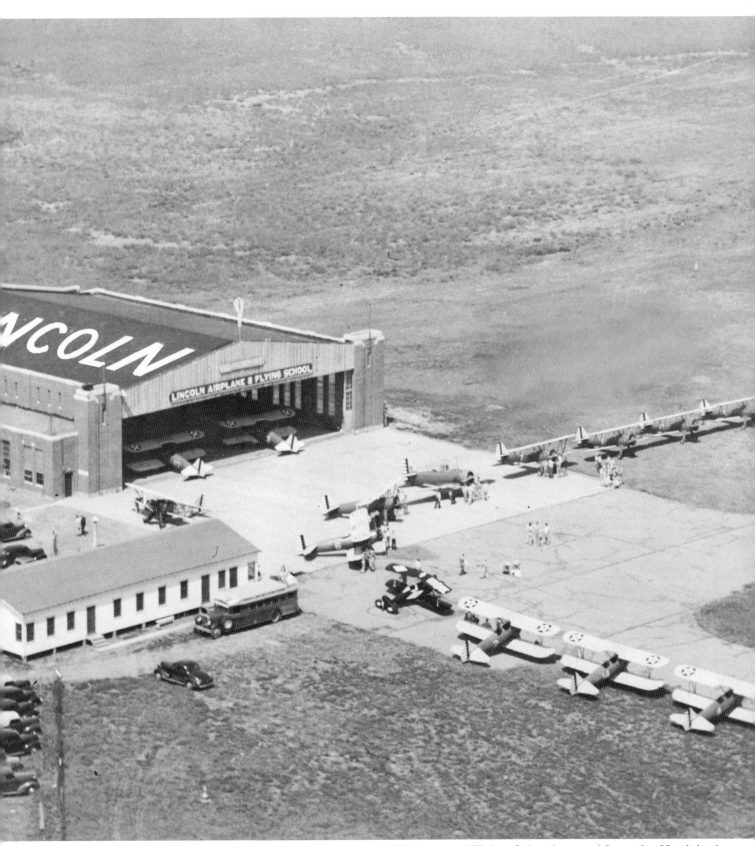

Union Airport in 1939, where the Lincoln Airplane and Flying School moved from the Municipal Airport. The photo shows the biplanes (Stearman PT-13s) the school used to train Army Air Corps cadets. The school and the airport were owned by E. J. Sias. The 320-acre airport closed in 1964 and became an industrial center. It was located north of Fletcher Avenue, east of U.S. Highway 77 and west of North Seventieth Street, just north of what were then the Lincoln city limits. The airport's red and green beacon tower still stands on the site.
RG3895-6-8

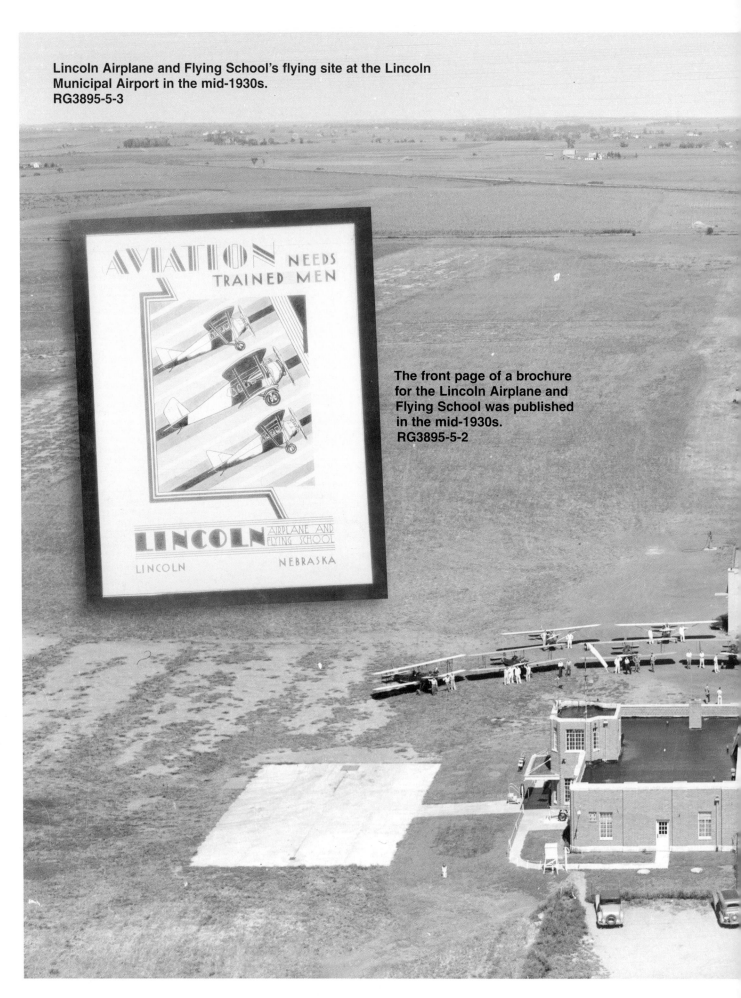

Lincoln Airplane and Flying School's flying site at the Lincoln Municipal Airport in the mid-1930s.
RG3895-5-3

The front page of a brochure for the Lincoln Airplane and Flying School was published in the mid-1930s.
RG3895-5-2

AVIATION NEEDS TRAINED MEN

LINCOLN AIRPLANE AND FLYING SCHOOL

LINCOLN NEBRASKA

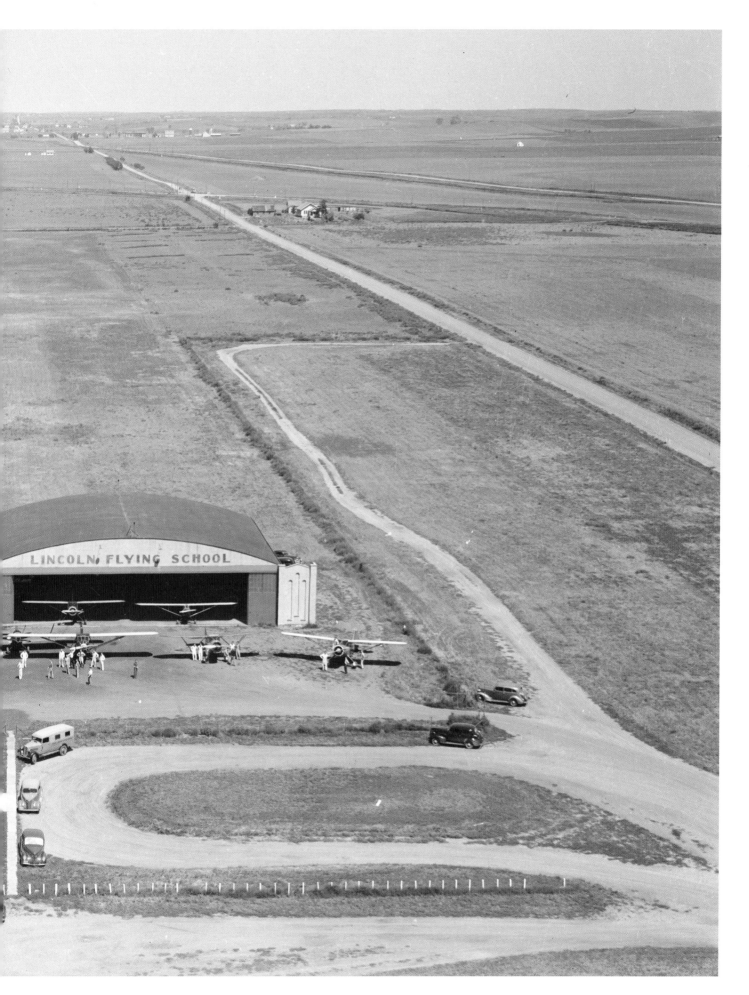

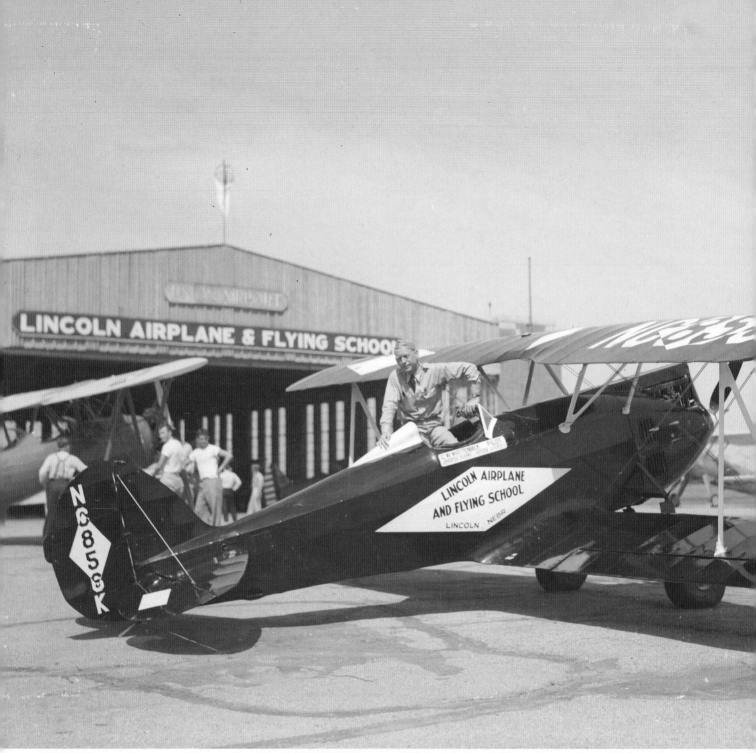

A Great Lakes Trainer at Union Airport, Lincoln Airplane and Flying School. The pilot is Clem Whittenbeck, the school's director of flying. The plane can be seen on the ground in the photo on p. 69.
RG3895-4-3

demand for trained pilots and mechanics dropped sharply as the war drew to a close; Sias closed the school and retired in July 1945. The Lincoln Aviation Institute, formed in 1949 by David Bornemeier, Charles Taylor, Thomas J. Umberger, and Charles L. Haeseker, served as successor to the Sias school.

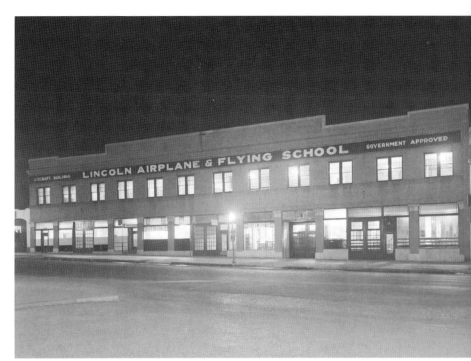

The Lincoln Airplane and Flying School on January 29, 1942.
RG2183-1942-0129-8

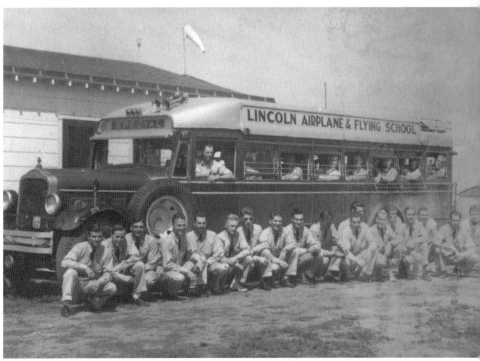

The school bus that took students back and forth from the Twenty-fourth and O building to the flying field. The photo was taken in 1939 or 1940.
RG2929-412

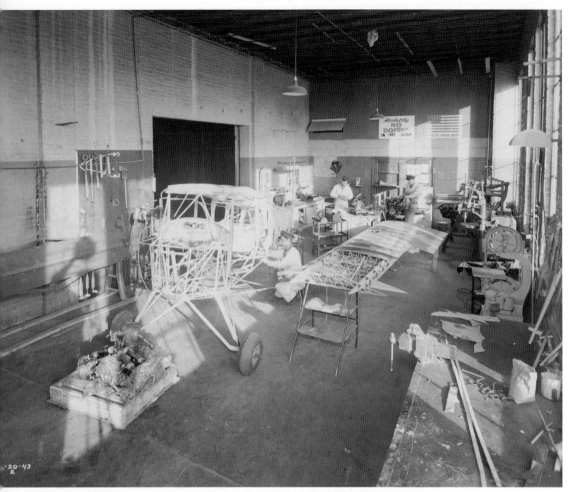

Lincoln Airplane and Flying School air frame-building classroom.
RG2183-1943-1220-2

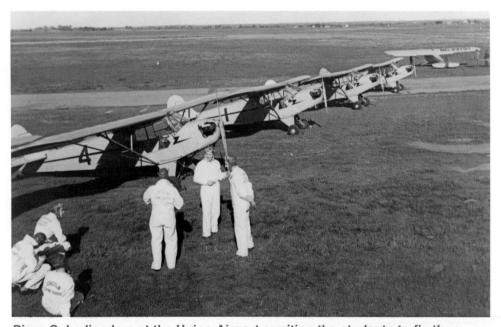

Piper Cubs lined up at the Union Airport awaiting the students to fly them.
RG1475-7

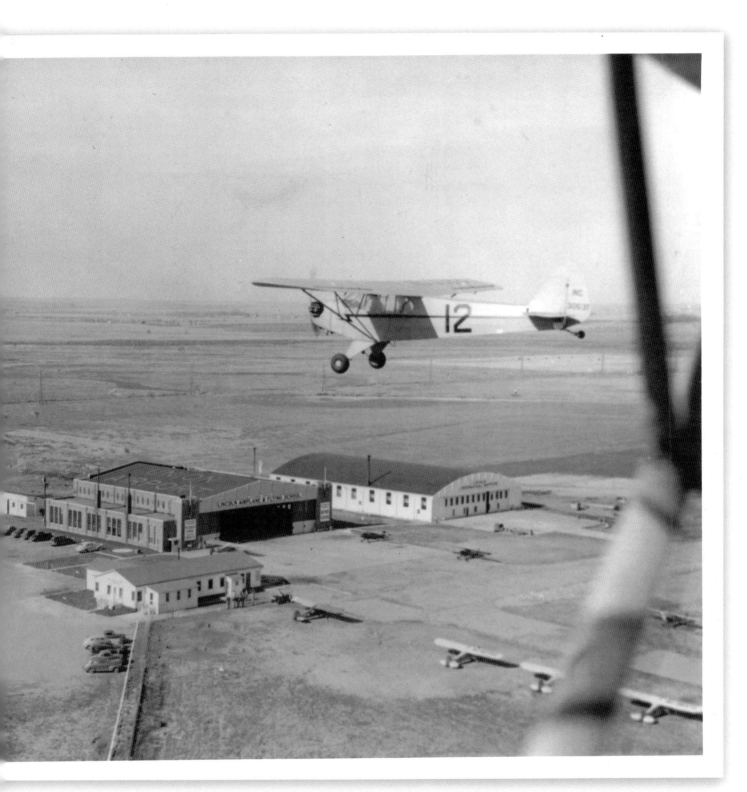

The Union Airport about 1942. The plane in the air is a Piper Cub.
RG1757-1

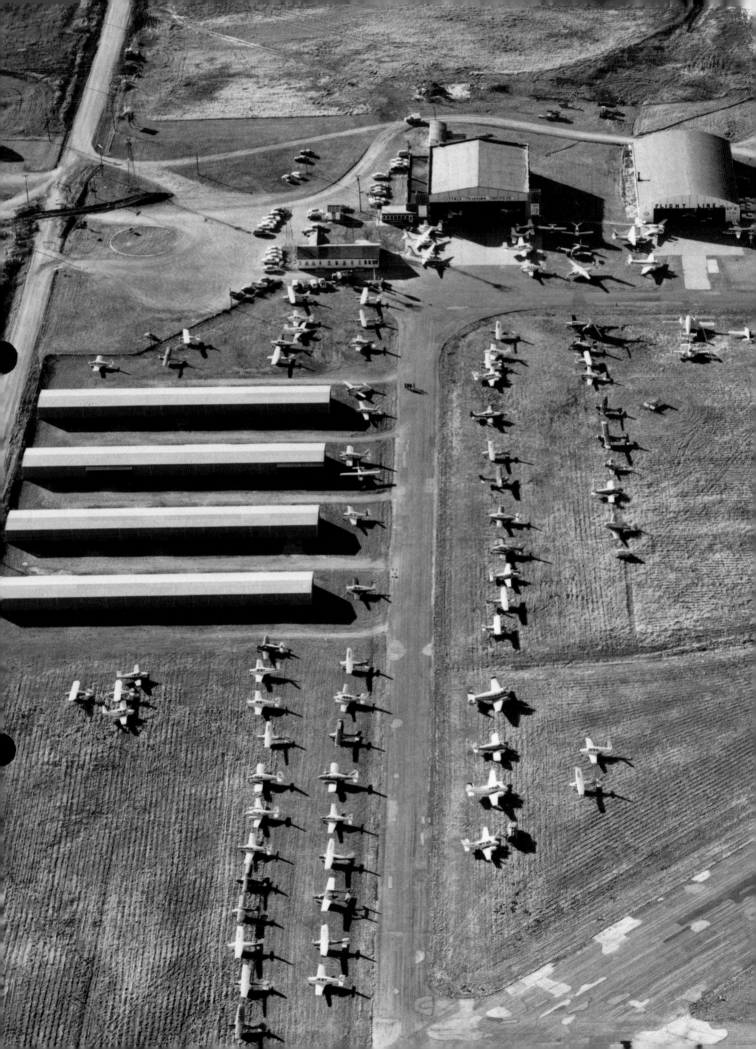

The aviation fever of the late 1930s was rampant among children as well as adults. *The Air Adventures of Jimmie Allen* was as popular kids' radio show from 1933 to 1947. This pin was one of the many premiums kids could win if they were in the Jimmie Allen Flying Club. Skelly Oil sponsored the show.
NSHS 8601-400

Union Airport as it looked in the 1950s or 1960s on a Husker football weekend. Fans from out of town flew in to support their team.
RG2929-443

CHAPTER 10

AIRMAIL IN NEBRASKA

In May 1918, the United States Post Office began experimenting with the use of airplanes to carry the mail. The service expanded slowly at first as everyone gained experience. Night flights began in February 1921; on February 22, Omaha airmail pilot Jack Knight became famous for his role in the post office's first around-the-clock, coast-to-coast flight. Knight's usual daylight route was from Cheyenne to Omaha. For the night experiment, he was scheduled to fly the leg from North Platte to Omaha, following the Platte River with the aid of huge bonfires at Lexington, Kearney, and Grand Island.

Omaha city lights guided him for the last forty miles. He landed at 11:10 p.m. and was greeted by an enthusiastic crowd of about two thousand spectators. But he received bad news from post office field manager William Votaw: the pilot for the next leg to Chicago was weathered-in in that city.

Votaw asked Knight if he would fly the 432 miles to Chicago. The weather forecast was poor, and Knight had never flown the route, even in good weather. Knight said he would do it if he had a map. Votaw could only find a road map. That was good enough for Knight.

He followed his compass to Des Moines, then flew through a snowstorm, following the railroad tracks to Iowa City. He refueled, ate a sandwich and napped while he waited for the weather to improve.

He took off again at 6:30 a.m. on February 23, arriving in Chicago at 8:40 a.m. The mail was transferred to a plane that carried it on to Cleveland and finally to New York City. Thus for the first time mail arrived in New York from San Francisco overnight.

This service did not become regular until July 1, 1924. It was nearly stopped before it started when a pair of severe storms (and possibly a tornado) struck Omaha on June 22, 1924. The storms demolished the airmail hangar and damaged the entire fleet of eleven planes at Ak-Sar-Ben Field (also known as Airmail Field and Center Street Field) at Sixty-fourth and Center streets. The airmail service was moved to Fort Crook, and in 1929 was moved again to the Omaha Municipal Airport, now called Eppley Airfield.

Between 1926 and 1928, the post office disbanded its aircraft fleet and contracted with private aviation

![A Boeing map showing the travel time from California to New York using different modes of transportation as they have developed.]

ELAPSED TIME REQUIRED FOR TRANSCONTINENTAL MAIL FROM STAGE COACH TO THE DAY OF THE AIR MAIL

1850 --- 24 Days
1860 --- 10½ Days
1876
1928 --- 100 Hrs
1928 --- 85 Hrs
--- 32 Hrs

A Boeing map showing the travel time from California to New York using different modes of transportation as they have developed.
RG3882-314

Jack Knight (left) and Clarence Lange dressed in the winter aviator's clothing issued by the United States Post Office, January 1922.
RG3882-266

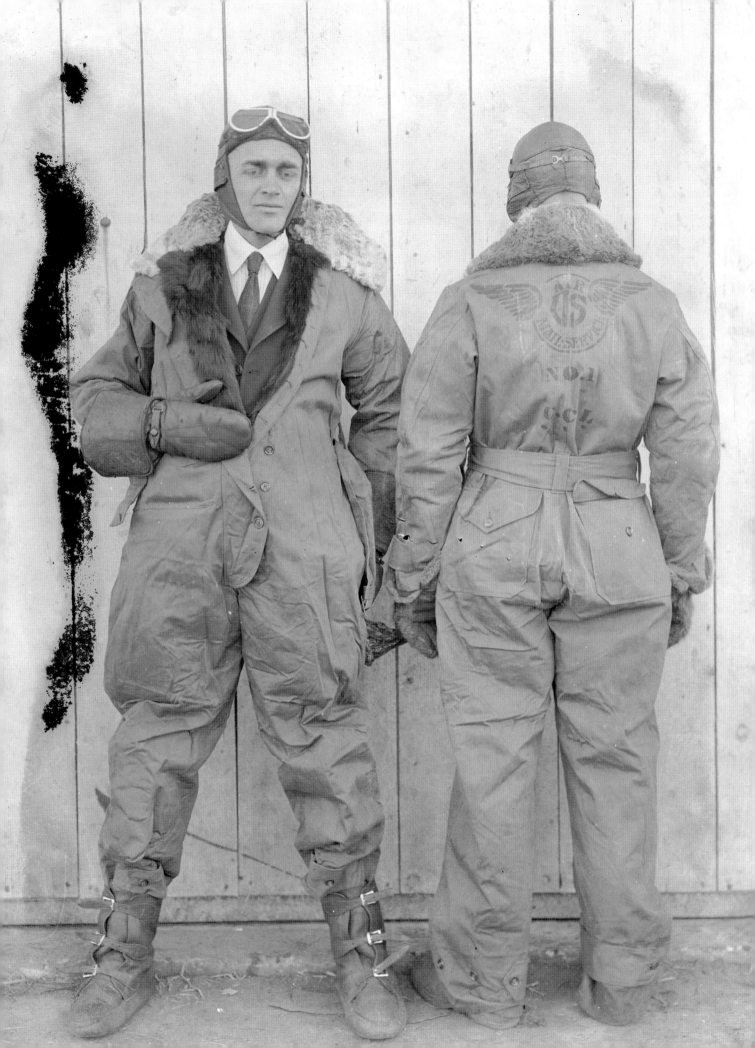

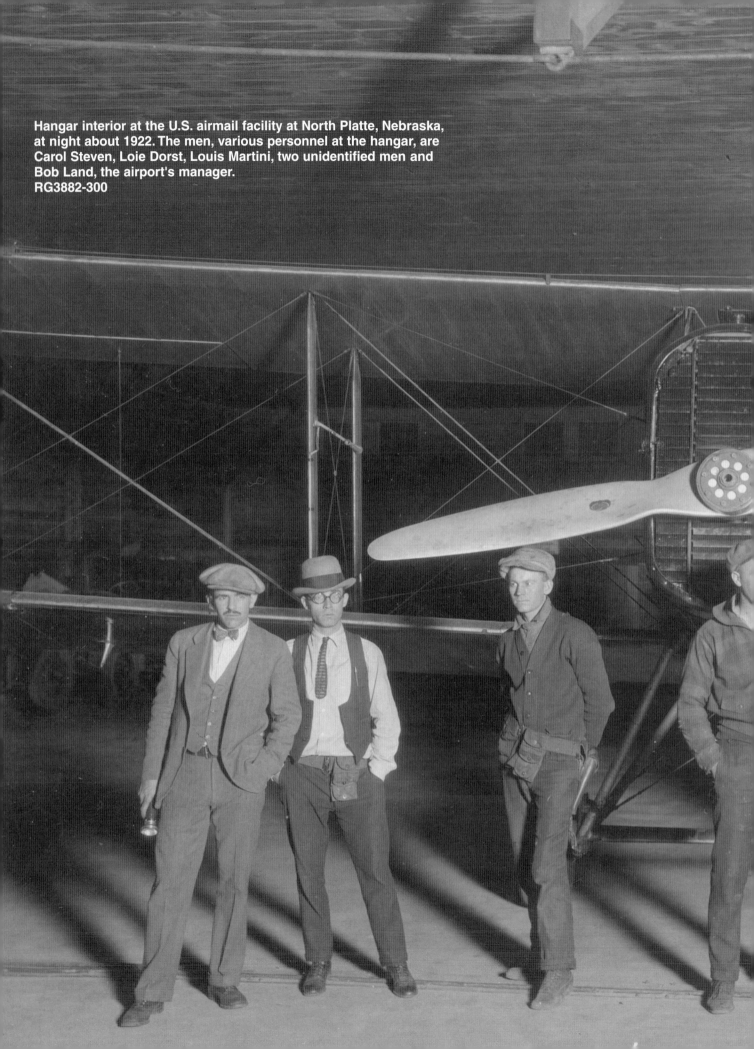

Hangar interior at the U.S. airmail facility at North Platte, Nebraska, at night about 1922. The men, various personnel at the hangar, are Carol Steven, Loie Dorst, Louis Martini, two unidentified men and Bob Land, the airport's manager.
RG3882-300

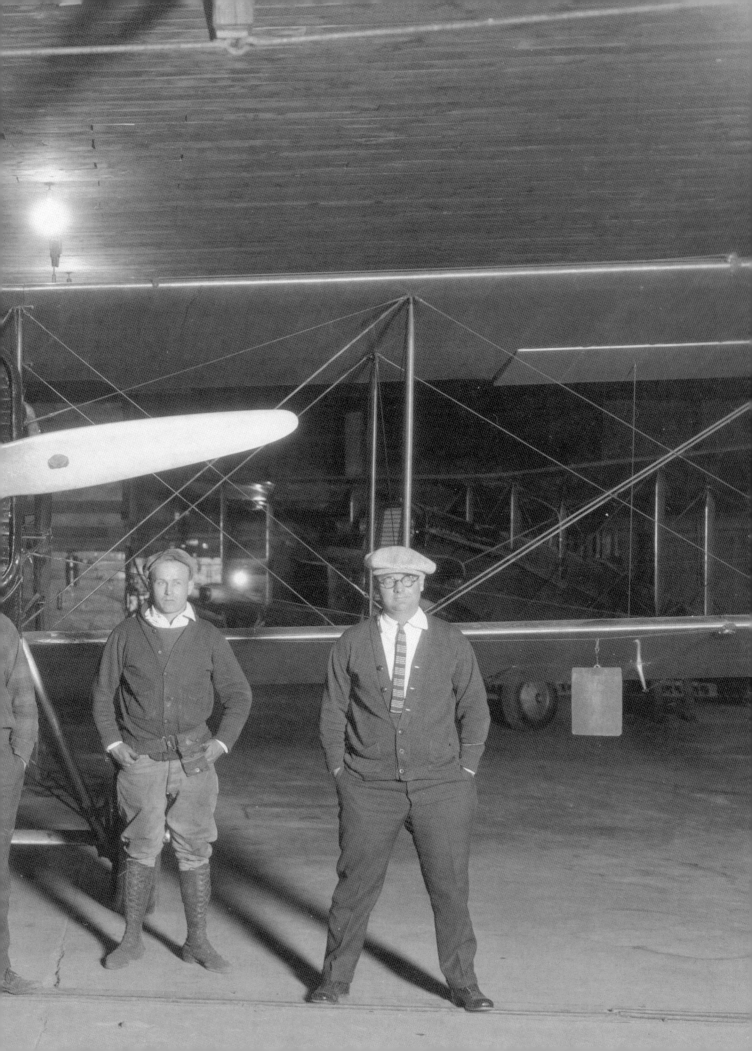

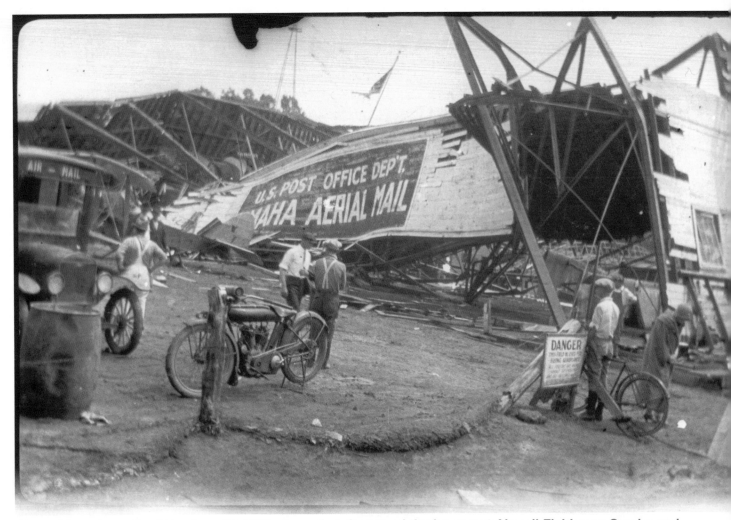

Above: The aftermath of the June 22, 1924, storm that destroyed the hangar at Airmail Field near Omaha and damaged all eleven mail planes just a week before the inauguration of the night mail service. RG3882-275

Below: What is probably a Lincoln Page airplane in front of the airmail hangar at North Platte around 1926. RG3474-4020

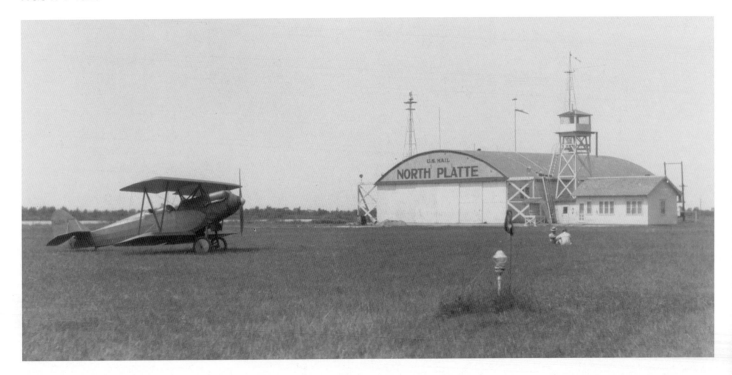

companies. Now, a rested pilot in a newly checked plane flew each leg of the route. The post office contracted with the Boeing Airplane Company to provide service on the east-west route that included Nebraska; as a result, Boeing flew regularly into Omaha and North Platte. Airmail service was pivotal in securing a bond issue that helped build the Omaha Municipal Airport.

The nation celebrated Airmail Week on May 15-21, 1928. It was the tenth anniversary of the first airmail route, which had connected New York City, Philadelphia, and Washington, D.C.

As part of the event, seven army planes from Fort Riley, Kansas, visited Omaha Municipal Airport. They flew high in formation over the city before landing at the airport, later flying on to Fort Crook. A number of organizations, including the American Legion, used Airmail Week to promote a $30,000 airport improvement bond issue.

A second Airmail Week was held in 1938. The main event occurred on May 19, when airmail service was provided to as many towns as possible nationwide. Nebraska enthusiastically joined the festivities. Towns located pilots, designated suitable airstrips, and designed commemorative envelopes with special images drawn or stamped on the paper.

That day 215 Nebraska towns sent out nearly four thousand pounds of airmail. The planes flew more than ten thousand air miles carrying mail from smaller towns to district hubs Omaha, Lincoln, Grand Island, and North Platte. Nebraska was one of the most involved states in the nation.

Airmail was also instrumental in bringing Boeing and United Airlines to Nebraska. The origins of the two companies are intertwined. Founder William Boeing was an aircraft builder and airline operator on the West Coast. When the U.S. Post Office turned the airmail service over to private contractors in 1927, Boeing began airmail and commercial air service between Chicago and San Francisco. This route soon connected with National Air Transport, which served

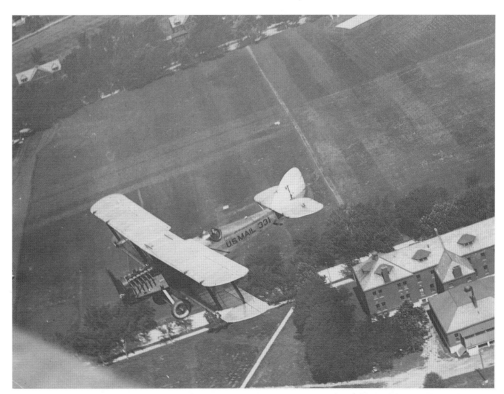

A U.S. Airmail De Havilland DH-4 circles over Jarvis Offutt Field, Fort Crook, Nebraska, about 1927. The airmail service moved to Fort Crook after a storm demolished the hangar near Ak-Sar-Ben. RG2929-149

the Chicago-to-New York route. Together, Boeing and National provided the first transcontinental passenger service.

In October 1928, the Boeing Airplane–Transport Corporation acquired Pacific Air Transport, Boeing Air Transport, and Boeing Airplane Company. In early 1929, the corporation changed its name to United Aircraft and Transportation Corporation and added several manufacturing subsidiaries.

Aircraft technology was advancing rapidly. Boeing used its Model 40, which could carry four passengers along with the mail, into the late 1920s. By 1929, it

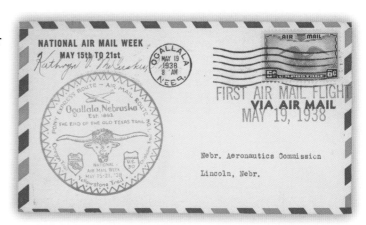

Nebraska towns celebrated National Airmail Week by creating their own unique airmail cachets (envelopes). This one is from Ogallala, Nebraska. NSHS 7121

A Douglas M-2 U.S. Air Mail plane at Fort Crook after 1924. The pilot is probably Lee F. Duncan.
RG3882-310

A mechanic adjusts the night flight lights on a De Havilland DH-4 at Fort Crook on July 1, 1924, the first night of night airmail.
RG3882-280

A United Airlines Boeing 247 getting serviced at Omaha's Municipal Airport in the early 1930s.
RG3882-368

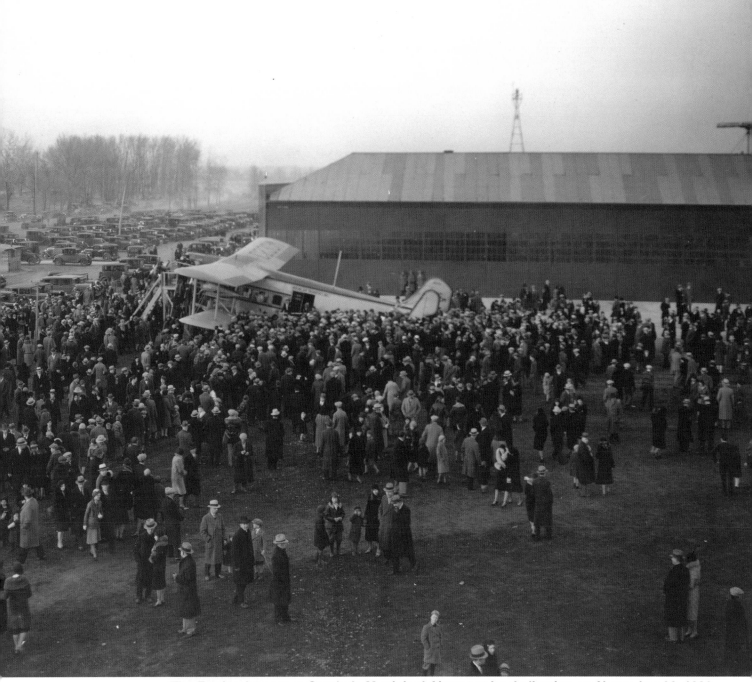

The Boeing hangar at Omaha's Municipal Airport at its dedication on November 30, 1930.
RG3882-351

had replaced the Model 40 with the Model 80, a picturesque tri-motor biplane. In 1930, it introduced the world's first stewardess service between San Francisco and Chicago.

In 1934, a Senate investigating committee charged that the U.S. Post Office had been influenced by large airline companies eager to control the awarding of the more lucrative mail routes. As a result, Congress passed the 1934 Air Mail Act prohibiting commercial airlines from owning aircraft or equipment manufacturing companies; United Air Lines became an independent airline company and Boeing became a separate manufacturing company.

Also in 1934, the Boeing 247 began replacing the Model 80. The 247 was the first modern commercial passenger plane, with twin engines, retractable landing gears, and an all-metal monocoque fuselage that greatly increased passenger comfort.

But the 247 had a short life as a commercial airliner. The Douglas Company soon introduced the DC-2 and then the famous DC-3. The latter could carry twenty-one passengers with greatly increased safety, speed, economy, and comfort. It became the dominant passenger airliner for the next decade, and as the legendary C-47 was the dominant military transport during World War II.

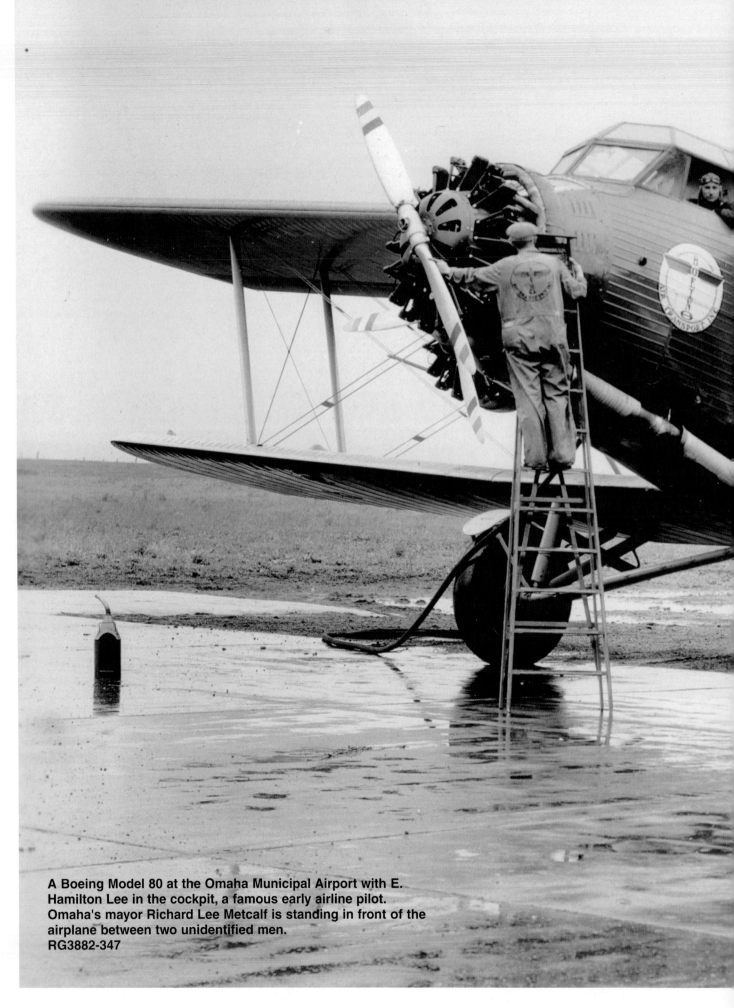

A Boeing Model 80 at the Omaha Municipal Airport with E.
Hamilton Lee in the cockpit, a famous early airline pilot.
Omaha's mayor Richard Lee Metcalf is standing in front of the
airplane between two unidentified men.
RG3882-347

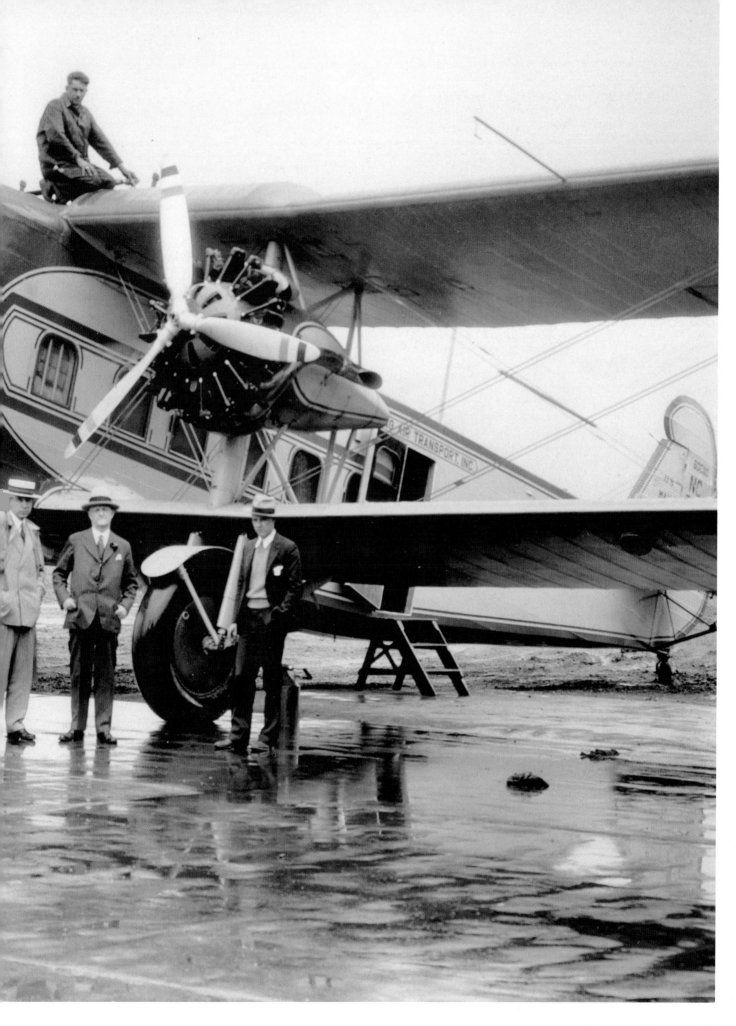

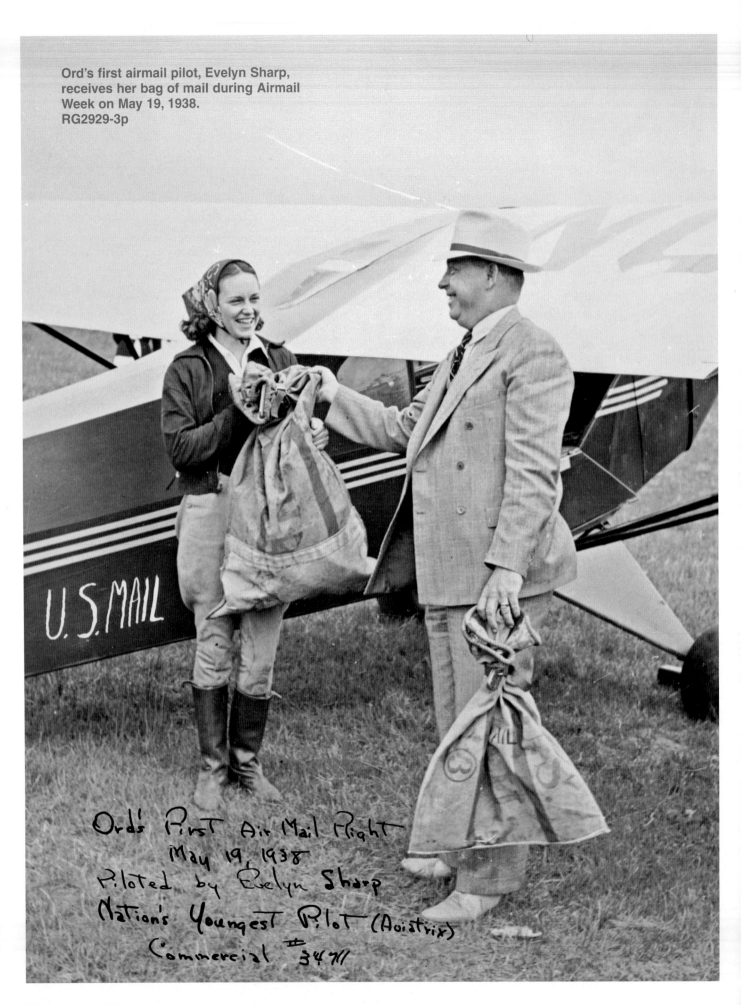

Ord's first airmail pilot, Evelyn Sharp, receives her bag of mail during Airmail Week on May 19, 1938.
RG2929-3p

Ord's First Air Mail Plight
May 19, 1938
Piloted by Evelyn Sharp
Nation's Youngest Pilot (Aviatrix)
Commercial #34711

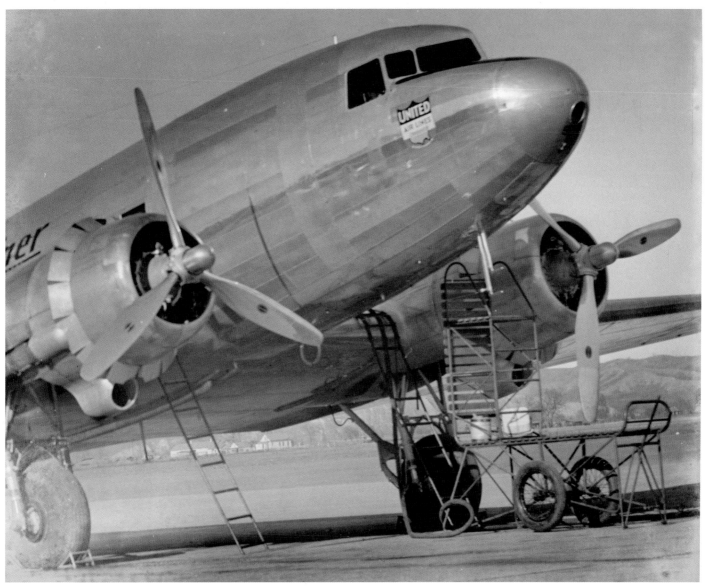

Front view of a Douglas DC-3 being serviced in Omaha.
RG3882-373

The first airmail in Crawford, Nebraska, was during Airmail Week on May 19, 1938. The men standing in front of the plane are, from left to right, Walter (Pop) Barnes, Dr. B. F. Richards, Earl Mahlman, Raymond Taggert, George Scott (postmaster), Pat Patterson, Jim Warren (pilot), and Earnest Martin.
RG3671-5-8

CHAPTER 11

OMAHA MUNICIPAL AIRPORT (EPPLEY AIRFIELD)

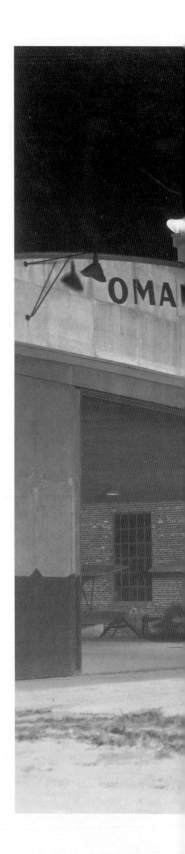

Charles Lindbergh's triumphant cross-country tour after his New York-to-Paris flight helped Omaha begin a major municipal airport. Land had been purchased in 1925 for this purpose; in 1927 the American Legion began a fund drive to raise $30,000 to build a hangar and improve the field near Carter Lake. The drive proceeded slowly and was still well short of its goal until Lindbergh's visit in late August 1927. With the excitement his visit created, the goal was reached and the hangar built. A second hangar soon followed, and Boeing built a third in 1930 when it moved its airmail and passenger service from Fort Crook to the Omaha Municipal Airfield (now Eppley Airfield). A modern passenger terminal was built in 1933.

The airfield saw much activity in the late twenties and early thirties. It was a stop on the Ford Reliability Tour in 1927. These tours promoted aviation, giving aircraft companies an opportunity to demonstrate their

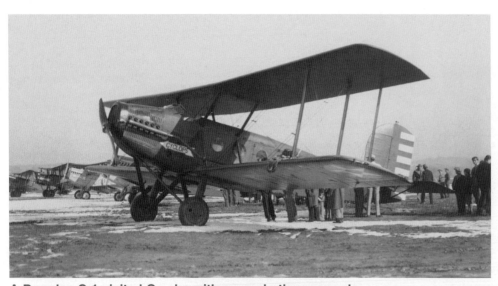

A Douglas C-1 visited Omaha with several other army planes on November 4 and 5, 1928.
RG3882-39

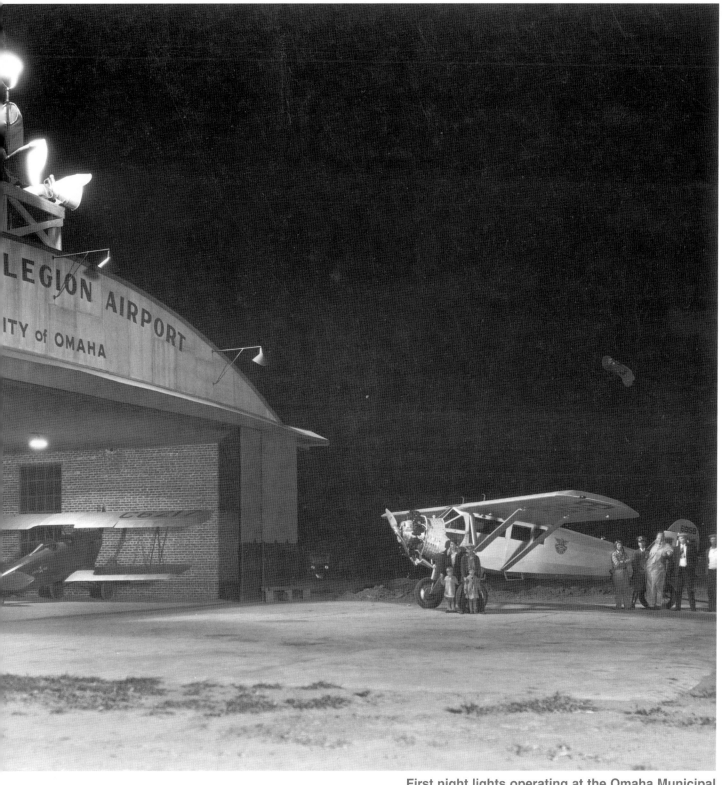

First night lights operating at the Omaha Municipal
Airport in August 1928. A Travel Air is in the hangar
and a Ryan Brougham is outside.
RG3882-612

In July 1927, a Waco 10 "Crosley" visited Omaha
as part of the Ford Reliability Tour.
RG3882-610

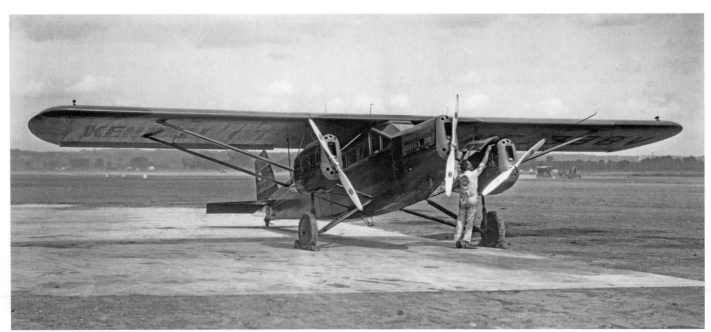

The Odgen Osprey was powered by three American Cirrus engines and was the fourth place finisher in the All American Flying Derby, a 1930 race sponsored by the American Cirrus Engine Company to promote their engines, which were the only ones allowed in the race. This race is claimed to be the longest air race ever held in this or any other country. The Ogden Osprey was the only three-engine plane in the race. RG3882-635

This glider, pictured here on August 16, 1929, was built by the Nebraska Sailplane Club at the Municipal Airport in Omaha. Brandeis was a major department store in Omaha. The glider was designed by Alexander Lippisch in Germany in 1926. Later, during World War II, Lippisch became famous for designing the Messerschmitt (Me) 163 Komet, a rocket-powered fighter plane. After the war, he immigrated to the United States as part of Operation Paper Clip, a program to bring leading German aviation scientists to the U.S. RG3882-506

new planes, engines, and other developments to people around the country in a well-publicized contest. The Omaha field was also the starting and finishing point for Nebraska Air Tours that promoted aviation and Omaha commercial interests.

Even famous pilots such as the French aviators Costes and Bellonte stopped in Omaha after their east-to-west, Paris-to-New York flight in 1930. Because of prevailing winds, crossing the Atlantic east-to-west was more difficult than flying west-to-east. Flying against the prevailing wind was very difficult for the planes of the time, as they needed more fuel capacity and flight time was substantially increased.

Commercial photographer Nathaniel Dewell captured most of the activity at the airfield, as he was onsite with his camera when anything of importance was happening. From the early 1920s to the mid-1940s he photographed flying activity at Ak-Sar-Ben Field, Fort Crook, Offutt Field, Steele Field, and the Municipal Airport with a series of almost seven hundred excellent pictures. Omaha's location, as well as aggressive promotion by the Chamber of Commerce and other business interests, helped generate many types of flying in that time.

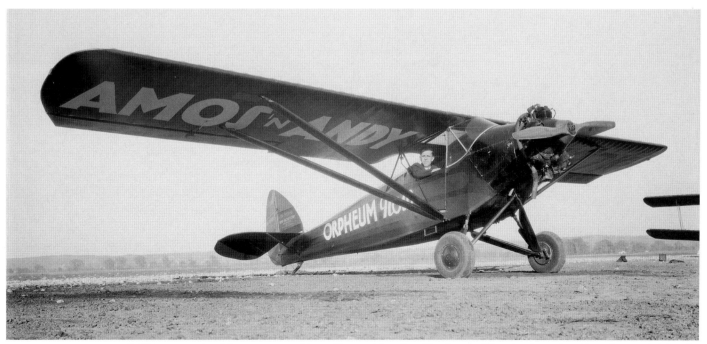

A Monopup by Monocoupe Aircraft used by the Orpheum Theater to advertise Amos 'n' Andy, a popular radio show, in October 1930. RG3882-1-63

An Aeronca C-2, February 13, 1930. The pilot is
E. J. Standring.
RG3882-1-653

This Lockheed Sirius, owned by Shell Oil Company and piloted by Capt. Gil Erwin and Capt. John A. Macready stopped at Omaha Municipal Airfield September 4, 1930. They were returning from the Chicago Air Races, where Macready had been injured in a crash the previous week. In 1923, Macready and Lt. Oakley Kelly made the first non-stop flight across the U.S. in 26 hours, 50 minutes.
RG3882-627

A De Havilland Gypsy Moth equipped with both pontoons and wheels lands on Carter Lake on June 3, 1930. Pilot Rusty Campbell said the plane was used by sportsmen to reach places otherwise inaccessible.
RG3882-648

Dieudonné Costes and Maurice Bellonte, French aviators, being greeted by Omaha officials on September 22, 1930. The Frenchmen had successfully flown across the Atlantic Ocean from east to west from France and landed in New York on September 2, 1930. They then toured the United States in their Breguet airplane.
RG3882-1-653

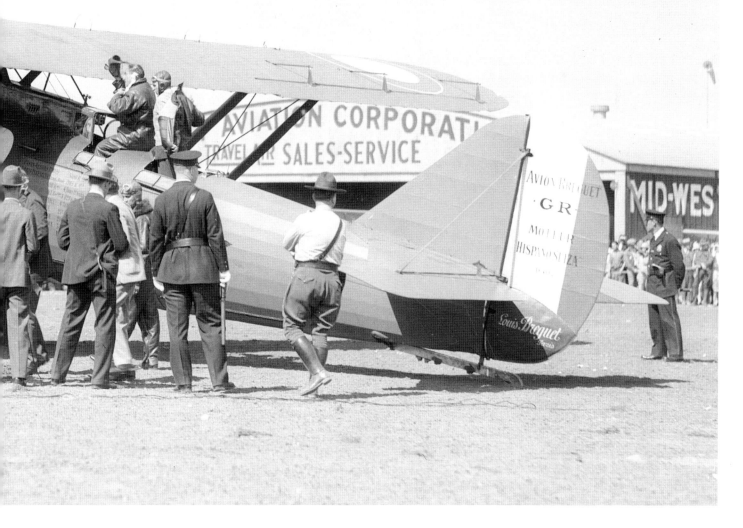

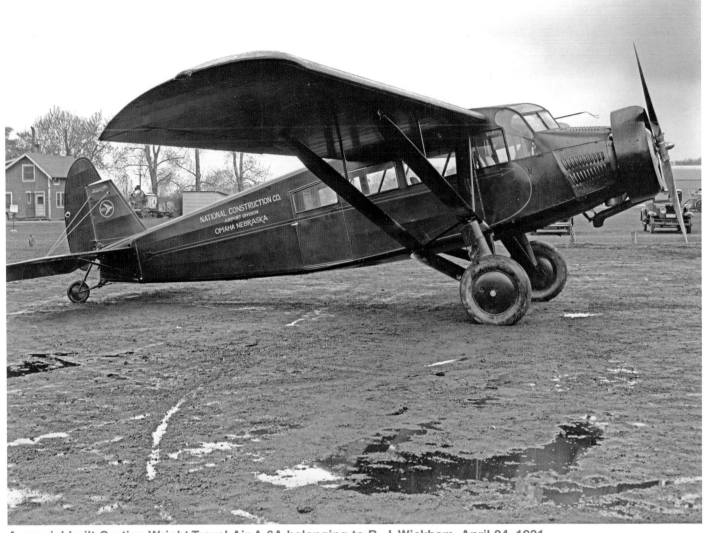

A special-built Curtiss-Wright Travel Air A-6A belonging to B. J. Wickham, April 24, 1931.
RG3882-510

Omaha Municipal Airport Terminal Building was built in 1933 to accommodate the increased number of passengers on commercial airlines.
RG3882-622

Beacon light at the Omaha Municipal Airport on November 20, 1930. RG3882-619

A demonstration of a new air ambulance service in a Fairchild F-24 at the Omaha Municipal Airport in the 1930s. Heafy & Heafy was better known as a longtime Omaha mortuary. RG3882-1-633

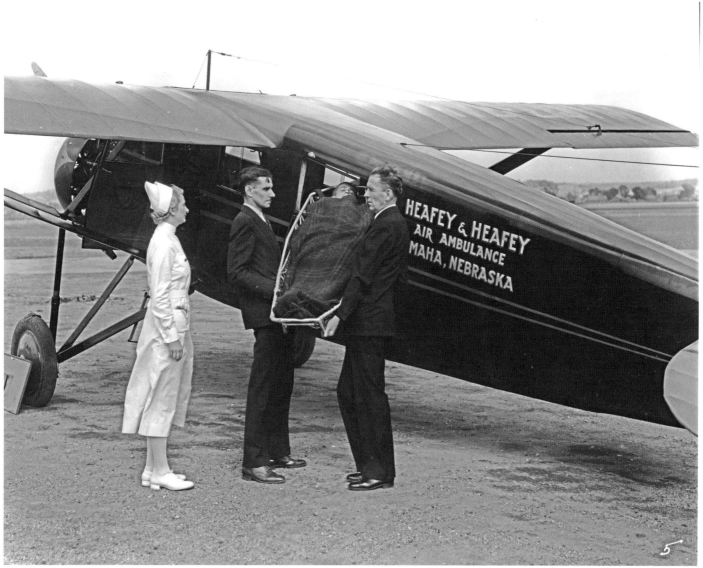

CHAPTER 12

OMAHA AIR SHOWS

Glenn H. Curtiss opened the Midwest Aviation Meet on July 23, 1910, with the first successful airplane flight in Nebraska. Curtiss brought three airplanes, and for five days he and his pilots thrilled Omaha crowds that gathered on the northwest corner of Forty-fifth Street and Military Avenue. In addition to airplanes, two men parachuted from hot-air balloons, and Fort Omaha's army balloon school also participated in the meet. First-day attendance exceeded seven thousand; the second day the crowd was estimated at ten thousand spectators.

World War I put a halt to most large-scale air shows. The Omaha International Air Congress of 1921 was the state's first big flying event after the war. It hosted the Pulitzer Race, a triangular race that awarded a trophy and three thousand dollars

This Jenny, probably piloted by E. M. Laird, has a stunt man hanging from the landing gear at the Omaha Air Congress in November 1921.
RG3882-3

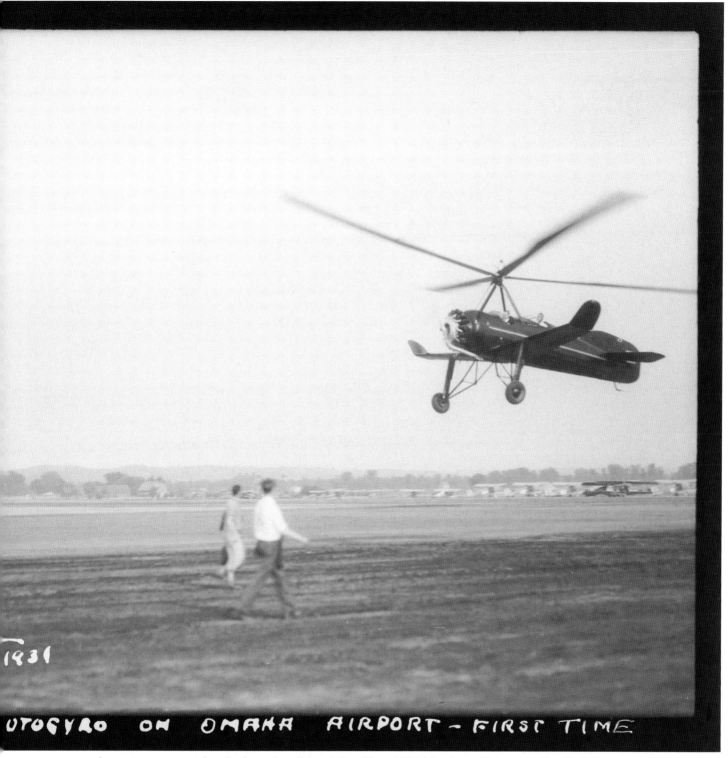

1931

UTOGYRO ON OMAHA AIRPORT - FIRST TIME

An autogyro coming in for a landing at the May 1931 air show. This was the first time an autogyro had been to the Omaha airport.
RG3882-538

to the winner. The race was held at Twenty-fourth and Reed (the area that later became Steele Field). Dempster windmill towers served as pylons marking the triangular race course. The first pylon was set at the main field, the second at Fort Calhoun, and the third across the Missouri River at Loveland, Iowa.

In addition to the Pulitzer Race, which was open to any kind of plane, the Air Congress included other triangular races limited to certain classes of planes, plus aerobatics, spot landings, and wing walking. In all, thirty-seven planes participated in this great event held in what is now an industrial area in north Omaha. The event featured famous pilots of the day such as Matty Laird (a designer of airplanes), Col. Harold E.

Pilot T. C. Legue of Des Moines was unhurt after nosing-in his JN-4 (Jenny) at the Omaha Air Congress in November 1921.
RG3882-4

Hartney (Capt. Eddie Rickenbacker's commanding officer during World War I), and pilots famous for their showmanship, including Bert Acosta, Clarence Coombs, and J. A. Macready. Spectators included Rickenbacker and French general Marshal Foch—both had come up from an American Legion convention in Kansas City.

The Air Congress was marred by the death of Harry Elbe, a parachutist who drowned when he landed in the Missouri River. Spectators saw him come down; according to reports at the time, observers rushed to a nearby rowboat hoping to rescue Elbe, but couldn't find the oars.

Elbe was not the event's only casualty. Col. H. E. Hartney broke his hip in the crash of his Thomas-Morse monoplane, and four young women passengers were injured when their Ashmusen "Blue Bird" crashed shortly after takeoff. One of them had to have part of her leg amputated.

Omaha went on to hold large and successful air shows at the Municipal Airport in 1931, 1932, and 1934 (it isn't clear why there was no 1933 event). These events featured pylon racing (a fifteen-mile

A Rapid Airlines sound truck for the May 15, 1931, air show.
RG3882-546

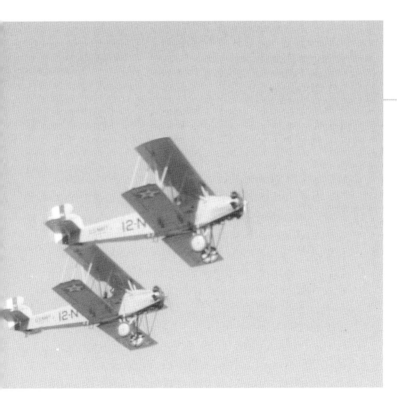

Navy Great Lakes trainers flew in from St. Louis for the air show on May 15, 1931, in Omaha.
RG3882-546a

A U.S. Army Air Corps Boeing P-12 coming in to land at the May 1931 air show.
RG3882-537

Dorothy Hester, age twenty, before setting a new world record by flying sixty-nine outside loops at the 1931 air show.
RG3882-160

triangular course), dead stick landings, balloon busting and bombing contests (using flour bags for bombs), autogyro flights, wing walking, and many spectacular rolls and dives. One of the most popular attractions at Omaha air shows was the Pitcairn autogyro flown by Johnny Miller. This forerunner of the helicopter amazed the crowd with its short takeoffs and landings.

The 1931 show featured some of the biggest names in aviation, such as Dorothy Hester, Tex Rankin, Maj. Clarence Tinker, and Charles "Speed" Holman. Hester, a twenty-year-old student

Two racers approach a pylon of the triangular race course during the May 15, 1931, air show. RG3882-534

of Tex Rankin, flew fifty-six inverted rolls (snap rolls), and next day flew sixty-two inverted loops to set a women's record that was not broken until 1989.

Rankin himself was a great showman, using the number thirteen on his planes as if to challenge fate. He won the U.S. Aerobatic Championship in 1936; two years later he won the International Aerobatic Championship. Major Tinker led the U.S. Army Air Corps Twentieth Pursuit Group of fifty-six Boeing P-12s to the meet in Omaha in 1931, which was a very large group of planes for the time. By 1942, Tinker had become a major general and was in

command of the newly created Seventh Air Force. Soon after, his B-24 crashed into the sea while he was leading a bombing mission near Midway Island on June 6, 1942, killing all on board. Tinker Air Force Base in Oklahoma City is named in his honor.

Spectators at the 1931 air show also witnessed the fatal crash of Charles "Speed" Holman as he flew his Laird Speedwing inverted over the field. Holman was Northwest Airlines' first pilot and had become the operations manager. He had won the prestigious Thompson Trophy at the National Air Races in Chicago in 1930 and had garnered many other

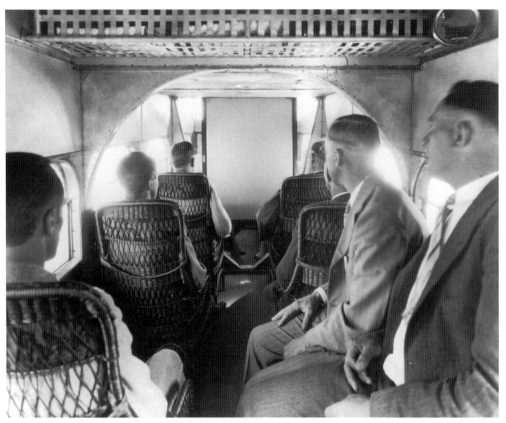

In-flight movies have a long history. This is the interior of a Ford Tri-Motor that is equipped with a movie screen on August 31, 1928.
RG3882-552

Omaha Municipal Airport during the May 1931 air show. The many cars and airplanes demonstrate the event's popularity.
RG3882-135

trophies for his aerobatic flying.

Ten-year-old Wallace Peterson was in the stands that day and later wrote about the crash for a 1998 issue of *Nebraska History*:

"Like every other spectator on that warm May afternoon, my eyes were locked onto Holman's

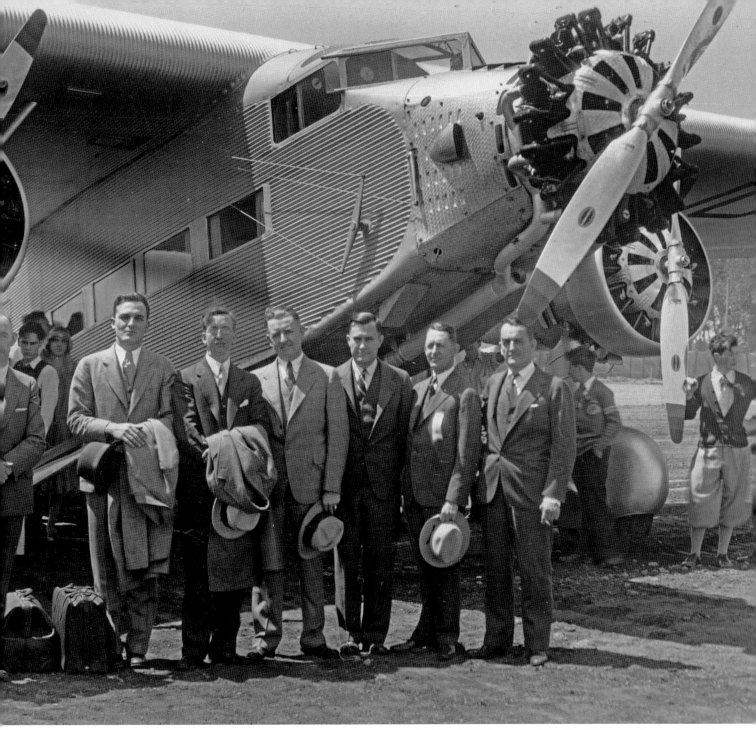

A group of dignitaries around a Ford Tri-Motor at the Air Show on May 16, 1931.
RG3882-67

biplane as he dove repeatedly to within a hundred feet of the ground, roared past the grandstands at around 250 miles per hour, and then zoomed and rolled high into the sky, only to turn in a hammer-head stall and start another descent. Holman and his plane were only a hundred feet or so away from the spectators when flying level after each dive.

"Holman started his last dive north of the field, flying downwind to give the spectators the illusion of even greater speed, rolling the Laird upside down when perhaps three hundred feet in the air. He clearly

intended to roar past the grandstands upside down, giving the crowd, as he told some fellow pilots before the flight, a "special thrill." He never made it.

"As the plane rolled over, everyone came to their feet, blocking my view so I did not see the final crash. But I heard it—it was like a great pop, as if a gigantic light bulb had been dropped onto concrete! For a moment there was absolute silence, as a cloud of dust rose from the spot of the crash. There was no fire."

The cause of the crash remains unknown.

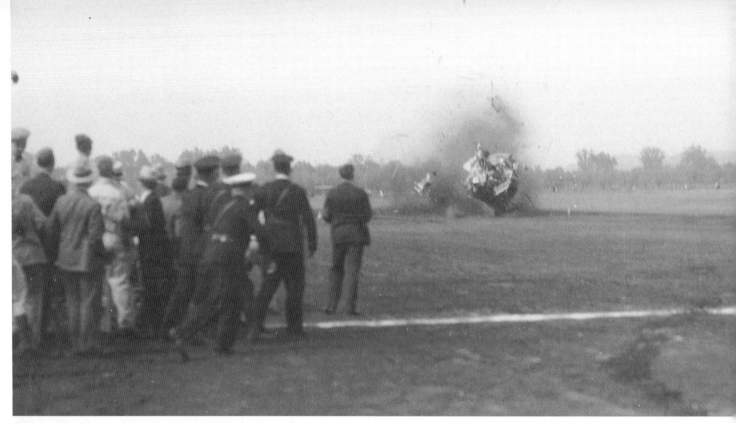

Charles W. (Speed) Holman was killed when his Laird Speedwing crashed while flying low and inverted over the field. Holman, a pilot and manager for Northwest Airlines, was a famous racer and stunt pilot.
RG3882-567

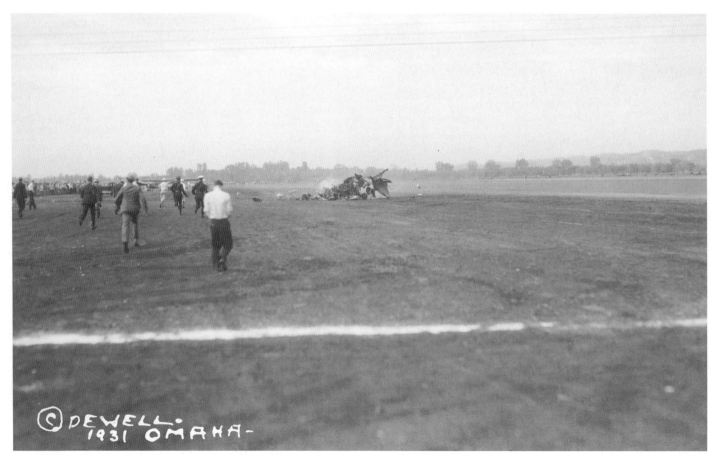

Moments after the initial crash when the plane came to rest on the field.
RG3882-547

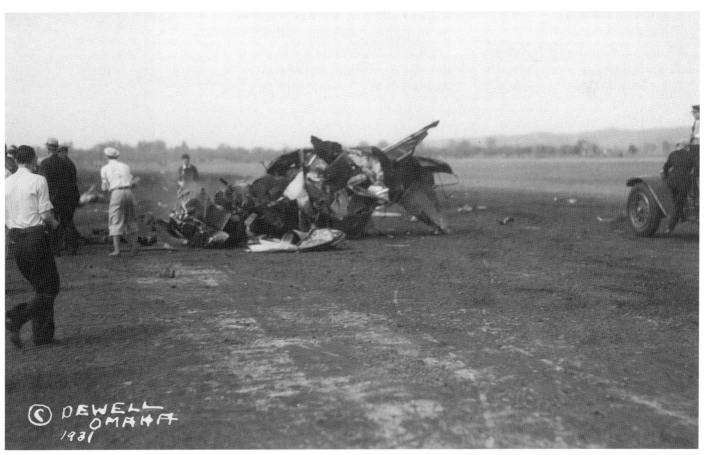

The wreck of Speed Holman's airplane.
RG3882-536

NEBRASKA'S WORLD WAR II AIRFIELDS

As the United States moved closer to entry in World War II, the U.S. Army Air Forces began studying the problem of where to provide flight training. Both the East and West Coasts were considered vulnerable in time of war, so it was best to look inland.

In studies conducted in 1940 and 1941, the USAAF found Nebraska ideal for military training purposes. The state had excellent year-round flying conditions, was lightly populated, and had inexpensive and relatively level land, reliable railroad lines, and strong public utilities.

Once the U.S. entered the war, air bases soon began popping up all over the Cornhusker State. The USAAF used twelve airfields in Nebraska during the war, building most from scratch. The sites were strategically located across the state, with Offutt Field at Fort Crook near Omaha in the east, Scottsbluff in the west, Ainsworth to the north, and McCook to the south.

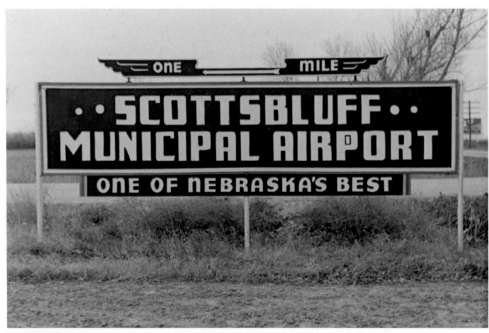

Scottsbluff Municipal Airport entrance sign.
RG2528-06-26

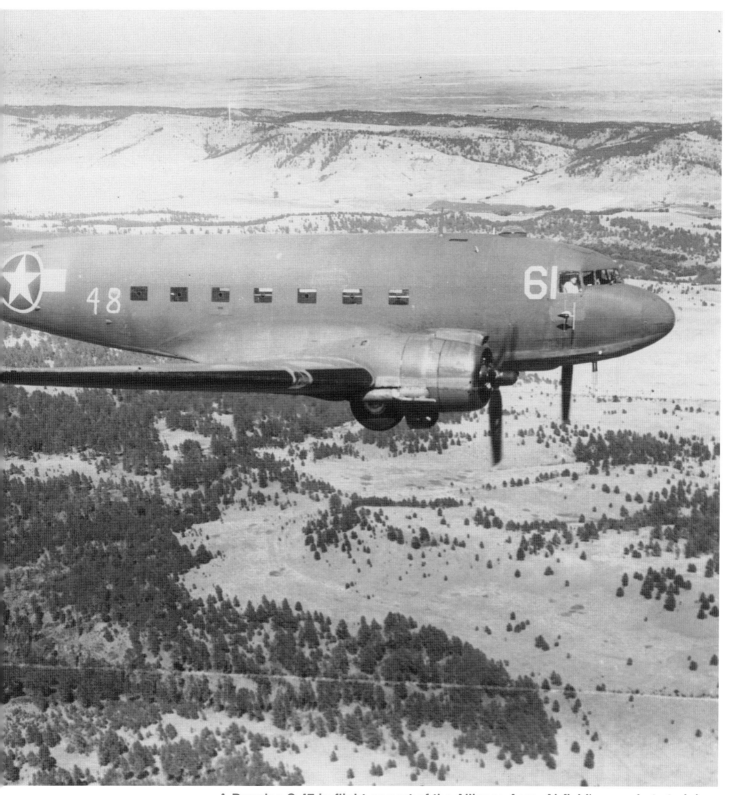

A Douglas C-47 in flight as part of the Alliance Army Airfield's parachute training.
RG1805-4

Though each airbase showed a certain amount of military uniformity, each had distinct characteristics and duties. In 2000, the Nebraska State Historical Society and the Nebraska Department of Aeronautics collaborated on a two-year project to document what remained of the former air bases. This partnership resulted in two survey reports, *Aviation Development in Nebraska* (the resource for this chapter) and *General Aviation in Nebraska*. The reports contain both historical details and inventories of the air bases in 2000; they are available online at nebraskahistory.org/histpres/reports.

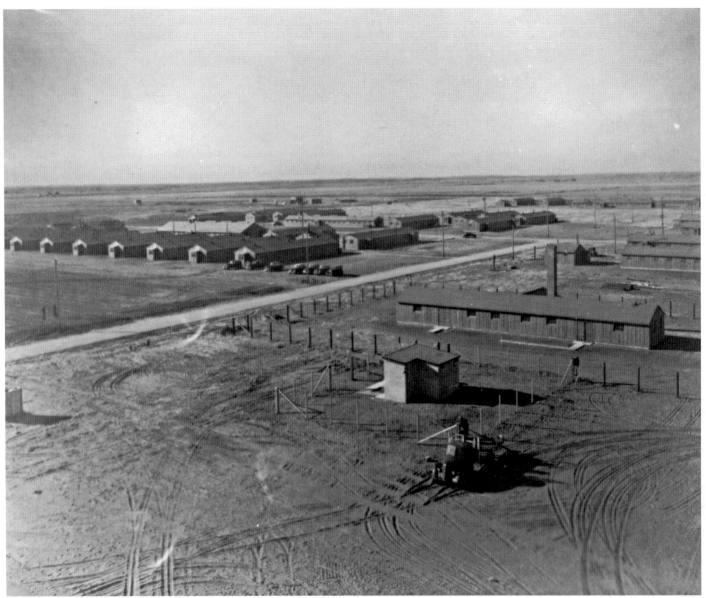

Above: Ainsworth Army Airfield, looking southwest from control tower.
RG3183-01-08

Below: Truck fill stands at gasoline storage at Ainsworth. RG3183-01-16

Ainsworth Army Airfield

The Ainsworth Army Airfield was built between August and November 1942 seven miles north of Ainsworth. The 2,403-acre site was acquired through condemnation and purchase from seven local landowners. Like other army airfields, its buildings were designed to be temporary and were made as cheaply as possible. Metal was scarce, so most were built of wood, concrete, brick, gypsum board, and concrete asbestos.

The government hired two hundred Native Americans from the Pine Ridge Reservation in South Dakota; other laborers came from as far away as Omaha and Sioux City, for a total of around 1,200 workers.

The base's main purpose was to train aircrews of the 540th and 543rd Bombardment Squadrons of the 383rd Bombardment Group based out of the Rapid City Army Airfield. The troops trained with Boeing B-17 aircraft before being sent to the European Theater. Bomber crews practiced bombing runs over the wildlife refuge in Cherry County. Later, the military conducted aircraft camouflage experiments at the field. In addition, one of the reinforced concrete buildings with vault-like metal doors was used to store the highly secret Norden bombsight, a mechanical analog computer that greatly improved bombing accuracy. Just before flights, the sight was taken from its storage building and loaded onto the plane under armed guard. Bombardiers swore an oath to protect its secrecy.

Ainsworth Army Airfield was then declared surplus property in 1948 and the city of Ainsworth received the title. Today it is the Ainsworth Municipal Airport.

Ainsworth Airfield control tower.
RG3183-01-21

View of Ainsworth barracks. RG3183-01-20

Alliance Army Airfield

The 4,205-acre Alliance Army Airfield was built between the summer of 1942 and August 1943 on a dry lake bed three miles southeast of Alliance. During construction, over five-thousand workers poured into the city of 6,669 people, severely taxing the available housing options. The workers moved into garages, storerooms, cellars, attics, and some even brought their own trailers. Housing became such a problem that the government built a housing project at the east end of town, known as "Chimney Town" because of the rows of chimneys along the rooflines.

On August 22, 1943, a crowd of sixty-five thousand Panhandle residents gathered for the dedication of the Alliance Army Airfield. The facility was immense. The housing area covered 1,088 acres and supported 775 buildings. It had its own railroad spur, and especially long runways because the base was planned as a training facility for paratroops and air commandos, which needed long runways for C-47s to tow gliders. The army chose the Sandhills for paratroop training because the grasslands provided a softer landing than wooded areas. As many as 14,000 paratroops were in the area before the spring of 1944.

After the paratroops left Alliance, the Second Air Force used the Alliance base in the fall of 1944 to train B-29 aircrews. In the summer of 1945, the Troop Carrier Command returned to the base to train for the proposed invasion of Japan, which was cancelled when Japan surrendered on September 6.

Despite speculation that the army would make the huge base a permanent installation, it was closed permanently and declared surplus property by December 1945. The site eventually became the Alliance Municipal Airport.

Bruning Army Airfield

On September 12, 1942, the federal government sent notices to twelve landowners east of Bruning, informing them they had ten days to move off their farms, removing livestock, farm equipment, feed and all possessions, and leaving crops in the fields. They were compensated approximately $50 an acre. The government moved some of the vacated farm buildings and houses and demolished others. The 1,720-acre base was dedicated August 28, 1943. It stationed four thousand military personnel and eight hundred civilian employees at its peak.

Bruning Army Airfield was a major training center for bomber crews and fighter pilots. Twelve bombardment squadrons and nine fighter squadrons completed proficiency training at the field before going overseas for combat assignments. In addition, Bruning conducted complete engine and airframe repairs for the B-24 bombers and P-47 fighters attached to the base.

After the war, Bruning became a state airfield until 1969. The property is now closed to traffic and is leased to local farmers and a cattle feedlot company.

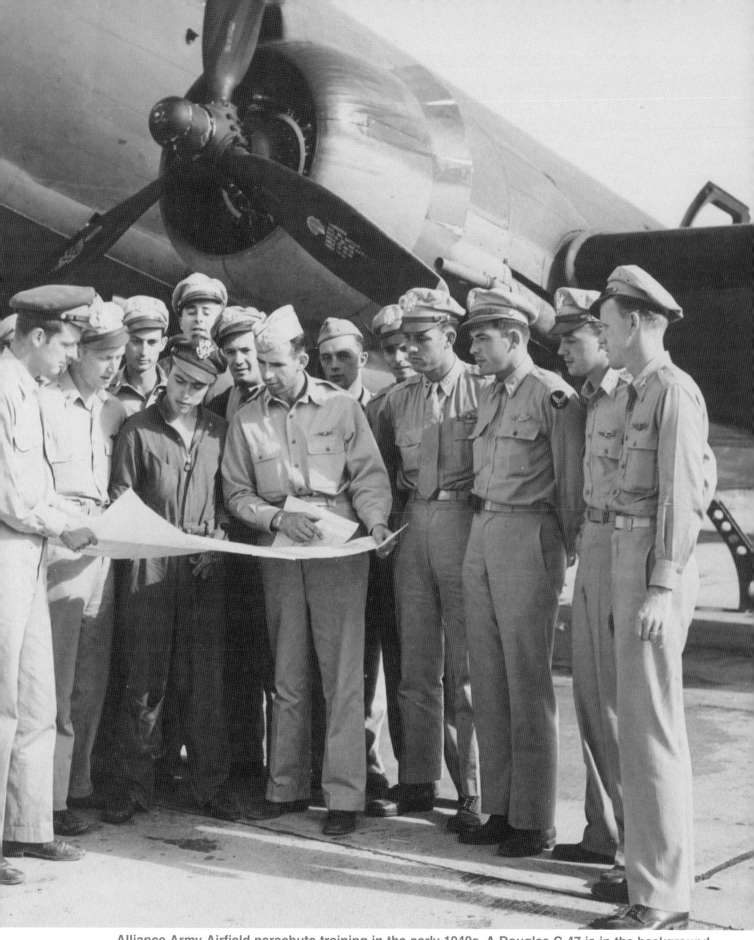

Alliance Army Airfield parachute training in the early 1940s. A Douglas C-47 is in the background.
RG1805-1

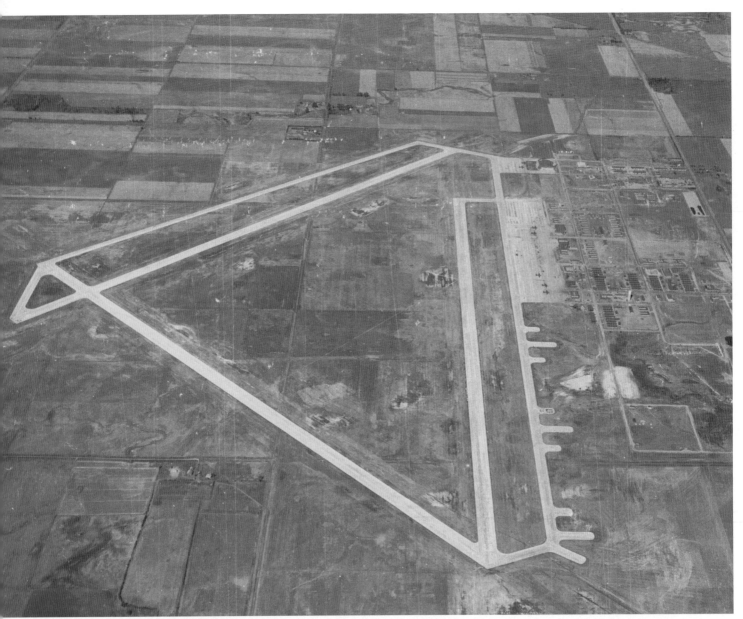

Fairmont Army Airfield. RG33360-02-27

Fairmont Army Airfield

Construction on the 1,844-acre Fairmont Army Airfield began in September 1942. Approximately a thousand laborers built the base, causing difficulties for nearby towns Geneva and Fairmont to find housing for the workers. When complete, the base provided quarters for thirty-seven hundred officers and enlisted men. The first military personnel arrived in November 1942.

The base began as a satellite base of the Topeka Army Air Base in Kansas, but by early 1943 became a major training installation for twenty-seven bombardment squadrons of the Second Air Force, along with bomber repair facilities and a 350-bed hospital.

One of the groups that trained at Fairmont was the 383rd Squadron of the 504th Bombardment Group.

From this group, Lt. Col. Paul Tibbets selected his crew for the *Enola Gay*, the B-29 that dropped the first atomic bomb on Hiroshima, Japan. (The plane itself was built at the Martin Bomber Plant in Bellevue, Nebraska.)

The airfield is still in use today as a state-owned civilian airport.

Fort Crook Army Airfield/Offutt Field

See Chapter 15.

Grand Island Army Airfield

Northeast of Grant Island, Arrasmith Airport became part of the Grand Island Army Airfield in 1942. Bomber aircrews trained there in the early part of the war; later, the field was a staging area for bomber crews preparing for assignments in Guam and

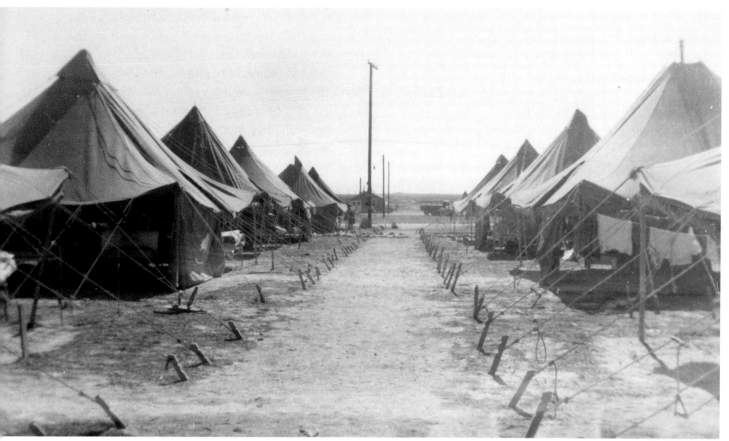

Harvard Army Airfield, 1945. RG3025-20

Tinian in the Pacific Theater of Operations. The base also offered major engine and airframe repair facilities for B-17 and B-29 bombers. One bombardment training wing and three bombardment groups were attached to Grand Island during the war.

Shortly after the war, the city of Grand Island acquired the airfield from the federal government for use as a municipal airport and industrial park.

Harvard Army Airfield

The community of Harvard received word on September 2, 1942, that a satellite army airfield would be located three miles northeast of the town. Farmers living on the 1,074 acres designated for the base were removed by September 17. The base was mostly completed by November 19, and military personnel began arriving in December.

Harvard soon became more than a satellite base. Though it was the smallest of the Nebraska army airfields, it became a major training center for bomber crews of the Second Air Force. Between August 1943 and December 1945, twenty-six bombardment squadrons received proficiency training at Harvard. The base also had repair facilities for B-17, B-24, and B-29 bombers.

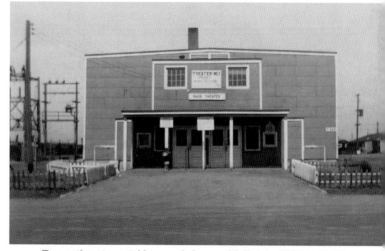

Base theater at Harvard Army Airfield. RG3025-08

After the war the land was turned over to the state of Nebraska. Since that time, area farmers have leased the land from the Department of Aeronautics for agricultural purposes, and the hangars are used for grain storage.

Kearney Army Airfield

Planning for the Kearney airbase began before the U.S. entered the war. In the early 1940s, Kearney, Grand Island, and Hastings formed the Central Nebraska Defense Council to convince Washington

that central Nebraska was a suitable location for defense-related activities.

Kearney and Grand Island competed with one another as locations for defense airports, which would serve as storage for aircraft being produced at Offutt Field and the Glenn L. Martin Bomber Plant near Omaha. Kearney began building its airport on October 21, 1941.

Keens Airport was dedicated the following August, but the army decided it was inadequate for military operations. In October, a thousand laborers were brought in to build a new airfield adjacent to Keens.

Construction proceeded at a frantic pace. Four hundred men were served in the first mess hall just five days after its construction began. When complete, the base housed nearly four thousand troops. As many as 139 B-29s could be parked along the taxiways, and six large hangars were built.

The base's primary mission was to provide a staging area for bombardment groups before deployment to overseas combat zones. Bomber aircrews were "checked out" for flying proficiency, and aircraft were prepared for future combat assignments.

The base remained open on a smaller scale after the war. The Twenty-seventh Fighter Wing was transferred here in 1947, using the P-51 "Mustang" and later the F-82 long range fighter to escort B-29 bombers equipped with atomic weapons. The base closed in March 1949 and the airfield became a municipal airport.

Lincoln Army Airfield
See Chapter 14.

McCook Army Airfield
Built in 1943, the 2,100-acre McCook Army Airfield was a major training base for B-17, B-24, and B-29 bomber crews, who received final proficiency training at the field before deployment in North Africa, Europe, and the Pacific Theater of Operations. During the war, the city of McCook scheduled "blackout" nights in which the town went dark for mock bombing raids.

In 1950 the city of McCook took possession of the airfield for a municipal airport, but its distance from the city made it inconvenient. A new airport was built closer to town, and portions of the property are now owned by a farmer, a local historian, and a local historical society.

Scottsbluff Army Airfield
Like Kearney, Scottsbluff promoted the use of its municipal airport for military/defense purposes only to have the Army deem it inadequate. In 1942 the military closed Scottsbluff Municipal Airport (it later became a prisoner of war camp) to make way for the new airfield.

The airfield's original mission was to train aircrews of B-17 and B-24 bombers of the Second Air Force, first as a satellite to an airbase in Casper, Wyoming, and after 1944 as a satellite of the Alliance Army Airfield. The facility was used for C-47 training flights and glider operations.

In 1947 the land was sold to the city of Scottsbluff for use as a municipal airport, but the military continued to use it for training until 1950. Today Scotts Bluff County operates it as William B. Helig Field.

Scribner Army Airfield
The military announced the construction of the Scribner Army Airfield on October 1, 1942, and sent

McCook Army Airfield.
RG2934-4-1

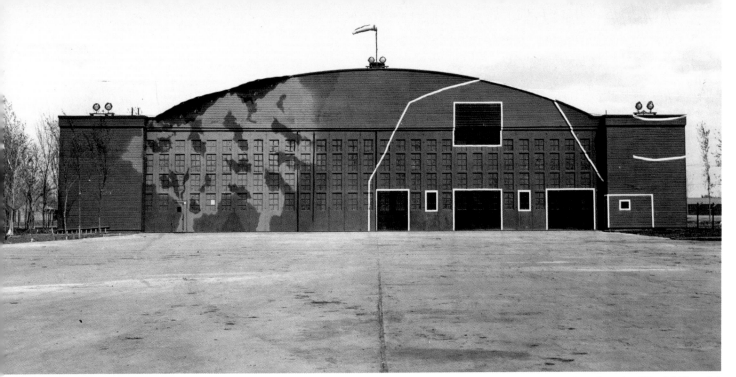

Camouflaged hangar at Scribner Army Airfield. Reprinted with permission from the *Omaha World-Herald*.

eviction notices to area farmers shortly thereafter. The base opened on December 9. Originally a satellite of an airbase in Sioux City, Iowa, Scribner became an independent base in 1943, with Ainsworth Army Airfield as its satellite.

As an Army Air Forces training facility, B-17 and B-24 bomber aircrews and P-47 fighter pilots completed proficiency training here before reassignment to the European Theater.

The army also tested airfield camouflage techniques on the airfield's runways and buildings. The airfield became a camouflage school, and by 1943, the entire base was camouflaged to look like a farm and small village to prove that an airbase could be hidden from the enemy. The hangar was painted red to resemble a barn, chicken wire was stuffed with green spun-glass to resemble trees, and a mock silo beside the barn housed the sliding hangar doors. Another building was given a steeple and painted to resemble a church, and a "school house" was built complete with spun-glass children. Even the runways were coated with tar, wood chips, and ground corncobs. The "crops" were then painted green or brown, depending on the season.

The state of Nebraska acquired the airfield after the war. By 1951, word came that the then-surplus base was being considered as the site of a proposed United States Air Force Academy. This plan fell through, but the Air Force did acquire 136 acres for installation of an ionosphere sounding station. The remainder of the former airfield was rented out. Scribner State Airfield is still in operation today, and an Air Force communications center is also located on the site.

After the War

Because the U.S. Army Air Forces bases covered thousands of acres and included hundreds of buildings, the government had to quickly dispose of large amounts of airplane parts, vehicles, training, office and hospital equipment, barracks furniture, and miscellaneous items. The government gave some items to schools and local governments and sold others to private owners, but it also burned much of the material and buried it in trenches on the bases.

As a result, many of the nation's airports fell into disrepair after the war. To solve this problem, the federal government developed the National Airport Plan, which created fourteen new airports in Nebraska and improved sixteen others.

The postwar years also saw the elimination of the Nebraska Aeronautics Commission and the creation of the Nebraska Department of Aeronautics, which in 1947 began negotiating with the War Assets Administration for the acquisition of five surplus airfields. As a result, Bruning, Fairmont, Harvard, Scribner, and McCook soon became state airports.

The U.S. Army built or used 389 major airfields during World War II. Of the twelve in Nebraska, six are currently municipal airports (Ainsworth, Alliance, Scottsbluff, Lincoln, Kearney, and Grand Island), four are owned by the Nebraska Department of Aeronautics (Harvard, Fairmont, and Scribner are operated as state airfields, Bruning is not), one is privately owned (McCook), and one is Offutt Air Force Base.

Most of the original World War II structures and

Douglas C-47s towing and releasing Waco gliders
near the Jones Ranch near Fort Robinson.
RG1517-88-6

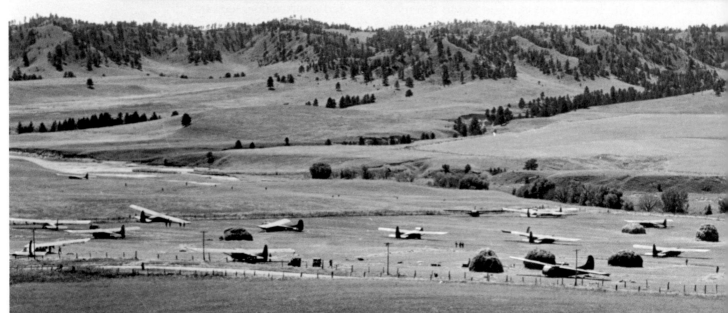

Gliders that landed on a hay meadow at the
Jones Ranch. RG1517-88-4

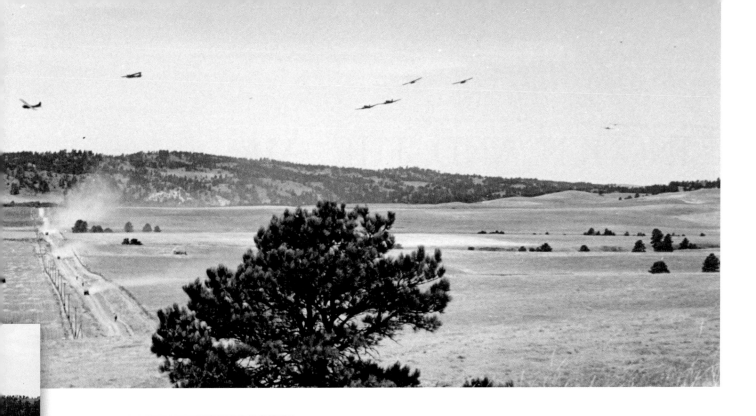

Many Waco gliders were damaged or destroyed on landing.
RG1517-8

buildings on the Nebraska airfields are gone, but their legacy lives on. Some landowners have never forgiven the military for seizing their lands and livelihoods. In contrast, many business owners fondly remember the revenue that thousands of troops brought into neighboring towns. Either way, the wartime airfields played important roles both internationally and locally.

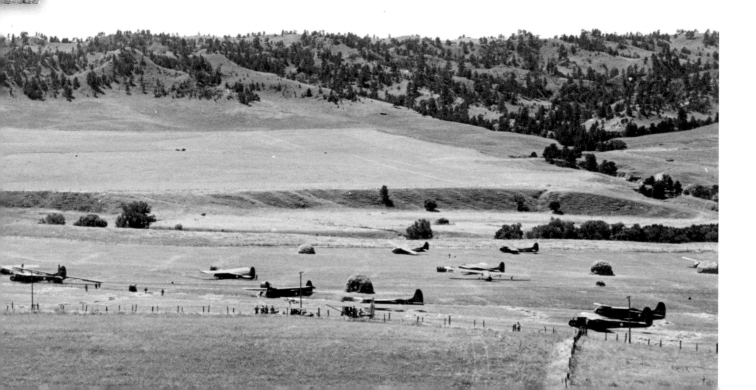

LINCOLN AND THE AIR NATIONAL GUARD

In 1913—the year that the Fort Omaha balloon school closed for the first time—the Nebraska National Guard Signal Corps built or assembled an airplane similar to a Curtiss Model D. Apparently they flew it in the vicinity of Fremont. Little more is known, but it's clear that Nebraska military leaders remained interested in aviation. In 1915, Capt. Castle W. Schaffer was made chief of aviation; shortly thereafter Ralph E. McMillen was commissioned as captain. These two men each furnished their own airplanes and were expected to finance their activity by flying exhibitions at county fairs and other public events. McMillen also became an accomplished aerial photographer. In 1916 he photographed the state capitol, the state penitentiary, and the university school of agriculture.

However, just a few months later, Captain Schaffer crashed at a county fair in Julesburg, Colorado, and

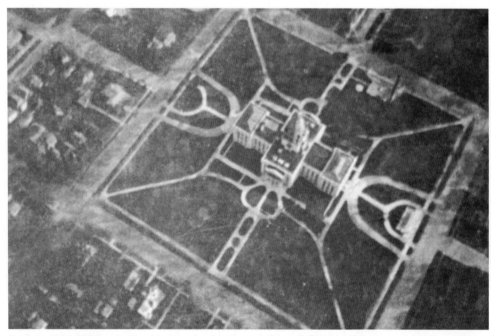

Before World War I, the Nebraska National Guard Signal Corps saw little more than taking aerial views of Lincoln landmarks. Ralph McMillen took this photo of the State Capitol from 4,000 feet in 1916.
RG2929-19A

Lincoln Air Force Base, looking southeast, with base housing in the foreground, barracks and B-47 bombers in the middle ground, and the Lincoln skyline in the distance.
RG0809-1-6-b

apparently gave up flying.

Edgar W. Bagnell of McCool Junction, who later received pilot training in Virginia, then joined Captain McMillen; they became the guard's two-man aviation unit. McMillen made several flights as part of the Fourth Infantry Regiment at Camp L. D. Richards, south of Fremont, and later joined the Fifth Regiment encamped near Crete. From there, he made a

twenty-five-mile flight to Beaver Crossing. McMillen also experimented with bombing during a number of his flights, using sacks of flour as bombs.

McMillen died in a crash during exhibition flying at St. Francis, Kansas, on September 2, 1916. As a volunteer program without federal funding, the aviation unit of the Nebraska National Guard could not attract additional pilots and did not survive

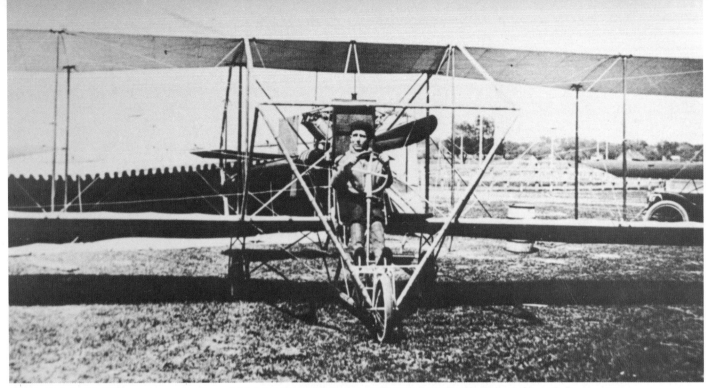

Capt. Ralph McMillen, commander of "Aerial Company A" of the Nebraska National Guard, in an early Curtiss-type airplane in 1916.
RG2296-91

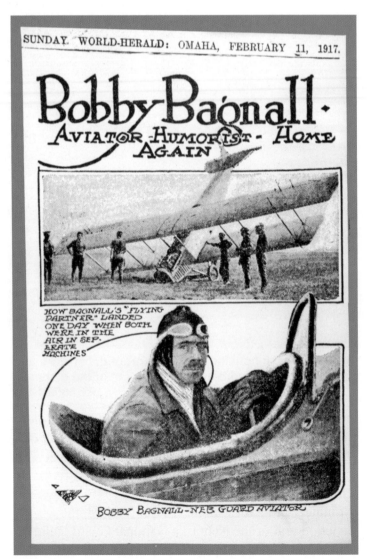

SUNDAY WORLD-HERALD: OMAHA, FEBRUARY 11, 1917.

Bobby Bagnall·
AVIATOR·HUMORIST·HOME
AGAIN

HOW BAGNALL'S "FLYING
PARTNER" LANDED
ONE DAY WHEN BOTH
WERE IN THE
AIR IN SEP-
ERATE
MACHINES

BOBBY BAGNALL·NEB GUARD AVIATOR

McMillen's death.

At that time, those who wanted to fly for the military went into the army. After training in Virginia and Mineola, New York, Bagnell was commissioned a lieutenant in the Signal Officers Reserve Corps in January 1917 and was assigned to the newly created Third Aero Squadron at San Antonio.

Years later, U.S. entry into World War II sparked a revolution in military aviation in Nebraska. Beginning in 1942, the Army Air Forces constructed eleven air bases in Nebraska at Scottsbluff, Alliance, Ainsworth, McCook, Kearney, Grand Island, Fairmont, Harvard, Bruning, Scribner, and Lincoln. These bases trained mechanics, pilots, and flight crews in the military fields of bombardment, glider towing, cargo parachuting, and aircraft maintenance and modification. They also provided advanced pilot training (flying lessons for beginners were reserved to bases in milder climates). As the war progressed, the bases were also used to gather and train bomber crews for overseas processing before their long flights to Europe and the Pacific islands. Advanced fighter plane training was conducted with the fighters making mock attacks on the bombers.

Edgar "Bobby" Bagnell (his name is misspelled in the illustration) flew with Captain McMillen in the Nebraska National Guard before going on active duty with the U.S. Army. RG2929-24

As for Nebraska's air bases, most were decommissioned after the war. However, the Lincoln base—though it was officially decommissioned on December 15, 1945—continued to operate for years in some type of military capacity. At first it was a Navy Reserve Training Station and Nebraska Air National Guard base. Later it became the Lincoln Municipal Airport.

As tensions between the Soviet Union and the United States developed into the Cold War, the air force reactivated the base in February 1954 and built a two-mile-long runway to serve the jet age. Several squadrons of Boeing B-47 jet bombers and Boeing KC-97 refueling tankers were based there until the mid-1960s, when the B-47 became obsolete and was phased out of service. Commercial and civilian aviation, as well as the Nebraska Air National Guard, now uses the airfield.

The Nebraska Air National Guard was organized after World War II and has been assigned a number of different aircraft with a variety of missions over the years. Its first plane was the North American P-51 Mustang, which proved to be an outstanding long-range fighter plane during the later stages of World War II. These planes could accompany long-range bombers from English airfields all the way

A Boeing B-47 getting maintenance work done on its jet engine in August 1960. RG2934-1-41

to Berlin and from Guam to Tokyo.

With the advent of the jet age, the Mustangs were replaced with Lockheed F-80 Shooting Stars, the United States' first operational jet fighters. The Shooting Stars were in turn replaced by the much superior North American F-86 Sabre, the U.S's first swept-wing fighter. During the Korean War, F-86 pilots had a ten-to-one kill ratio over the Russian-designed MiG-15.

By the 1970s, the air guard's mission was changed to photoreconnaissance with the arrival of the Republic F-84, and then the famous McDonnell F-4 Phantom. The F-4 was a rather homely aircraft, but it was an excellent design used for many years by the U.S. Air Force and the Navy, as well as by many of our allies.

With the 1993 switch to the Boeing KC-135 aerial tanker, the air guard's mission became in-flight refueling, which resulted in many long-range international flights in support of U.S. Air Force operations in the Middle East.

The Boeing KC-135 celebrated its fiftieth anniversary in 2006. A total of 820 of these historic planes were built. Several engine upgrades over the years gradually improved its performance: it is now 26 percent more fuel efficient, has nearly double the thrust, and 95 percent less engine noise.

A Douglas Globemaster at the Lincoln Air Force Base after the base's reactivation in February 1954 for the Cold War. RG0809-1-17

Left: The crew of a B-47 getting ready to board their aircraft in September 1956. They will represent the base's 98th Bombardment Wing in the 1956 SAC bombing-navigation competition.
RG2934-1-5

Opposite: A Boeing KC-97 refueling tanker in flight.
RG3713-2-17

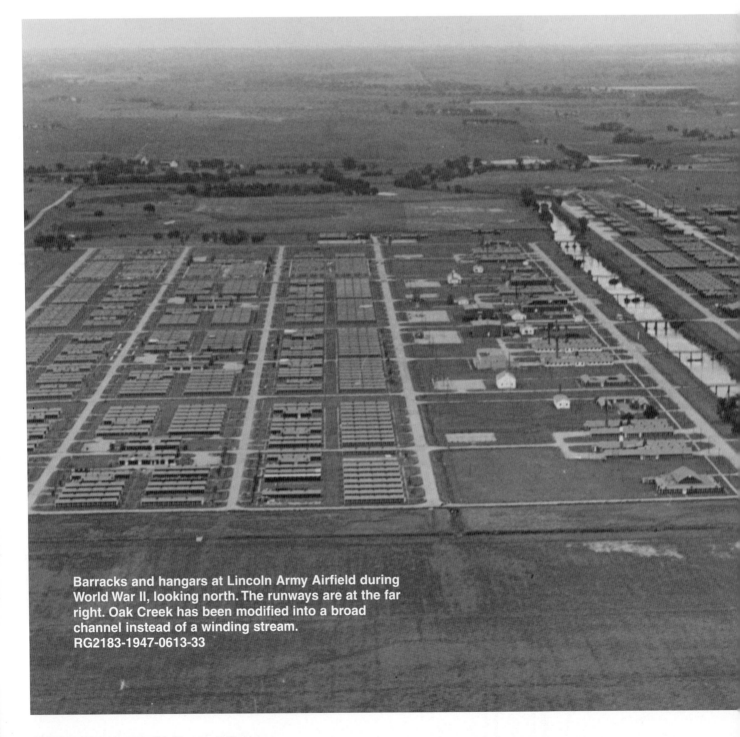

Barracks and hangars at Lincoln Army Airfield during World War II, looking north. The runways are at the far right. Oak Creek has been modified into a broad channel instead of a winding stream.
RG2183-1947-0613-33

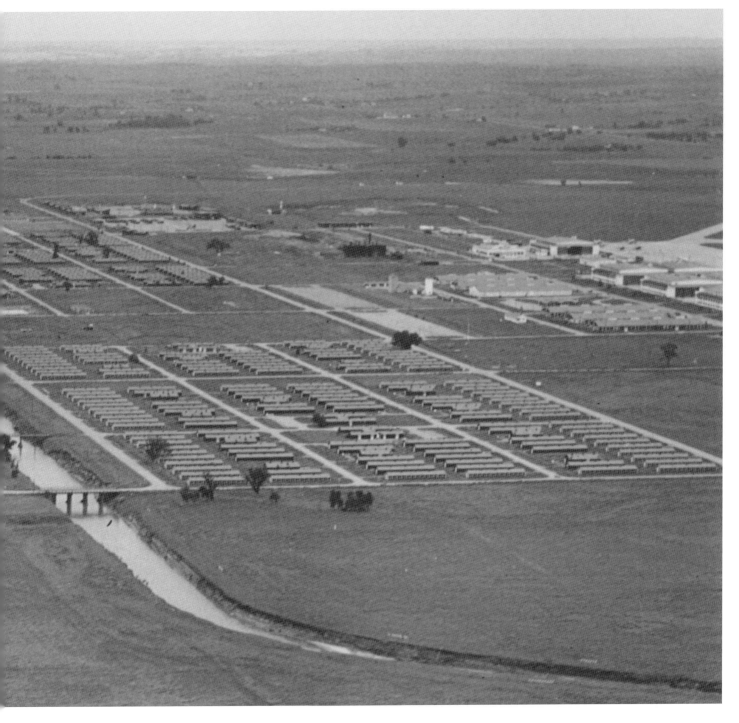

A North American P-51 Mustang, which was the first plane assigned to the Nebraska Air National Guard.
RG1777-6

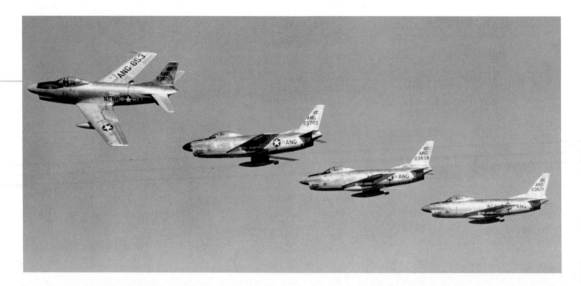

North-American F-86 Sabrejets flying in formation with fuel drop tanks attached.
RG2929-102

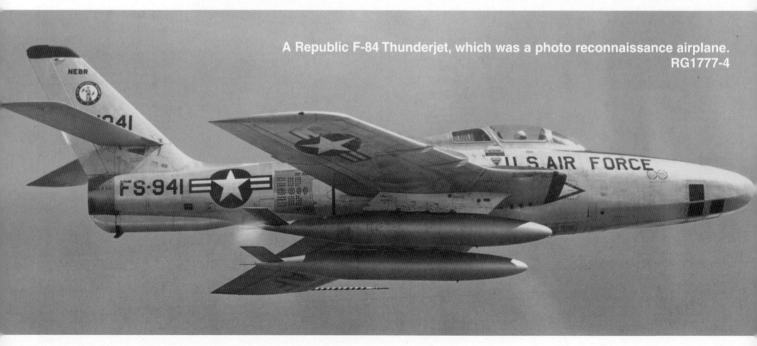

A Republic F-84 Thunderjet, which was a photo reconnaissance airplane.
RG1777-4

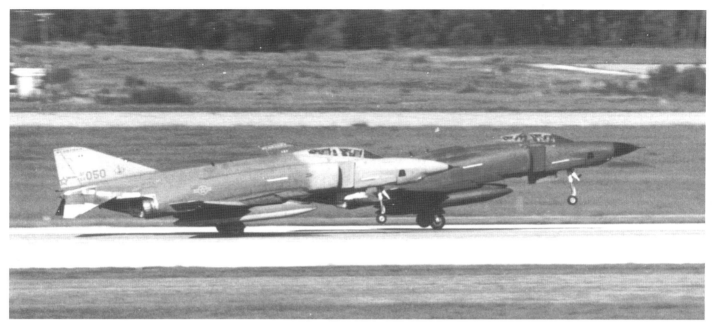

The F-4 Phantom replaced the Thunderjet.
RG1777-1

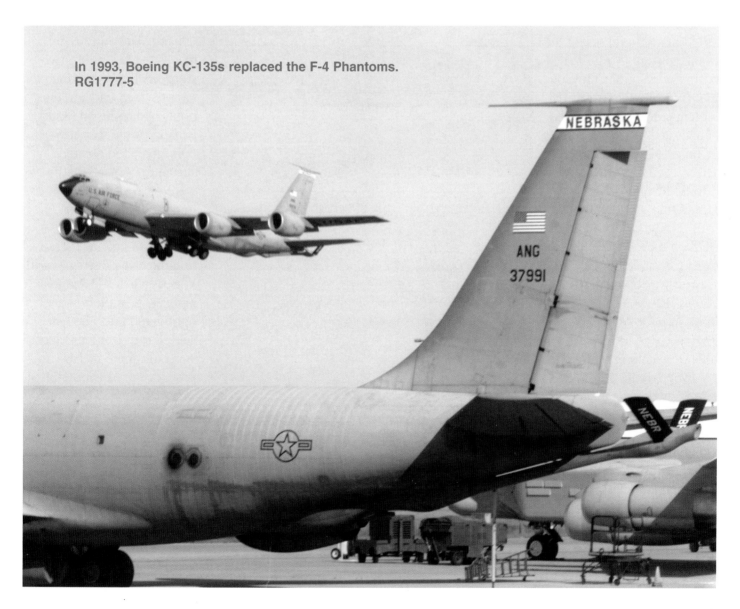

In 1993, Boeing KC-135s replaced the F-4 Phantoms.
RG1777-5

CHAPTER 15

FROM OLD FORT CROOK TO OFFUTT AIR FORCE BASE

Old Fort Crook entered the air age in the early 1920s. In 1924 the landing field was renamed Offutt Field in honor of Jarvis Offutt, an Omaha pilot killed in a training flight in France during World War I. Airmail operations moved to Offutt Field after a violent storm destroyed its hangar at Ak-Sar-Ben Field in June 1924 (see Chapter 10).

In September 1924, the U.S. Army's "Round the World" fliers stopped at the field on their way to the West Coast. Nathaniel Dewell was on hand to record the event. In his book *Rudder, Stick and Throttle*, Robert Adwers tells of watching the planes fly over Twenty-fourth and Ames streets as Omaha factory whistles announced their arrival.

The U.S. Army had bought four specially designed Douglas planes for its "Round the World" pilots. They took off from Lake Washington, near Seattle, on April 6, 1924. Each plane was equipped with both wheels and floats; because of the planes'

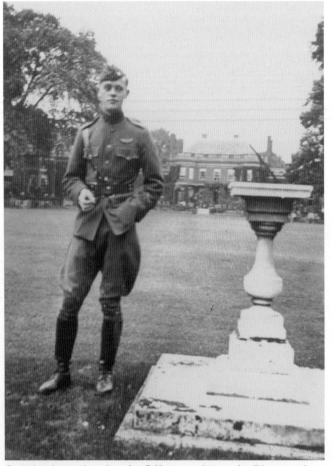

Omaha-born Lt. Jarvis Offutt on leave in Plymouth, England. He was killed in an air crash August 13, 1918, while serving as a pilot for the Royal Air Force flying a new plane to France. RG2432-1-144

modest range, the route was flown in a series of relatively short stages. Two planes were lost during the 175-day trip, one in Alaska and the other in the North Atlantic between the Orkney Islands and Iceland. The other two planes made seventy-two stops in all. By the time they reached Omaha, the pilots had come about 90 percent of the way toward their goal, and excited spectators sensed that they were witnessing an important moment in aviation history.

Offutt Field's next claim to fame came during World War II, when it became a major U.S. military base during and after the war. The Martin Bomber Plant was built there in 1941 to produce the Martin B-26. The plant built 1,585 of these twin-engine medium bombers.

Ed Rassmussen of Nebraska was a photographer for the 387th Bombardment Group and flew as a crew member on Martin B-26s in Europe. His pictures are an excellent historical record of the lives and deaths of B-26 aircrews.

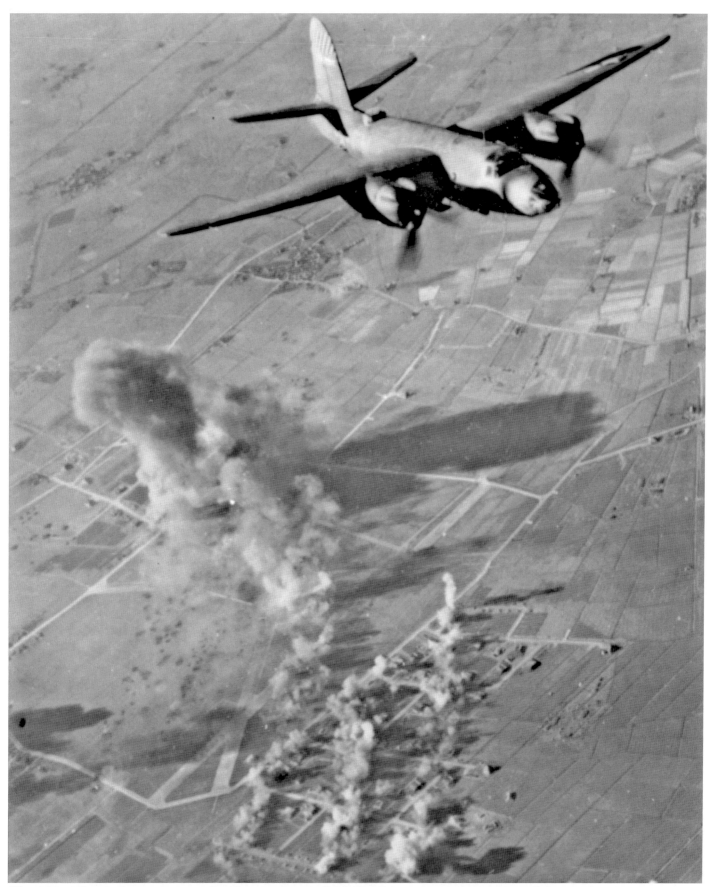

The 322nd Bomb Group sent ten bombers to bomb Schipol Airdrome near Amsterdam, flying at tree top level, as the pilots had been trained. All were lost to Nazi flak gunners hidden in Dutch windmills. The 387th Bombardment Group, the group to which Nebraska photographer Ed Rasmussen was assigned, was their replacement. The group was grounded and retrained at 12,000 feet to use the new Norden bombsight. On December 13, 1943, using 34 bombers carrying 4,000 pounds of bombs each, the airdrome was eliminated with near perfect bombing. RG2440-42

During the war, Martin production switched to the Boeing B-29, the largest four-engine bomber of World War II. The plant produced 531 "Superfortresses," including *Enola Gay* and *Bockscar*, which dropped the atomic bombs on Hiroshima and Nagasaki, Japan. The plant also did modification work on North American B-25s. Production halted at the end of World War II.

However, the military presence in the area continued. The Strategic Air Command (SAC) was established in 1946 and moved to Offutt Air Force Base in 1948. For many years Boeing B-52, KC-135, and British Vulcan planes were based there. With the end of the Cold War, President George H. W. Bush ordered the stand-down of SAC in November 1991. Today, the United States Strategic Command (STRATCOM) uses the command center.

A Martin NBS-1 Bomber at Fort Crook in the early 1920s. RG3715-2-7

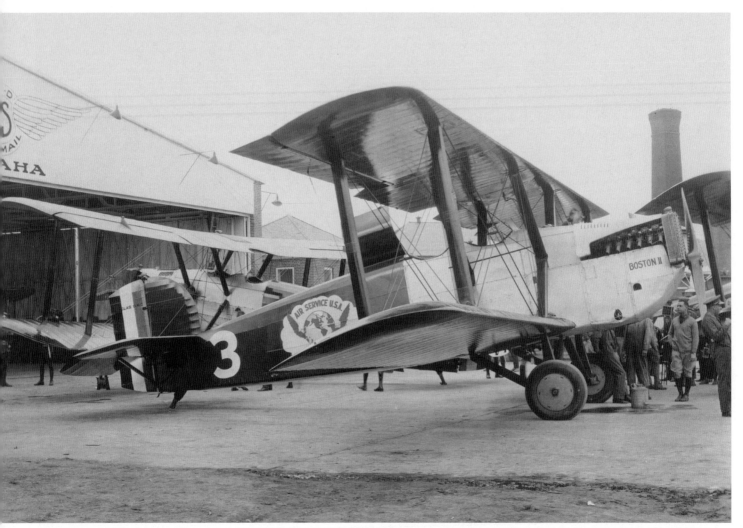

One of the U.S. Army's Douglas-O-5DWC World Cruisers during their stop at Fort Crook September 17, 1924. These planes were on their way to the West Coast to complete the first flight around the world. RG3882-49

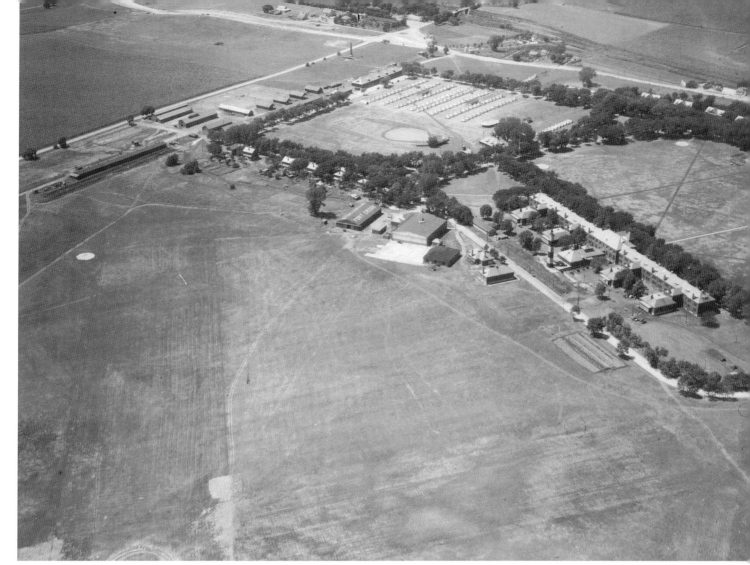

An aerial view of Fort Crook and Offutt Field in 1931.
RG3882-677

This plane, a French Breguet Bre.14 named the *Ern* was used by Mathew Stirling, a California ethnologist and the leader of an expedition to New Guinea. Hans Hoyte was the pilot. This picture was taken at Fort Crook October 22, 1925, before the expedition. RG3882-606

The U.S. Army dirigible TC-6 visiting Fort Crook in May of 1925.
RG3882-1-91

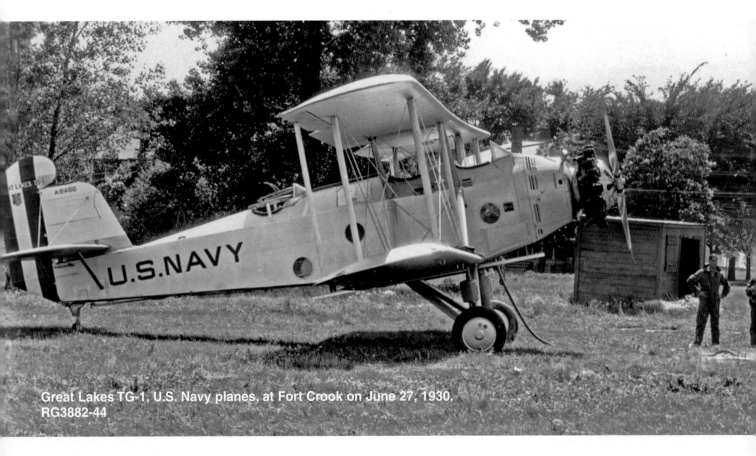

Great Lakes TG-1, U.S. Navy planes, at Fort Crook on June 27, 1930.
RG3882-44

While attempting to avoid a local storm, the dirigible's bag was ripped and collapsed in gale force winds. No one was injured in the crash, but the airship was damaged beyond local repair.
RG3882-1-92

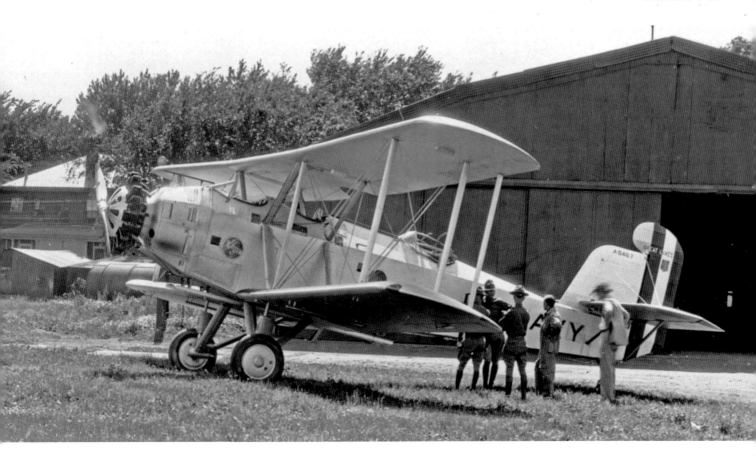

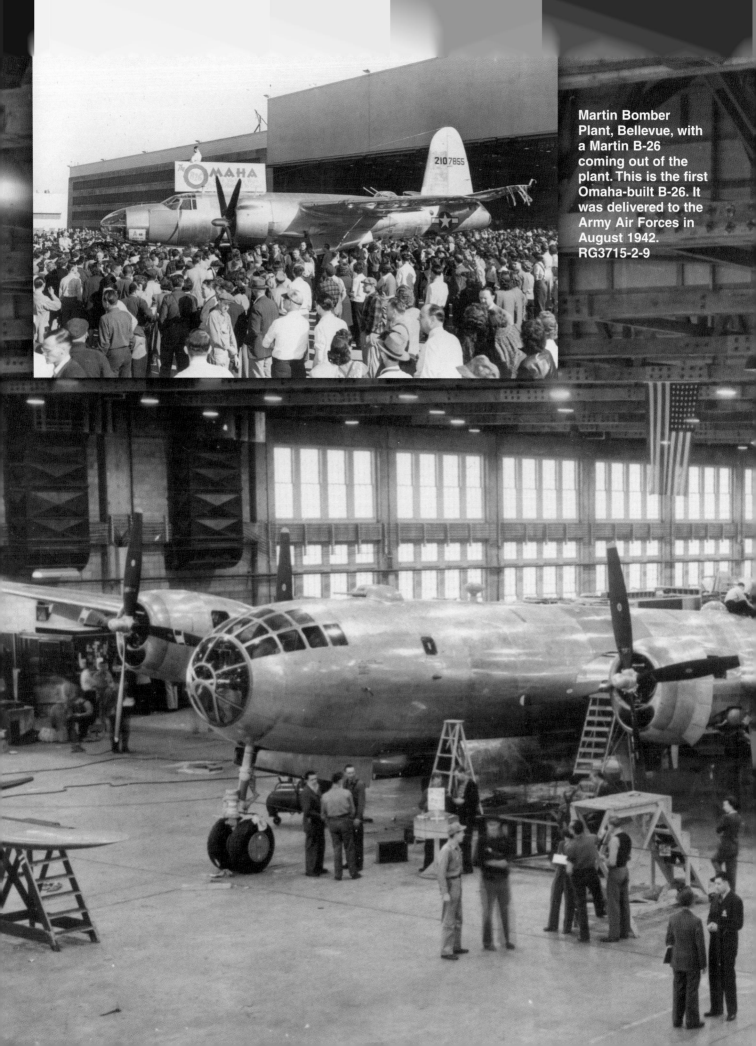

Martin Bomber Plant, Bellevue, with a Martin B-26 coming out of the plant. This is the first Omaha-built B-26. It was delivered to the Army Air Forces in August 1942. RG3715-2-9

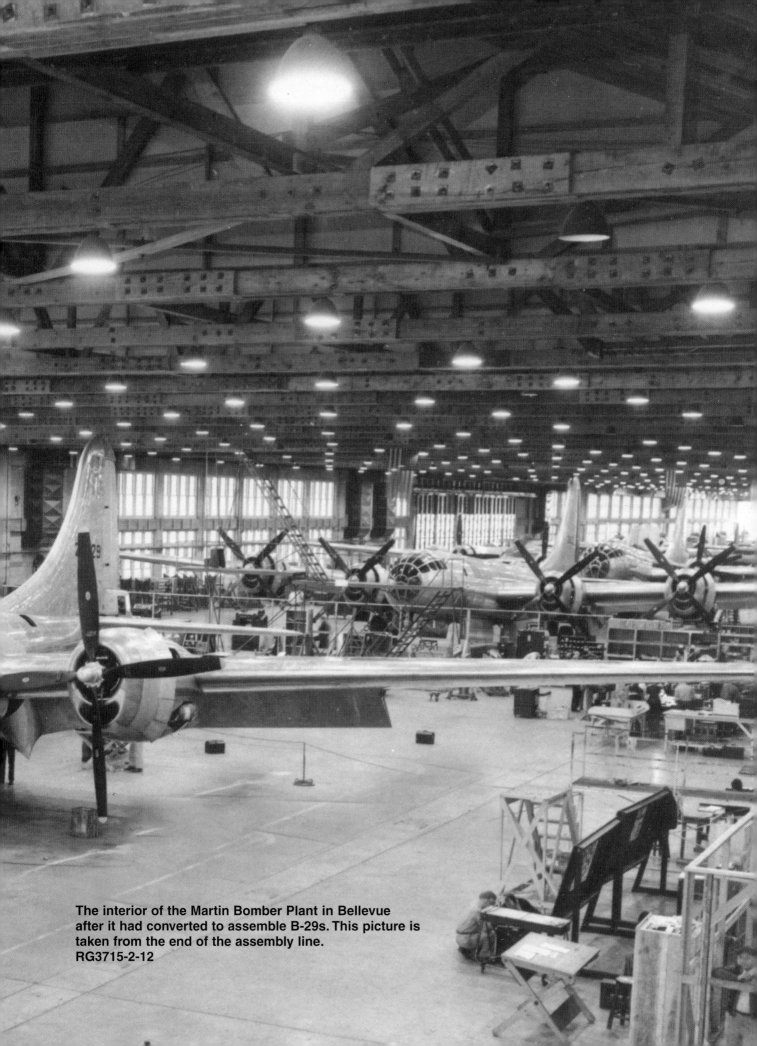

The interior of the Martin Bomber Plant in Bellevue after it had converted to assemble B-29s. This picture is taken from the end of the assembly line.
RG3715-2-12

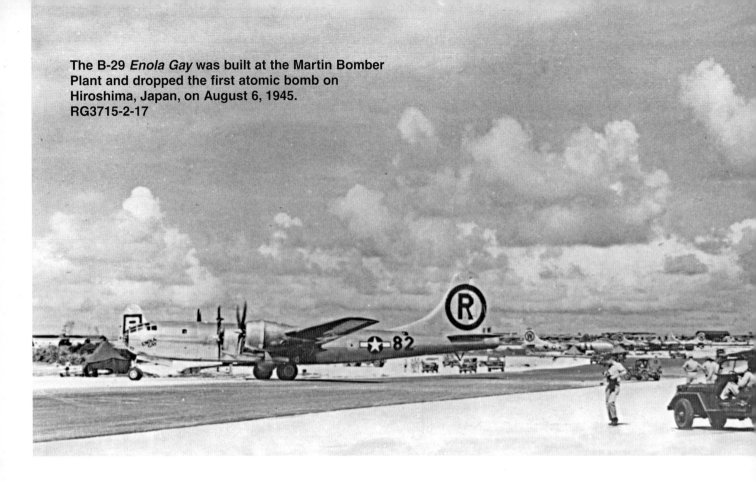

The B-29 *Enola Gay* was built at the Martin Bomber Plant and dropped the first atomic bomb on Hiroshima, Japan, on August 6, 1945.
RG3715-2-17

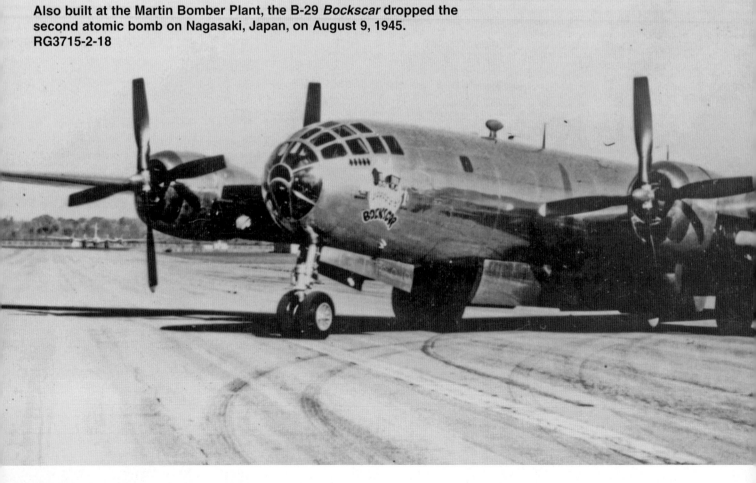

Also built at the Martin Bomber Plant, the B-29 *Bockscar* dropped the second atomic bomb on Nagasaki, Japan, on August 9, 1945.
RG3715-2-18

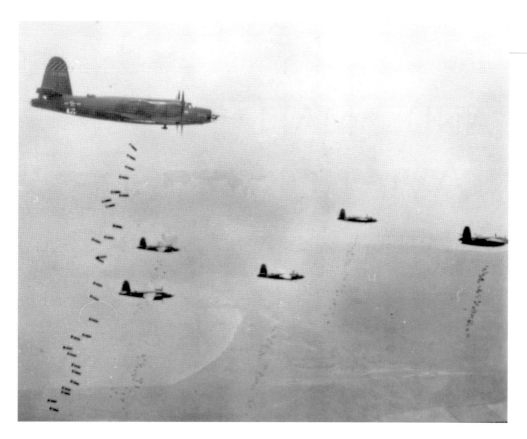

The 387th Bomb Group using 36 bombers, each dropping 28, 100-pound fragmentation bombs set to explode about 100 feet in the air. Anti-personnel bombs were used to help clear hedgerows for troop advance from beach-heads. The photo was taken at 6:00 a.m. on the first mission of D-Day, June 6, 1944, by Nebraska photographer Ed Rasmussen. RG2440-61

RURAL AND SMALL-TOWN AVIATION

A lthough much of Nebraska's early aviation involved the military, civilians also used the new technology in their work. One of those civilians was Dr. Frank A. Brewster. During his early years of medical practice in Beaver City, Dr. Brewster often had great difficulty getting to his rural patients because of that area's poor roads. In 1919, he bought a new Curtiss JN-4 "Jenny," and World War-I-trained Wade Stevens became his first pilot.

On May 23, Dr. Brewster made history as the first doctor to fly to a patient when he flew to attend Guy Sidey, an oil field worker in rural Herndon, Kansas. The fifty-five-mile trip by air is credited with saving Sidey's life, since Dr. Brewster was able to quickly remove a piece of steel from Sidey's head. The trip to Herndon would have taken over three hours by car.

Dr. Brewster later moved to Holdrege and regularly flew to hospitals he had founded in the area.

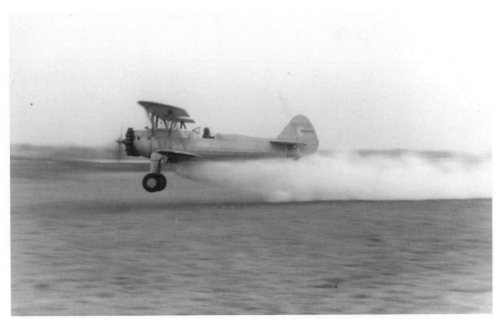

A Stearman P-17 crop-dusting. Stearman P-17s were originally built to be World War II pilot training planes.
RG2929-491

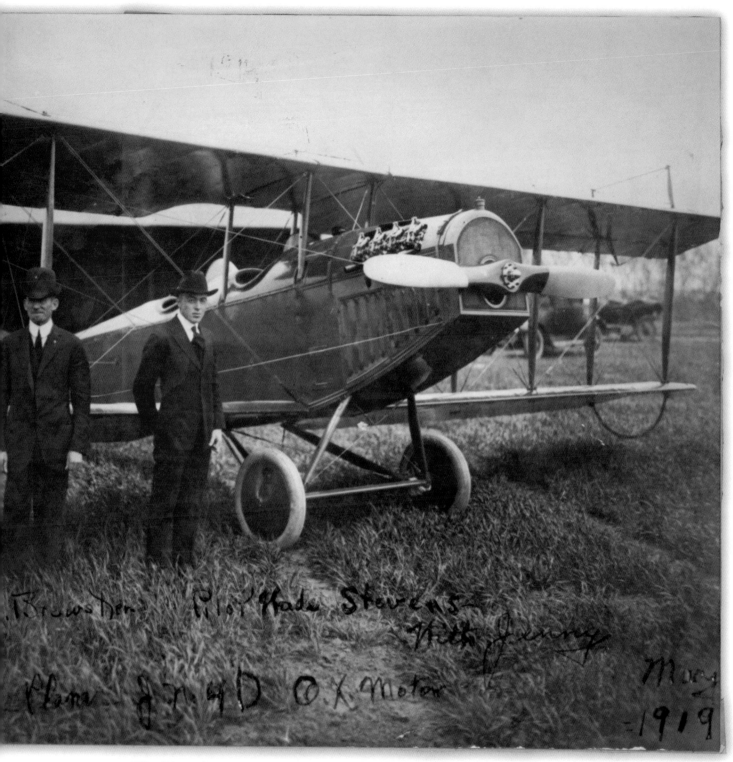

Pilot Wade Stevens and Dr. Frank A. Brewster standing in front of a JN-4 (Jenny) near Holdrege.
Photo courtesy of the Nebraska Prairie Museum, Holdrege, Nebraska. RG2929-495

He owned a number of airplanes over the years, including a Curtiss Oriole, a Stinson Reliant, and a Ryan Navion—but did not receive a pilot's license until he was seventy-one years old.

Medicine wasn't the only profession to use aviation. On September 13, 1929, the *McCook Daily Gazette* became the first newspaper to begin regular delivery of its papers by airplane. Publisher Harry D. Strunk, a thirty-seven-year-old who had started the paper at age nineteen, decided that the area's horrible roads, rising postal rates, and the public's obsession with aviation would make the risk worth it.

The Curtis-Robin cabin monoplane, christened *The Newsboy*, took off before a crowd of five to six thousand. *The Newsboy* delivered papers to outlying towns mere hours after the paper had been printed.

The Flying Farmers and Ranchers' first meeting at the Union Airport on February 2, 1946. From left to right are a Piper Cub, a Taylorcraft, and an Aeronca Champion.
RG2929-440

The Newsboy's run ended in July 1930 when it was damaged by a wind storm. Because of the expense, Strunk decided not to repair the plane. But the risky venture had already paid off. The *Gazette's* circulation increased from 2,800 subscriptions in 1928 to 4,500 subscriptions by 1930. It continues to be one of the largest newspapers in its circulation category today.

Of course, many more planes were used in Nebraska agriculture than in the medical or media professions. The use of airplanes in agriculture began in 1921, when a World War I-surplus Jenny piloted by John A. Macready was used to dust six acres of catalpa trees for the sphinx caterpillar near Troy, Ohio.

Macready was one of the pioneer pilots of the 1920s. In addition to giving the first successful crop-dusting demonstration on August 31, 1921, in September of that year he set an altitude record of 40,800 feet flying an open cockpit LUSAC-11 biplane at Cook Field, near Dayton, Ohio. Two months later, he took third place in the Pulitzer Cup Race in

Early crop dusting in the 1920s. Location unknown.
RG2929-66

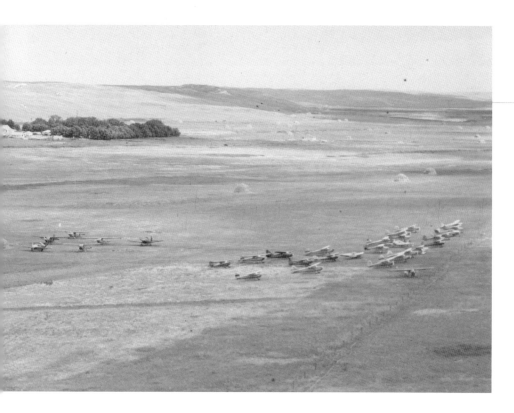

A Flying Farmers and Ranchers' fly-in at the well-known Spade Ranch near Ellsworth, probably in 1954-55 when Lawrence Bixby was president of the organization. Bixby was the operator of the Spade.
RG2929-444

This Piper Pawnee, built in 1969, was one of the first airplanes built specifically for crop-dusting. RG2929-495

A Piper Cub converted to crop-dusting right after World War II. RG2929-494

Omaha. Macready and Lt. Oakley Kelly completed the first nonstop flight across the United States in 1923. They took off from Long Island, New York, on May 2 and landed at San Diego, California, twenty-six hours and fifty minutes later.

Aerial crop-dusting expanded to include dusting cotton for leaf worm and the boll weevil in 1922, and continued to expand during the 1920s and 1930s. In Nebraska, crop-dusting became a thriving business after World War II as cheap surplus military observation and training planes became available for use. In addition, new chemicals were available to control weeds and insects to enhance crop production.

In the 1960s, airplanes began to be specially designed for crop-dusting. These planes could carry heavier loads at higher speeds and were much safer for pilots, as the cockpits were designed to keep chemicals away from the pilot and provide better crash protection.

Nebraska farmers and ranchers found other uses for airplanes. They found light airplanes ideal for checking their land operations in a timely and economical manner, and realized that hay meadows make excellent landing strips.

To organize their efforts and keep in touch with their fellow aviators, Nebraska Flying Farmers and Ranchers was founded on February 4, 1946, at Union Airport in Lincoln. The organization is active to this day. Members now use their planes for many purposes besides inspecting their land. They make quick trips to repair farm machinery, fly to cattle sales, seed fields and ranges, kill coyotes, go shopping, and take

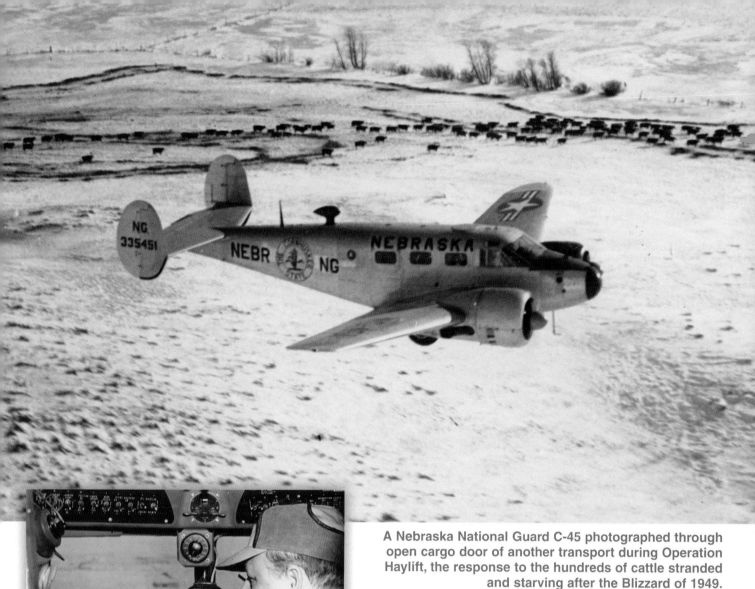

A Nebraska National Guard C-45 photographed through open cargo door of another transport during Operation Haylift, the response to the hundreds of cattle stranded and starving after the Blizzard of 1949.
RG3139-109

Governor Val Peterson in co-pilot seat of an airplane during Operation Haylift in 1949.
RG3139-114 SFN6988

pleasure trips. The organization holds regular fly-ins throughout the state for both social and educational purposes.

But it took a notoriously hard winter to set the stage for the most famous episode in rural Nebraska aviation. During the winter of 1948-49, brutal snowstorms dropped enough snow to create forty-foot drifts in some areas, cutting off many parts of Nebraska from much-needed supplies. At first, private pilots and local air services did their best to fly in supplies and carry sick and injured people to hospitals. Then the federal government stepped in. The air force mobilized "Operation Haylift," which flew in feed to the two million head of cattle that were slowly starving to death on the snow-covered plains.

Pilots risked their lives for the mission, flying in high winds, low visibility and extreme cold, and often landing on snow-covered fields or airstrips. And although there were far more cattle in trouble than Haylift could serve, the flights provided some measure of temporary relief.

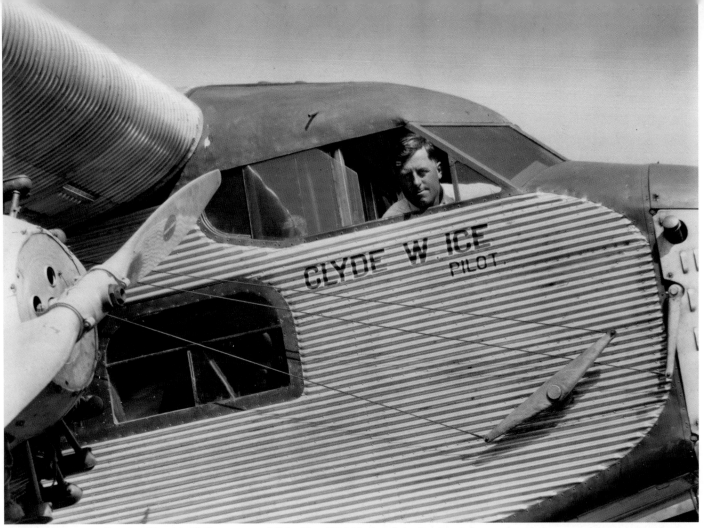

Clyde W. Ice, a pilot for Rapid Airlines, used this Ford Tri-Motor for charter trips and gave rides at barnstorming events. Unlike most early pilots, Ice lived a very long life. He died at age 103.
RG3882-1-550

In 1928 Clyde Ice and the Ford Tri-Motor pictured above carried a 1,320-pound hog named Dazzler from Omaha to the Iowa State Fair in Des Moines. Owned by the Deichmann family of Leigh, Nebraska (William Deichmann is pictured above), Dazzler was hazardous cargo. "I didn't want him trying to turn around in there," Ice later wrote. "When you're up in the air and something that big starts moving around, it could create a ruckus."

The September 13, 1929 *McCook Daily Gazette* ran this front page picture of *The Newsboy* as well as a banner headline that read "Skyways converge on M'Cook Port." McCook had a two-day celebration and air show to kick off air delivery service.

THE McCOOK DAILY GAZETTE

HOME EDITION

Volume VI—Number | United Press Leased Wire | McCOOK, NEBRASKA, FRIDAY, SEPTEMBER 13, 1929 | N. E. A. Features and Pictures | Price Five Cents

SKYWAYS CONVERGE ON M'COOK PORT

MANY PLANES HERE TO ATTEND TWO-DAY FETE

Squadrons of Planes On New American Legion Field Joined By First Nebraska Air Tour Caravan To Take Part In McCook's Air Show

IDEAL DAY FOR FLYING

Crowd from Over Big Area Will Witness Dedication And Inaugural Events

Given rousing welcomes at Auburn, Falls City, North Platte and other points on their itinerary, the members of the Omaha All-Nebraska air tour, in 27 odd planes, were to be given a more stirring reception at 1:30 p. m. Friday when their airport at the skies landed at the McCook American Legion airport to take part in the inauguration of The Gazette's air delivery service and the dedication of the legion airport, which were to be features of the Friday afternoon program of the big first two-day aeronautical carnival sponsored by The Gazette.

The overhanging clouds of Friday morning had scattered after noon and the day was regarded as almost perfect for the type of program that was to be presented.

The Omaha flight was to be heralded by the arrival at the plane bearing Major H. J. Hougland, flight commander, and his aides. Shortly after Major Hougland landed, the other ships in the great flight were to come to earth, one ship at a time, in response to signaled orders from the ground. Andy Nielson and Lawrence Eisminger, Maj. Hougland's aides, were to assist the local American Legion airport overseers in getting the fleet safely to land.

By noon today it appeared definitely that the Omaha fleet was to see the largest crowd of its gigantic flight when it arrived in McCook. Parade were conducted

Wounds Wife; Kills Self

Keokuk, Ia., Sept. 13—(UP)—Believed by police to have been jealous because of the presence of his wife's first husband, David Kay, 43, shot and seriously wounded his wife and then killed himself yesterday. Mrs. Kay was shot in the thigh. The first husband, named Young, lived in the rear of the Kay home and was the father of Mrs. Kay's twelve children.

SAYS GIRL BANDIT IS INSANE PERSON

Husband of Texas Girl Who Robbed Bank Is Calmly Trying To Save Her

New Braunfels, Tex., Sept. 13—(UP)—A young attorney today called a succession of witnesses before a jury of 12 German farmers in a crowded here and with a calm which ended his personal feelings, sought to prove his wife insane.

The wife, Mrs. Rebecca Bradley Rogers, sat dumbfaced and unresponsive staring through spectacles at a spot on the wall from which she had hardly taken her eyes during the four days of her trial on a charge of bank robbery. She appeared the victim of a preoccupation in which there was no room for emotion.

Otis Rogers had met "Becky" on the shaded campus of the Texas University a little more than three years ago. The two were married secretly. Hardly had he left the campus when he was called to her defense. That defense today was the claim that the girl

Inaugurates New Newspaper Service

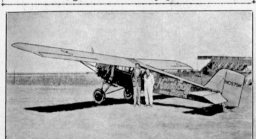

Above is pictured The Newsboy, The Daily Gazette's new Curtiss Robin cabin monoplane, now in service with the now famous Challenger motor, which was formally placed in service Friday with reference at the American Legion airport. With Steve Tuttle at its controls the ship took the air to deliver this edition of the Gazette over the longest newspaper route any newsboy ever carried.

Saturday Set For Date Of Funeral Of a Flyer

Lincoln, Sept. 13—(UP)—Funeral services for Frank Creecy, Lincoln aviator, killed when his plane crashed during a stunting exhibition at Columbus Wednesday, will be held here Saturday afternoon.

Creecy, who was touring with the Nebraska air trippers, was killed instantly when the wing of his ship collapsed at low altitude in a spot on the wall from which he had hardly taken a power dive. The plane fell 1,000 feet

GOVERNOR TALKS ON ADVANCEMENT SHOWN BY STATE

Tells Of Progress Shown Since Early Days Of Transportation

URGES FLOOD CONTROL

WIDER PROBE OF LOBBY DEMANDED

Shearer Case Puzzles Men Of Senate As To What Else Has Gone On

Boy "Stool Pigeon" Has Drawn Fire From Judge

Mangum, Sept. 13—(UP)—Employment of an 11-year-old school boy by Federal prohibition agents as a dry informer brought the caustic comment from Federal Judge Harry B. Anderson that it is a disgrace, a crime, and ought to be stopped."

If they strain, the youth to lose during trial of two alleged liquor law violators, that all one are things it had bought whiskey on "evidence."

The first fight was completed

ABANDON HOPE OF FINDING LOST SHIP

No Trace Remains of Boat Or Crew For Which Lake Michigan Hunt Waged

NEWSBOY CARRIES PAPERS FOR TEST

Gazette Plane Carries Its First News Cargo To 30 Towns In Four Hours

ATTAINS GREAT SPEED

"It can be done." It has been done."

The last doubts were dispelled from minds of members of The Daily Gazette mechanical staff Thursday evening when "The Newsboy," the Gazette's new Curtiss Robin monoplane, piloted by Steve Tuttle, alighted on the new American Legion air field a bare four hours after it took off with its first cargo of newspapers which were distributed to the plate in a preliminary test of the first actual newspaper route of its scope in the world. The test was a complete success.

Readers of The Gazette in 30 towns in southeastern Nebraska and northwestern Kansas received at their homes the first actual airplane edition of this newspaper in no instance later than two hours after their copies left the press room.

As in the intention when the route is formally and permanently established within the confines of The Gazette, the delivery last night was made in two flights. The first "hop" was destined as far as Orleans, returning by way of Beaver City, Wilsonville, Danbury and other towns on the approach of the St. Frank branch of the Burlington. The second hop was westward to Imperial across to Enders, south to Atwood, Kan. and eastward again on the St. Frank branch to Oberlin and Cedar Bluff, Kan.

The first flight was completed with The Newsboy back on the field for its second load of papers and furiously into the air one minute and 15 minutes after taking off with its second load the plane appeared out of the south in the last gathering dark. The total mileage covered on the two jogs of the journey is estimated at over

HOPES SEEN THAT NAVY REDUCTIONS COME SOON

Announcement Of Premier MacDonald's Intended Visit To America Forecasts One Of First Mighty Blows To Be Struck Against War

Flyer Lost In Canadian Wilds 17 Days Is Found

Winnipeg, Man., Sept. 13—(UP)—Thin from hunger, but otherwise well, C. F. Moss, pilot, who his plane was forced down by motor trouble in the Wild Reen Lake district, was found Thursday by a fellow flyer, Victor Partridge. Moss is the pilot of an exploration company.

THAYER CONVICTED OF KNIFE ASSAULT

One Of Principals In Fight Over Booze Will Pay His Penalty For Offense

William Thayer, characterized by John Fahnenbruch made an active ment with Howard Hayden, Thayer's alleged accomplice, was found guilty Thursday afternoon in district court on a charge of intent to wound, in took but a little more than an hour for the jury to return the verdict.

State testimony showed that John Fahnenbruch made an active ment with Howard Hayden, Thayer's alleged accomplice, was found guilty Thursday afternoon in district court on a charge of intent to wound, in took but a little more than an hour for the jury to return the verdict.

PACT SEEMS ASSURED

Dawes' Preliminary Job is Apparently Leading Up To Big Agreement!

By Lyle C. Wilson

Washington, Sept. 13—(UP)—Civilization flexed its muscles in London and Washington today for the first of a series of mighty blows against war.

Announcement of Premier MacDonald's intention to arrive here October 4, plan experience of optimism at the state department, combined today to make Anglo-American agreement upon a basis of naval reduction appear assured, if agreement is within grasping distance and can be won, events of tremendous humanitarian significance are expected to flow from the Hoover-MacDonald naval negotiations.

The basis upon which MacDonald's determination to arrive here and President Hoover are hopeful of agreement was announced today. Thirty-six hours ago President Hoover's ideal of naval reduction seemed to be fading before British isolation from open curtailment of the American building program ahead if possible. Only the secondary objection of limitation were greatly available.

After hours of conferring, instructions were sent Ambassador Dawes and a few hours after the British foreign office informally announced MacDonald would call for the United States September 25th.

The White House withheld comment upon MacDonald's announcement, but message which would have such curtailment of the American building program ahead if possible.

CHAPTER 17

AIRPLANE CRASHES

During these early years, airplane builders not only had to obtain the right parts, plans, and funds to build these flying machines, but also find men brave (or crazy) enough to pilot them. The machines' fragile, cloth-covered frames were made of wood, metal fittings, and wire cable. The engines were prone to fail because the first builders and pilots were forced to experiment with the new gas internal combustion engines, to find ways to lubricate and cool them, and to develop ignition systems with spark plugs that would not foul.

The pilots also had to teach themselves to fly by trial and error. They had to learn to take off into the wind, get the plane up in the air, sustain flight, make turns, and maneuver the plane without stalling and spinning—and without instruments. When a plane lost flying speed and stalled, it could go into a spin and crash. Early instruments such as the tachometer, oil pressure gauge, altimeter, and air speed indicator made flying safer, but the

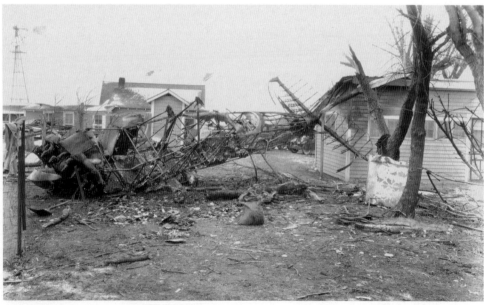

The remains of an airmail plane crash near Fort Crook while attempting a night landing on January 6, 1929. The pilot, Norman Potter of Salt Lake City, escaped with minor injuries, but three-fourths of the mail was damaged in the fire. Lee Watson, a farmer and owner of the house the plane hit, pulled Potter away from the wreckage to save him from the fire.
RG3882-330

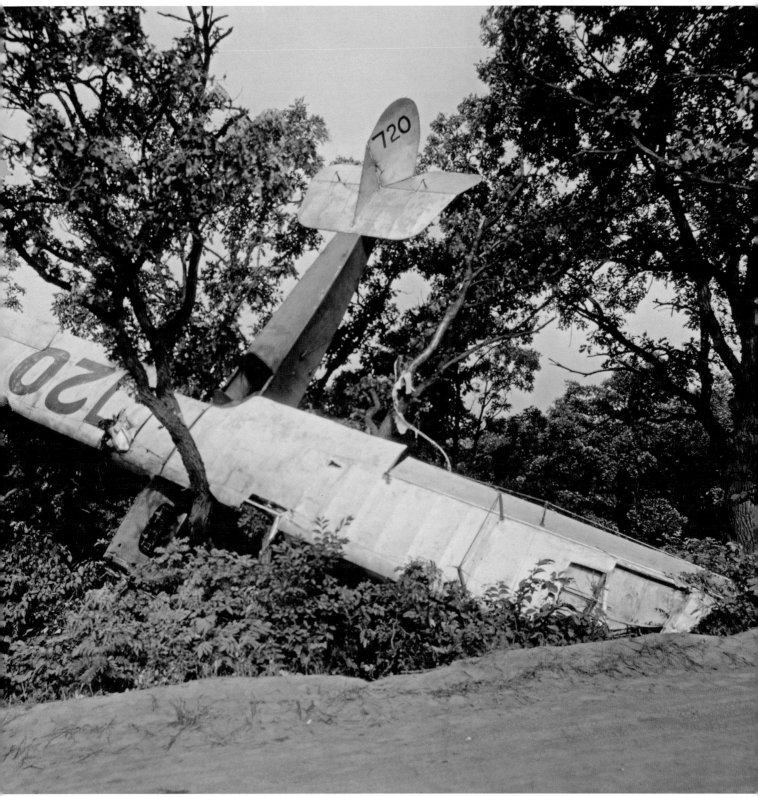

Twenty-one-year-old Jack Kenwood of Omaha survived this crash with only minor injuries. The Curtiss JN4 came down in the trees just north of Council Bluffs on August 15, 1927, after the engine failed.
RG3882-1-94

technique for recovering from a spin had not yet been discovered.

Inclement weather could be just as hazardous. Pilots learned that they had to take wind conditions into consideration when they took up a plane, but an understanding of wind patterns helped little when they had to fly in less-than-ideal conditions. Many of the early demonstrations took place at fairs, where excited spectators paid in advance to see flight for the first time. On a windy day, promoters would delay flights,

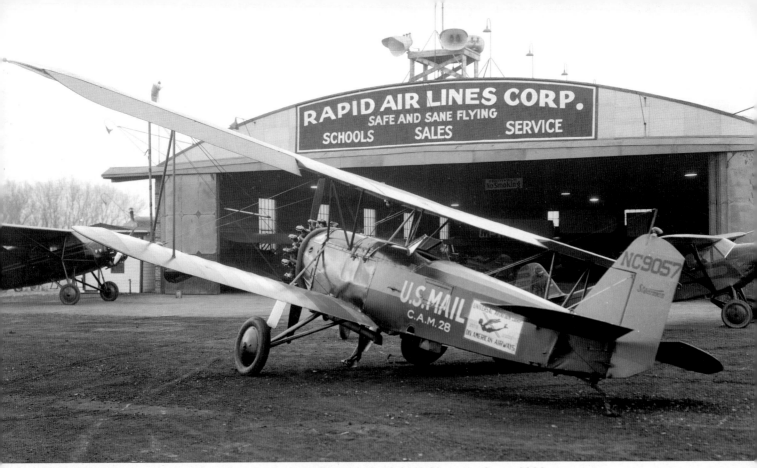

A Universal Airlines Stearman airmail plane at Omaha Municipal Airport, about 1930.
RG3882-541

but if the crowd became insistent, pilots were sometimes obliged to attempt a demonstration, often with disastrous results.

By the late 1920s, the technology of airframe and engine design had advanced enough that weather problems and human error, instead of equipment failure, became the major cause of air crashes. As new instruments were introduced, pilots learned blind flying techniques for poor visibility. They came to rely upon turn and bank indicators as well as an artificial horizon. Those instruments provided information counter to what was mistakenly perceived by their bodies, subject to vertigo when visibility was limited. In addition, better altimeters and compasses were developed during this period. It took the introduction of radio, radar, and later electronic equipment to reduce weather-related crashes.

With the coming of the jet age, new design and piloting problems developed, as was evident at the Lincoln Air Force Base in the mid-1950s, when a number of Boeing B-47s crashed locally. Today human error is the major remaining factor in crashes.

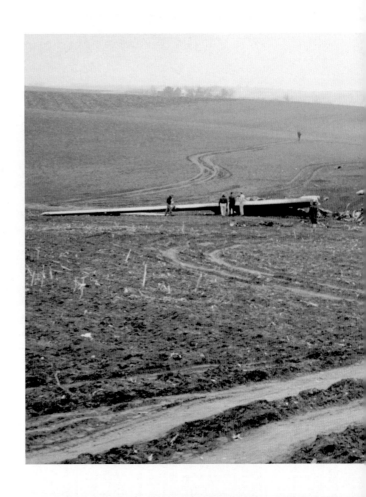

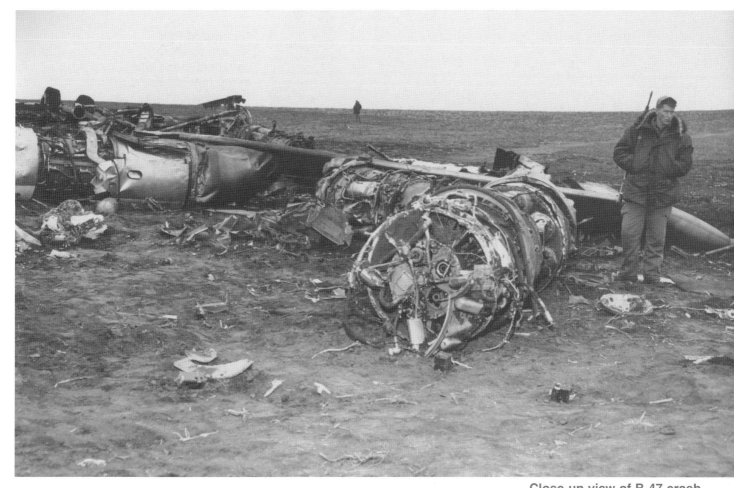

Close-up view of B-47 crash.
RG0809-15-50

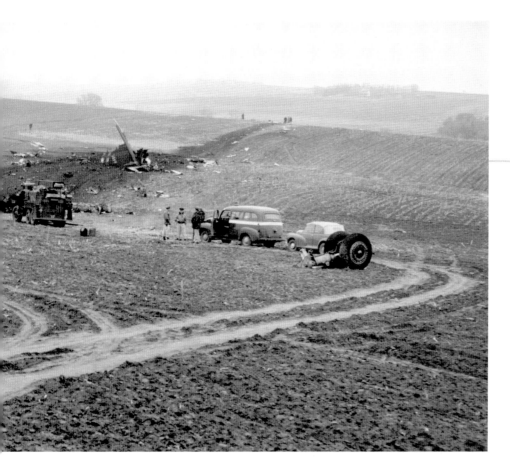

A B-47 crashed in a field near Raymond, Nebraska, on Wednesday, May 2 1956, killing its four-member crew. It was the second B-47 crash in the area. The first occurred on April 6 and was also fatal to its crew members.
RG0809-15-48

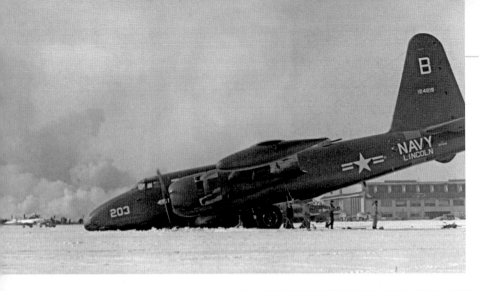

A Lockeed P2V Neptune with a collapsed nose wheel at the Lincoln Naval Air Station, which was part of the Lincoln Municipal Airport. RG0809-15-51

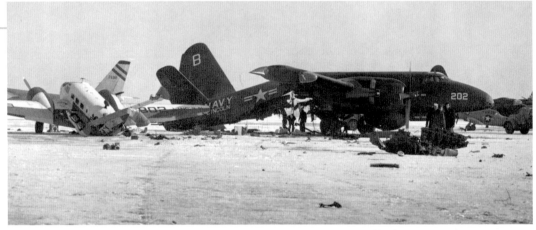

A Beechcraft 18 and a P2V Neptune in what appears to be a ground accident. The circumstances of the crash are unknown to the author. RG0809-15-53

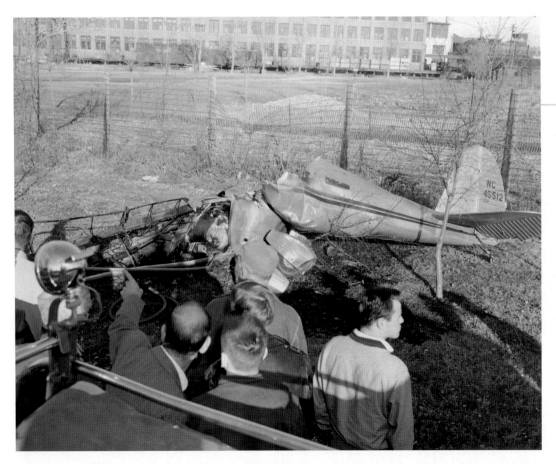

This crash, which was just north of the Burlington Havelock Shops, took the lives of an instructor and student when they collided with another student just after take-off from Lincoln's Union airport on December 19, 1954. The plane is a Luscombe. The other plane was piloted by Terry Edwards, a student pilot on his first solo flight. Edwards survived. RG0809-15-14

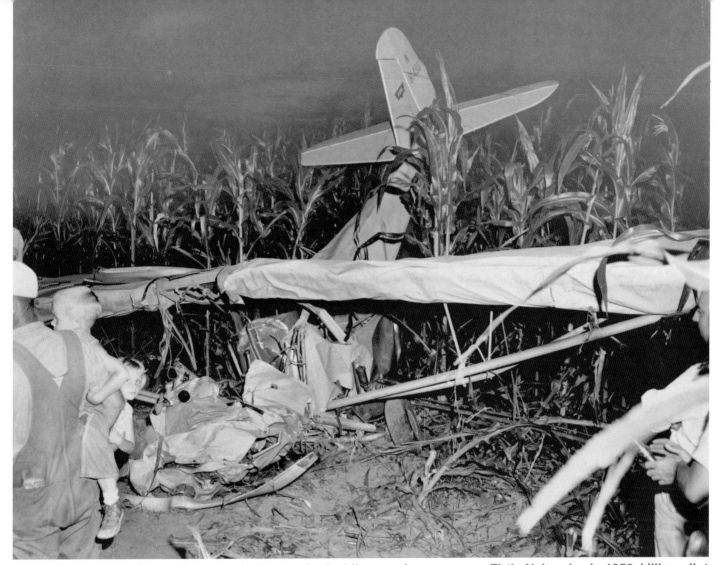

This Aeronca Champion crop duster crashed while spraying corn near Firth, Nebraska, in 1956, killing pilot Arthur Van Sickle of Lincoln. He was an experienced crop duster and flight instructor; a heart attack or sudden illness was thought to be the cause of the crash. RG0809-15-37

A Rockwell Aero Commander as it looked on its arrival to begin service as a state airplane in 1967. RG0809-9-1

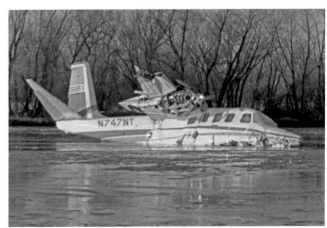

The state airplane after its crash at North Platte after experiencing engine failure. The cause of the accident was the result of fuel starvation from a missing fuel tank cap. The pilot, Howard Vest, was the director of the State Aeronautics Department at the time. RG0809-9-3

CHAPTER 18

AFTERWORD

Today, aviation has become both a military and civil flying business. Nebraska's ties to both are exemplified by the Strategic Air and Space Museum in Ashland and Duncan Aviation in Lincoln.

The Strategic Air and Space Museum began when Col. A. A. Arnhym, under the direction of SAC's commander-in-chief, Gen. Thomas S. Power, began collecting artifacts in 1959. The museum's first airplane, a B-36 Peacemaker, arrived on April 22, 1959, and the museum was dedicated in May 1966.

In 1996, after a fundraising effort that raised over thirty million dollars, the museum moved from its previous location at the north end of Offutt Field to its new facility between Lincoln and Omaha. It now contains more than forty military aircraft and

missiles and is a major tourist attraction.

Duncan Aviation began when Donald Duncan purchased the Beechcraft distributorship in Omaha. The company opened its Lincoln location in 1963 and became an original distributor of the new Learjet, one of the first affordable business jets. Under the leadership of Donald's son Robert, the company now services all major business aircraft and specializes in aircraft sales, overhaul, painting, modification, inspection, troubleshooting, fueling, and repair. It is the largest family-owned aircraft sales and support facility of its kind in North America.

Memories of aviation's "Golden Age" (1920s-30s) are kept alive by many individuals who restore and fly airplanes of this era. Gary Petersen's

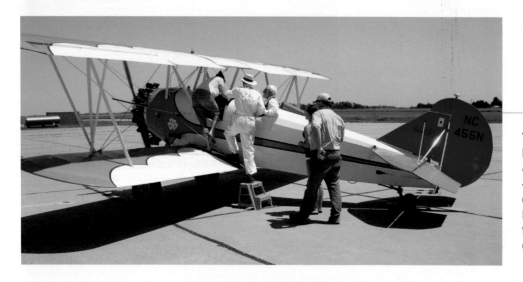

The author had a ride in this beautifully restored Travel Air 4000. Note the gray-haired pilot —most of the pilots at this event were late-middle aged. Many of the wives selling the tickets were dressed in period costumes.

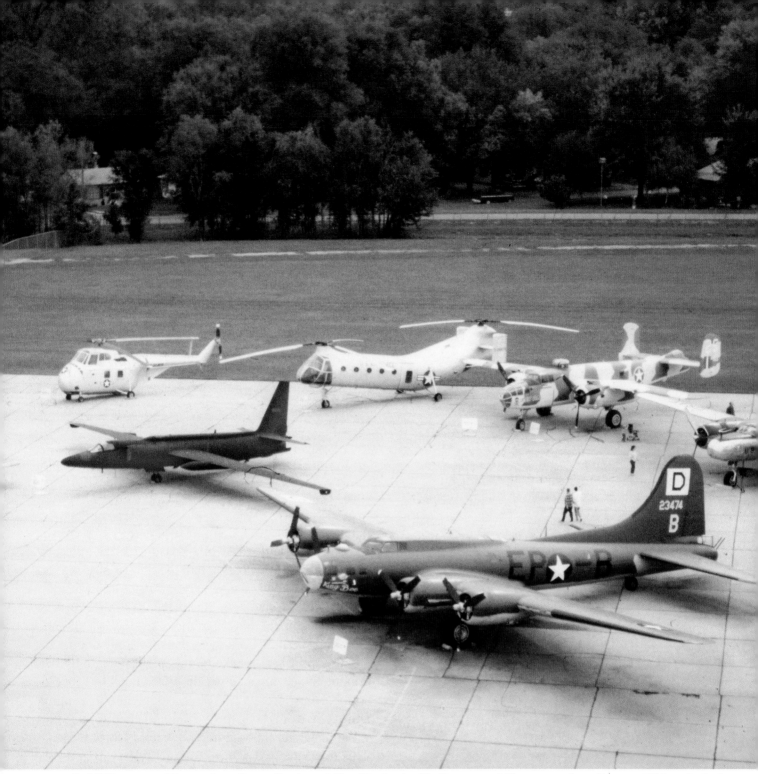

Cold War-era military aircraft on display at the Strategic Air Command Museum when it was still located at Offutt Air Force Base. Photo courtesy Strategic Air and Space Museum, Ashland, Nebraska.

beautifully restored Waco biplane on the cover of this book is such an example. Two organizations that play a major part in preserving aviation history are the American Aviation Historical Society and the Experimental Aircraft Association. The latter group has an annual fly-in at Oshkosh, Wisconsin, which draws large numbers of old aircraft and thousands of spectators.

In the summer of 2008, the American Barnstormer Tour stopped in Hastings with thirteen planes from the Golden Age. Several of these sold rides, and I had a wonderful flight in a Travel Air. This flight brought back the fond memories of barnstorming in Sutton, Nebraska, in 1946 with my flight instructor, Tasker Sherrill.

After World War II, thousands of military-trained

The old SAC Museum at Offutt Air Force Base. Back row, left to right: B-17 Flying Fortress, B-25 Billy Mitchell, B-52 Stratofortress. Front row: B-47 Stratojet, KC-97 Stratotanker, B-29 Supefortress, B-36 Peacemaker. Courtesy Strategic Air and Space Museum, Ashland, Nebraska.

An SR-71 "Blackbird" at the Strategic Air and Space Museum in Ashland, Nebraska.

pilots tried to stay in aviation. Some found jobs in commercial aviation. Others tried to get by as crop dusters and flight instructors. Some barnstorming was still done; my flight instructor did some of this and he took me along a few times.

During our Sutton trip, I sold tickets and helped passengers into the cockpit of his Waco UPF7, a vintage open-cockpit biplane of the 1930s. We also had a new Aeronca Champion, piloted by a Myron Larken. The field was a small pasture a few miles south of Sutton; when we had two heavy passengers we needed to push the Waco's tail right up to the fence so that it had enough space to take off. We had lots of customers that day and we needed gas to get back to Lincoln before dark. This meant flying to a small airport at Clay Center to gas up. They only had enough aviation gas to get the Waco back to Lincoln, so the little Aeronca was taxied to an auto gas station and we used that gas to fly back to Lincoln.

We made another memorable trip to North Bend. This time, the two planes were a Taylorcraft and the Aeronca. After two or three flights I noticed a liquid coming out of the Aeronca's engine cowling, and I quickly told Myron Larken, the pilot. He opened the cowling and discovered that the sediment bowl in the fuel line had broken. One of the men in the small crowd said it looked just like a Chevy automobile sediment bowl—he said he had one in his auto repair shop. We walked the two or three blocks into North Bend to get it, then returned to the plane and installed the bowl. It fit perfectly. We continued taking passengers and then flew back to Lincoln in the early evening.

For a sixteen-year-old boy, this was a great adventure.

An aerial view of Duncan Field in the late 1950s or early 1960s.
RG2153-2-4

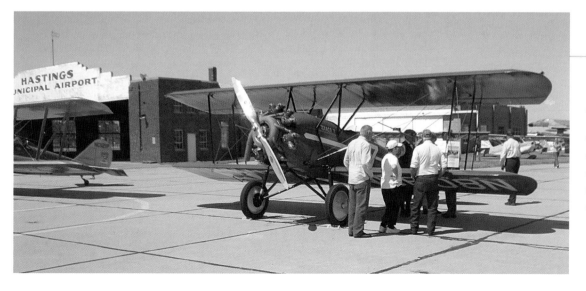

During the 2008 Barnstormers Tour, this Waco biplane, painted with the Texaco Oil logo, was parked in front of the 1930 hangar at the Hastings Airport.

NOTES

Chapter 1

2 Robert Adwers, *Rudder, Stick and Throttle* (Omaha, Neb.: Making History, 1994).

4 *Omaha World-Herald*, October 14, 1907, 1.

4-5 Durham Western Heritage Museum, Omaha, Neb. personal visit, 2003.

4, 8 *Omaha World-Herald Magazine*, March 5, 1933.

4, 8-9 *Omaha Bee*, April 6, 1919.

3, 6-7 *Polk Progress*, July 29, 1976.

8 *Lincoln Star*, August 31, 1907, 8.

8 *Ibid.*, September 4, 1907, 10.

8 *Ibid.*, September 5, 1907, 10.

8-9 *Lincoln Star*, January 2, 1911, 1.

8-9 *Ibid.*, January 4, 1911, 1.

9 *Ibid.*, September 3, 1918, 2.

9 *Ibid.*, September 6, 1920, 1.

9 *Ibid.*, December 30, 1910, 12.

10, 12 *Omaha World-Herald Magazine*, March 10, 1963, 14-15.

12-13 *Pireps*, Nebraska State Department of Aeronautics Newsletter 5 19 (May 1971).

12 "Nebraska's Second Pilot," *Hebron Journal*, September 29, 1911, 4.

12-13 Duane Hutchinson, *Savidge Brothers, Sandhills Aviators* (Lincoln, Neb.: Foundation Books, 1982).

12-13 Thayer County Historical Society, "Those With Wings," *Museum Muse* (Thayer County Historical Society, 1985).

13 *Omaha World-Herald*, June 23, 1912, 13.

Chapter 2

14 Inez Whitehead, "Fort Omaha Balloon School: Its Role in World War I," *Nebraska History* 69 1 (Spring 1988): 2-10.

14 Ed Regis, "Torture Chamber," *Air & Space/Smithsonian* (April-May 2006): 43-47.

16-19 *Pictorial History of Fort Omaha*, ed. William Frederick Collins, William O'Neil Goodwin and Joseph E. McClynn, O.I.C. Publication, ca. 1918.

Chapter 3

20-22 William G. Chrystal, "Orville Ralston: Nebraska War Bird," *Nebraska History* 76 4 (Winter 1995): 164-76.

20-22 *Sunday Omaha World-Herald Magazine*, April 4, 1971.

20-22 Nebraska State Historical Society RG2432 – Orville Alfred Ralston.

Chapter 4

26-31 Scott Berg, *Lindbergh* (New York:

Berkley Trade, 1999).

26-31 Charles Lindbergh, *The Spirit of St. Louis* (New York: Scribner, 1953).

29 *Omaha World-Herald*, July 16, 1978, 13 B.

29 Harlan (Bud) Gurney, letter to Nebraska State Historical Society, November 5-6, 1977.

30 United Airlines, *Robertson School of Aviation Newsletter* (Fall 1927).

Chapter 5

32 *Lincoln Journal Star*, September 26, 1965, F11.

32 *Omaha World-Herald*, July 16, 1978, 13 B.

33-37 Harlan (Bud) Gurney, letters to Nebraska State Historical Society in the 1970s.

33-37 Harlan (Bud) Gurney, letters to Mrs. Ethel (Page) Abbott, September 27, 1966.

Chapter 6

38 U.S. Department of Transportation, Federal Aviation Administration letter, to Nebraska State Historical Society, September 2, 1981.

38 Darlene Ritter, "Ethel Ives Tillotson: Nebraska's First Aviatrix," *Nebraska History* 63 2 (Summer 1982): 152-62.

38 *Omaha World-Herald*, May 8, 1921.

38 *Omaha World-Herald*, October 1, 1921.

38 *Ibid.*, May 14, 1938.

38, 42 Diane Bartels, *Sharpie: The Life Story of Evelyn Sharp*, Nebraska's Aviatrix (Lincoln, Nebraska: Dageforde Publishing, 1996).

38 *Omaha World-Herald*, May 8, 1921.

38-40 Louise Tinsley Miller, letter to Nebraska State Historical Society, January 19, 1984.

42 Adwers, *Rudder, Stick and Throttle*.

42 Nebraska State Historical Society RG3046 – Dorothy Barden.

42 Nebraska State Historical Society RG3441 – Grace Elizabeth (Betty) Clements.

Chapter 7

46 *Lincoln Star*, March 14, 1920, 4.

46 *Nebraska State Journal*, March 28, 1920.

48 *Lincoln Star*, May 7, 1922.

48 Ibid., October 5, 1919.

48-52 Adwers, *Rudder, Stick and Throttle*.

48-52 Peter M. Bowers, "Lincoln and Lincoln Page," *The AOPA PILOT* (February 1980).

48-52 Ernest K. Gann, *Ernest K. Gann's Flying Circus* (New York: Macmillan,

1974).

48-52 Frank Wiley, *Montana and the Sky: The Beginning of Aviation in the Land of the Shining Mountains* (Helena, Montana: Montana Aeronautics Commission, 1966).

48-52 George E. Johnson II, *The Nebraskan* (Winter Park, FL: Anna, 1981).

49 Nebraska State Historical Society RG3726 – Encil Chambers, Series 3 Oversize Plans for 1930 Baby Lincoln and 1925 Lincoln Sport and S. Swenson Lincoln Sport drawings.

50, 54 *Lincoln Star*, June 24, 1928.

51 Jerrold E. Sloniger, *One Pilot's Log: The Career of E. L. "Slonnie" Sloniger* (Charlottesville, VA: Howell Press, 1997).

53 *Omaha Bee*, June 28, 1925, 1.

54 *Omaha World-Herald*, May 14, 1931, 6.

54 *Lincoln Journal*, October 12, 1930.

56-58 Nebraska State Historical Society RG3009 – Arrow Aircraft company records.

56 Jim Christensen, grand nephew of Johnny Moore, letter to Nebraska State Historical Society, April 3, 1999.

56-58 *Lincoln Star*, March 8, 1921, 13B.

56 *Lincoln Journal*, March 1, 1931.

56-58 *Omaha World-Herald*, July 21, 1929.

56 Ibid., August 25, 1929.

56-58 Smithsonian Museum, "Sports Flying," Air & Space/Smithsonian 3 2 (February 1969).

58 *Ibid.*, February 13, 1974.

58 *Lincoln Journal*, January 16, 1978.

Chapter 8

64 *Omaha World-Herald*, July 29, 1928.

64-67 Adwers, *Rudder, Stick and Throttle*.

65-67 John C. Furstenberg and Jack L. Furstenberg, *Omaha's Adventure with the Overland Sport* (Omaha, NE: John C. Furstenberg and Jack L. Furstenberg, August 1989).

65-66 *Ibid.*, September 25, 1929.

65 *Ibid.*, October 13, 1929, 7 C

65-66 Louise Tinsley Miller letter to Leigh Delay, NSHS Historian, January 1, 1989.

Chapter 9

68-69, 72 E. J. Sias memo to Mr. Woods, October 17, 1938, Nebraska State Historical Society RG3009, Arrow Aircraft.

68-72 George E. Johnson III, *The Nebraskan*.

68-72 Robert F. Schirmer USAF (Ret.), "AAC

and AAF Civil Primary Flying Schools: Part V, Lincoln Primary, 1939-1945," *American Aviation History* Journal 37 1 (Spring 1992): 18.

68 *Sunday Journal Star*, August 27, 1939, D.

68, 72 *Ibid.*, March 30, 1941.

68 *Ibid.*, August 28, 1927, 16 M.

69 Lincoln City Directories, 1920-1936.

68-72 Del Harding, E. J. Sias: *An Annotated History of his Lincoln Airplane and Flying School and Lincoln Aeronautical Institute* (Lincoln: Del Harding, April 2004).

Chapter 10

78-79 Doyle Werner, North Platte, Neb., personal interviews, 1995-2000.

78 *Omaha World-Herald*, February 22-24, 1921, 1.

78, 83 *Ibid.*, July 2-3, 1924, 1.

78, 83 *Ibid.*, November 16, 1924, 1.

78-87 Donald Dale Jackson, *Flying the Mail* (New York: Time Life Books, 1982).

83 *Omaha World-Herald Magazine*, May 17, 1931, 3.

83 Kathleen Alonso, "3,937 Pounds of Letters: National Air Mail Week in Nebraska, May 1938," *Nebraska History* 86 4 (Winter 2005): 110-23.

Chapter 11

92 "Army Planes in Omaha," *Omaha World-Herald*, November 4-5, 1928.

92, 97 *Omaha Bee*, "Nebraska Air Tour," June 29, 1930, Section A12.

92-97 Adwers, *Rudder, Stick and Throttle*.

96 Craig Caskey, letter to author, September 2005.

96-97 *Omaha World-Herald*, "Glider," August 17 & 19, 1929.

97 *Ibid.*, "Monopup," October 23, 1930.

100 "Macready." USAF Museum. http://www.waptd.af.mil/museum/afp/afp799.htm

101 *Omaha World-Herald*, "Coste and Bellonte," September 23, 1930.

101 *Ibid.*, "De Havilland Gypsy Moth," June 3, 1930, 21.

102 *Ibid.*, "Travelair A6A," April 25, 1931.

103 *Ibid.*, "Lighting," October 15, 1929.

Chapter 12

104-106 *Omaha World-Herald Magazine*, November 3-7, 1921, 1.

104-111 Adwers, *Rudder, Stick and Throttle*.

106 *Omaha World-Herald*, November 1, 1921.

108-110 *Omaha World-Herald*, May 10, 1931, 2.

108-110 *Ibid.*, May 12-13, 1931.

108-110 *Ibid.*, May 17, 1931.

108-110 *Ibid.*, May 23-24, 1931.

108-110 *Omaha World-Herald Magazine*, July 14, 1946, 17 C.

Chapter 13

114-123 Barbara M. Kooiman, *Aviation Development in Nebraska*, Nebraska State Historical Society State Historic Preservation Office and Nebraska Department of Aeronautics (Mississippi Valley Archaeology Center at University of Wisconsin-La Crosse, September 2000).

114-123 *General Aviation in Nebraska* Nebraska State Historical Society State Historic Preservation Office and Nebraska Department of Aeronautics (Madison, Wisconsin: Mead & Hunt, 2001).

Chapter 14

126 Robert Casari, "Aviation Corps of the Nebraska National Guard 1915-1917," *Nebraska History* 56 1 (Spring 1975), 1-19.

126-128 *The Perry* (Iowa) *Daily Chief*, April 16, 1982, 1.

126 *Lincoln Star*, October 19, 1915, 1.

126-128 Douglas R. Hartman, "Early Nebraska National Guard," *American Aviation Historical Society Newsletter* (Fall 1990): 226-32.

126-133 Wendy Johnson, Nebraska Air National Guard, letter to author, 2000.

127-128 *Ibid.*, March 3, 1916, 1.

127-128 *Ibid.*, March 13, 1916, 1.

126-128 *Ibid.*, July 23, 1916, 8.

127-128 *St. Francis* (Kansas) *Herald*, September 7, 1916.

Chapter 15

134-143 Adwers, *Rudder, Stick and Throttle*.

134-143 David Nevin, *The Pathfinders*, ed. Time-Life Books (New York: Time Life, 1981), 41.

135, 143 Nebraska State Historical Society RG2440 – Edward Rasmussen.

136 *Omaha World-Herald*, September 17-18, 1924, 1.

136-143 Tony Reichhardt, "Tales from the Era when the Air Age met the Stone Age," *Air & Space/Smithsonian*

(November 2004): 61-62.

138-139 *Omaha World-Herald*, May 3-4, 1925, 1.

140-141 *Omaha World-Herald*. March 3-4, 1941.

Chapter 16

144-145 Angela Cooper, Director Nebraska Prairie Museum, letter to Nebraska State Historical Society, undated.

144-145 Steven A. Arts, "Beaver City's Flying Doctor," *Aviation History* 2 4 (Fall 2001): 36.

144-145 *Furnas County Past and Present* (Curtis Media Corporation, 1987), 1:52.

145 *Omaha World-Herald*, September 8, 1929, 5 C.

144-145 *Ibid.*, March 28, 1948, 5 C.

145-146 Liz Watts, "Flying Newsboy Takes to the Air," *Nebraska History* 86 4 (Winter 2005): 132-45.

147-148 Eldon W. Dawes and George E. Lemmer, "Crop Dusting," *Agricultural History* 39 3 (1965): 123-35.

148-149 Gladys Phillips of Beaver Crossing, personal interview and correspondence about Flying Farmers and Ranchers organization, April 2004.

148-149 Keith Carter, "Saddlehorses of the Sky," *Nebraska Farmer*, January 5, 1946, 1.

147-148 Vinton Jones, letter to author, November 11, 2005.

149 Harl A. Dalstrom, "I'm Never Going To Be Snowbound Again: The Winter of 1948-1949 in Nebraska," *Nebraska History* 83 3-4 (Fall/Winter 2002): 110-166.

150 Mary Krugerud, "Dazzler's Story," *Nebraska History* 80 4 (Winter 1999): 182-84.

Chapter 17

152-154 Walter J. Boyne, "The Dawn of Discipline," *Air & Space/Smithsonian* (June-July 2009): 62-69.

153 *Omaha World-Herald*, August 15, 1927.

152 *Ibid.*, January 6-7, 1929, 1.

155 *Lincoln Star*, April 7, 1956.

155 *Ibid.*, May 3, 1956.

156 *Lincoln Star*, December 20, 1954.

157 *Sunday Journal Star*, December 3-4, 1967, B1-3.

157 *Lincoln Journal Star*, December 6, 1967, 1.

157 *Lincoln Star*, July 26, 1956, 1.

INDEX

ACKNOWLEDGEMENTS

I want to thank the following people who contributed in the process of putting this book together. Without their help and guidance the book would not have been possible. David Bristow, John Carter, and Kylie Kinley, for their encouragement, editing and research; Pat Gaster, Jim Potter, and Bonnie Quinn for editing and proofreading; Dale Bacon, Dell Darling, and

Karen Keehr for photo research and scanning; and Paul Eisloeffel, Karlyn Anderson, and my son, Mike Goeres for research.

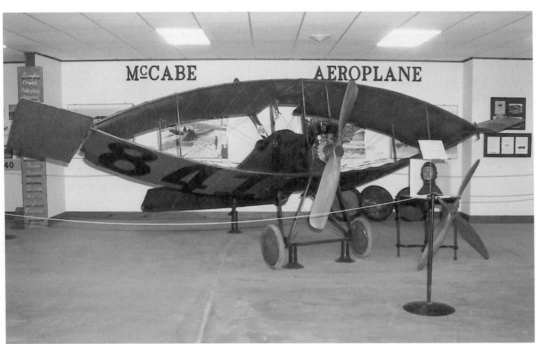

The 1918 "Baby Biplane" was designed by Ira Emmett McCabe of Lexington, Nebraska. He hoped to sell it to the navy as a submarine-based reconnaissance plane. It would be assembled from a kit, take off on pontoons, and be disassembled after it returned to the sub. But the war ended and the navy didn't buy the plane. Photo courtesy of Dawson County Historical Society and Museum, Lexington, Nebraska.